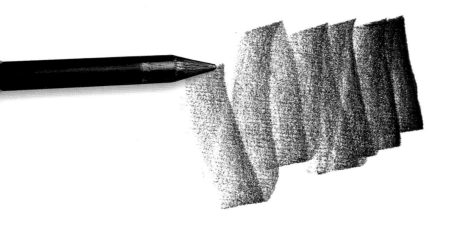

The Complete
Artist's Handbook

DRAWING
AND PAINTING

STERLING
New York

HOW TO ACCESS THE ADDITIONAL CONTENT

You may access it by registering on the website
or through augmented reality:

THROUGH THE WEB PAGE

Register at the website
by signing up for free at
www.books2AR.com/MDP;
scratch below and enter the code:

THREE SIMPLE STEPS:

1

Scratch off
the rectangle

2

Access the website and
enter the code

3

Sign up

WHAT YOU WILL FIND IN THE ADDITIONAL CONTENT

Step-by-step-
exercises
to see the process
in greater detail.

WITH AUGMENTED REALITY

2. Use the App to scan the pages where one of these two icons appear:

 At the beginning of the page, this icon indicates additional **step-by-step** content.

 At the beginning of the page, this icon indicates additional **gallery work** content.

1. Download the AR application for IOS for free at **http://www.books2AR.com/MDPIOS** or for Android at **http://www.books2AR.com/MDPAndroid**

Or with:

QR for IOS QR for Android

 Available on the **App Store**

 ANDROID APP ON **Google play**

THREE SIMPLE STEPS:

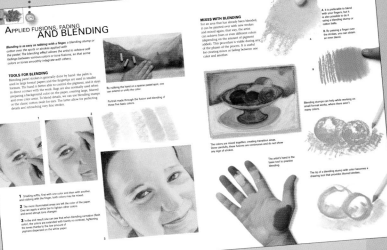

1

Download the App for free

The App requires an Internet connection in order to access the additional content.

2

Scan the image where the icon appears

3
Discover the content

+⊡ **A**ugmented **R**eality

 View gallery work for inspiration and ideas.

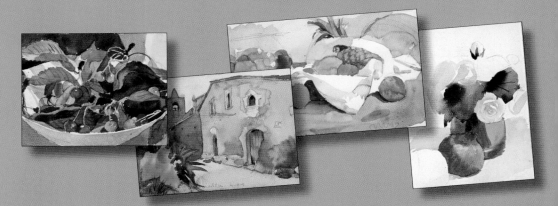

CONTENTS

PAINTING TECHNIQUES, 128

THE COMPLETE
ARTIST

Artistic work, like any human endeavor, is undoubtedly helped by talent, but knowledge of the materials and application of the different technical possibilities also plays a significant role.

This complete guide gathers all of the fundamental lessons of drawing and painting, with the aim of putting in your hands the full range of media and resources that will allow you to develop your artistic abilities. In it, you will find, in great detail, all of the current materials in the fine arts market and their different application techniques—a complete compendium of artistic materials and detailed procedures and techniques for mastering the arts of drawing and painting. Each section is accompanied by clear explanations that allow you to understand and correctly use the materials, as well as by numerous examples and basic tricks, so that it is possible to see and understand the immediate application of each process, its effects, and its creative potential. We try to avoid complex explanations of painting techniques and alchemical mixtures—the materials, mixtures, and effects are simply and clearly presented.

This work covers everything from the most traditional artistic techniques (a fundamental aspect of any artist's repertoire) up to the most interesting modern procedures. We analyze some of the most recent techniques, including synthetic materials, that in recent decades have made their way onto the artist's worktable. Similarly, it examines and appraises some lesser-known materials that have not received much attention in other manuals—many of which have been recently reincorporated into contemporary artists' work to expand the technical possibilities of traditional media.

This book may be read as a practical manual, a reference work, or a source of inspiration, thanks to the vast number of examples and short exercises of all of the subjects and styles presented. We hope that the wide array of techniques examined and developed in this work serve to help and stimulate both the amateur artist and the professional to continue experimenting, and to offer precise information regarding the technical and interpretative possibilities that each discipline holds within.

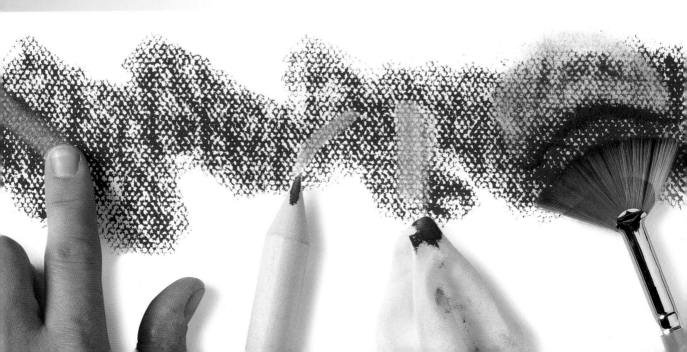

TECHNIQUES D

RAWING

Drawing is the fundamental basis of all art—the elemental structure of all techniques. Observation, composition, and planning are its crucial components. For that reason, to begin in any artistic discipline it is indispensable to understand the most essential drawing materials and basic drawing techniques.

Drawing is a challenge; it is an exploration, an analytic view, but it is also a finished work in its own right. Drawing has traditionally been the main discipline in learning art, and the most distinguished artists still consider it to be the driving force behind their work.

This section will cover, exhaustively, the materials and the graphic possibilities that they provide.

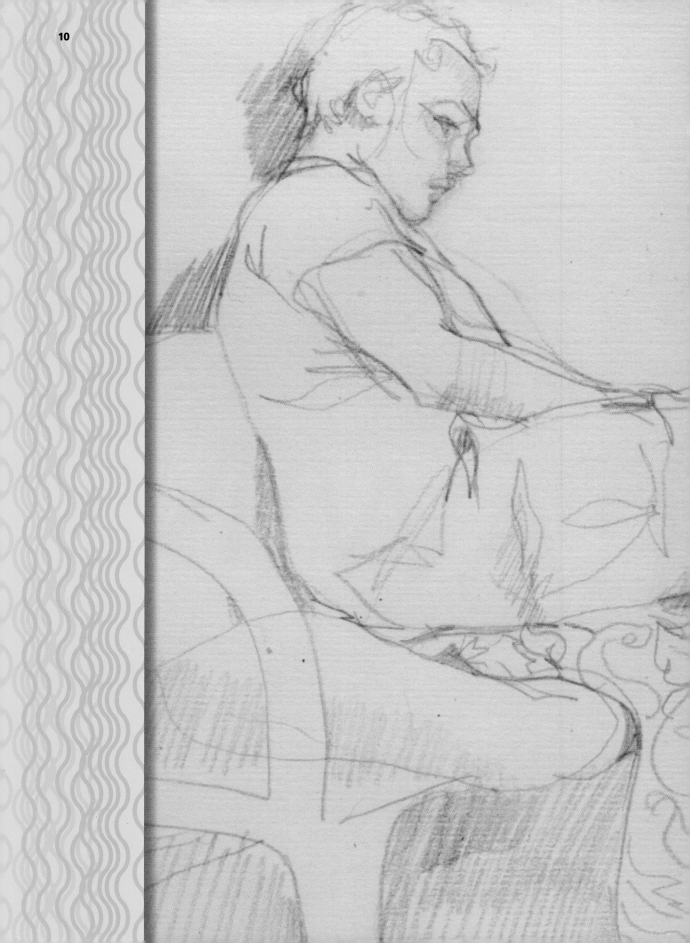

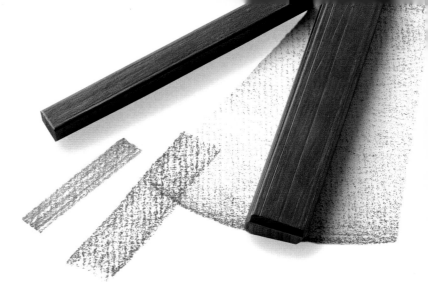

*T*he pencil, whether graphite or colored, is one of the drawing media that enjoys the most popularity among both students and art professionals. This is no doubt due to its durability, portability, and ease of use compared to other materials. It is also the most immediate, versatile, and sensitive drawing medium, as it is just as useful for drawing a sketch or making an insertion or a quick note as it is for creating a complete, precise, and very detailed drawing. The sharpened tip and wooden covering allow the artist to always have control of the line; further, it can be erased and redrawn as many times as necessary.

Opposite: Pencils allow for a direct and calligraphic stroke. They offer great possibilities in linear drawings.

GRAPHITE AND COLORED PENCILS

GRAPHITE: PENCILS, OTHER TOOLS, AND TECHNIQUES

The graphite or lead pencil is one of the drawing media that enjoys the greatest popularity thanks to its durability and malleability. It is also an immediate drawing tool, and just as useful in sketching a quick drawing as in creating a very detailed work. Graphite is brittle and greasy to the touch, and comes in various forms: sticks, pencils, lead, and powder. Some of these forms are reviewed in the following pages.

Natural graphite rocks are greasy to the touch and leave dark traces when rubbed against a surface.

Drawing with a graphite pencil is appropriate when you want the work to have a more linear appearance.

The grades of graphite pencils are ordered according to their progressive hardness: from 5Hs, which produce the lightest stroke, to 9Bs, which produce the darkest shading.

THE QUALITY OF CEDAR WOOD

Tody, graphite is not used in its pure state; rather, its lead is made up of the pulverized mineral mixed with clay. Once both materials have been combined and clad within a wooden covering, they provide a more rigid and abrasive material. Graphite pencils are typically encased in cedar wood, a material that is sufficiently soft to allow for sharpening and resistant and rigid enough to ensure the pencil's quality. Although pencils are made from other soft woods, only cedar meets all the quality requirements.

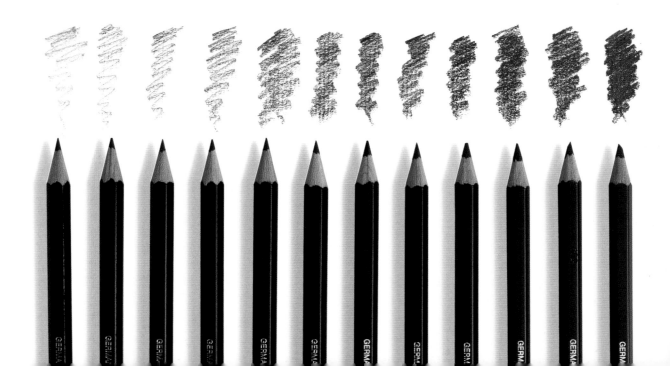

GRAPHITE, LEAD PENCILS, AND SILVER TIP

The confusion between graphite and lead arose when, in the past, it was believed that graphite was a variety of lead rather than crystalized carbon. This confusion has persisted until today, as people still speak of "lead pencils" or "lead," not realizing that there is no relation whatsoever between graphite and lead. Centuries ago, the points of other metals— gold, copper, or silver—were used as a drawing medium and provided a line similar to that of graphite.

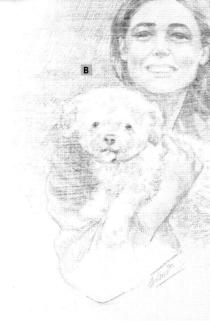

A. Mechanical pencil with silver lead.

Graphite powder may also be used for drawing if applied with a cotton ball or blending stump.

B. This paper has a fine layer of zinc oxide to allow for abrasion when drawn on with a metal tip and, as a result, a softer stroke.

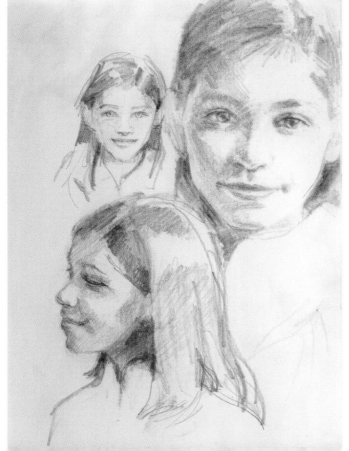

BETTER ON SMOOTH AND SATIN-FINISH PAPER

Drawings done with graphite do not need any final fixing, although it is sometimes recommended. On paper, graphite has a soft and velvety quality when used for shading, or an intense and sharp quality when the tip is pressed against the paper. The artist has very precise control of the line because it can be erased and drawn anew as many times as needed.

The graphite pencil offers its best characteristics on fine grain or even satin-finish paper.

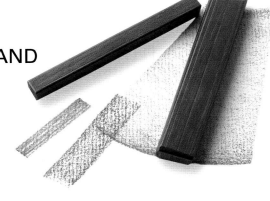

Effects with Graphite Sticks and Woodless Graphite Pencils

Graphite sticks or bars are thicker pieces of agglutinated graphite that range between 10 and 15 mm of thickness. They tend to a have a quadrangular or hexagonal shape with smooth faces, and may be applied with the edge, end, or tip.

Some varieties of bar graphite may be used for large-scale works, especially those requiring extensive shaded areas.

Graphite sticks can be rectangular or square, and come in different levels of hardness.

A. To control the stroke with a woodless graphite pencil, it is essential to correctly incline the tip of the graphite lead with respect to the paper.

B. Different results are obtained when drawing with a sharp or a blunt tip.

C. The stroke appears widest with the maximum amount of inclination.

A

B

Woodless graphite provides a thicker and wider stroke than a regular pencil, and is very malleable and easy to control.

SHADING WITH GRAPHITE STICKS

Graphite sticks are not enclosed by a wooden or plastic covering, allowing for a wide variety of strokes, especially broad, shading, and fades that are achieved by transversally dragging the stick over the paper. If the graphite is soft, the shadings may even be blended to achieve shading or fading without the appearance of strokes or grains. The majority of drawers tend to simply blend with their fingers to have more control over the fading, although, as we shall see further on, a blending stump can be used for the same effect.

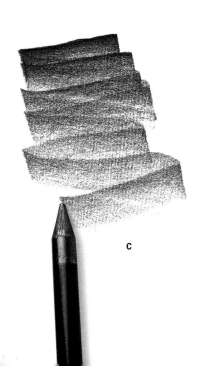

C

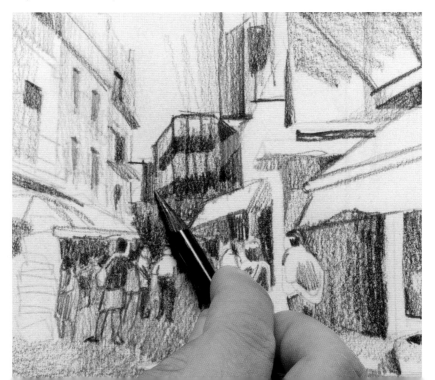

RECTANGULAR STICKS AND WOODLESS GRAPHITE PENCILS FOR LARGE FORMATS

If you prefer broad stokes, you can opt for rectangular-section bars (in the case of sticks), or hexagonal-section wood-less pencils. They allow for broad and intense strokes, and even, uniform shading. Their use is similar to that of charcoal sticks.

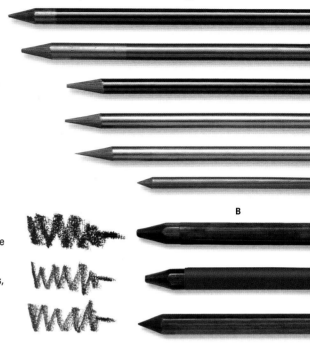

A

B

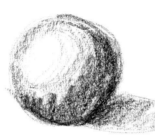

It is easy to extend a smude shadow with a graphite stick or woodless graphite pencil.

Cylindrically cut woodless graphite pencils (A) and ones with hexagonal bodies, of three different hardnesses (B).

1

WOODLESS GRAPHITE PENCILS

Woodless graphite pencils differ from bars in that they come in cylindrical cuts as well. They are usually divided into two groups: those that are inserted into mechanical pencils, and those are used as a conventional pencil. The first kind range from 1 to 6 mm thick, and are generally sold in three or four hardness grades. Ones that are pencil shaped (all lead) are easily sharpened and come in different hardnesses, from grades four to six, depending on the manufacturer.

1 By adjusting the pressure placed with the lead and the inclination of the tip, the artist can achieve a wide variety of strokes and different intensities of gray.

2 Graphite lead's versatility makes it a very sought-after tool for making notes and quick sketches.

2

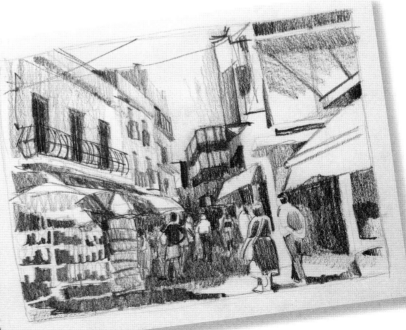

LINE TECHNIQUES WITH GRAPHITE

Line drawing is among the most popular techniques done with a graphite pencil; it is a drawing whose value lies in the intensity and intentionality of the line, in its thickness and inflections. The artist beginning to draw with pencils should research the different varieties of strokes and their graphic interest.

It is important to do simple exercises and practice line strokes to obtain fluent strokes without stressed, superimposed, or overly broken lines.

Graphite line strokes should be fluid and spontaneous. Try to avoid constant reworking or overworking.

HARDNESS GRADES

The stroke intensity applied with graphite depends on the grade of hardness of the lead or pencil, which appears printed in numbers and letters on the upper end of the pencil. For artistic drawing, softer leads are recommended, which start from HB and move up to the higher B range. The H range, of harder pencils, is used for technical drawing. It is worthwhile to have several different pencils and two or three mechanical pencils so the most suitable one can be selected in each case. There is also another variety: pencils marked with the letter F—the tip can be sharpened a lot due to its extreme hardness.

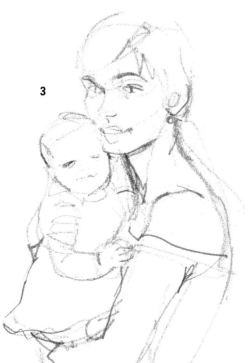

1 The preliminary drawing is done with a harder pencil, inclining the tip so that the stroke is not too intense.

2 As the drawing progresses, softer pencils are used and more pressure is placed on the stroke.

3 The last lines are the most accurate, and they are finer and intended to define the figure's face.

The thickness and intensity of the stroke varies if done with a blunt or well-sharpened tip.

STROKE VARIETY

Generally, in pencil drawings based only on lines, the artist must constantly adjust the thickness and intensity to obtain variety and avoid the cold monotony of a uniform line. The decision of where to increase the thickness and intensity of the line depends on the nature of the theme. Generally, the norm is to draw fine, soft lines in the subject's illuminated contours, leaving the thicker and more intense lines for shaded areas.

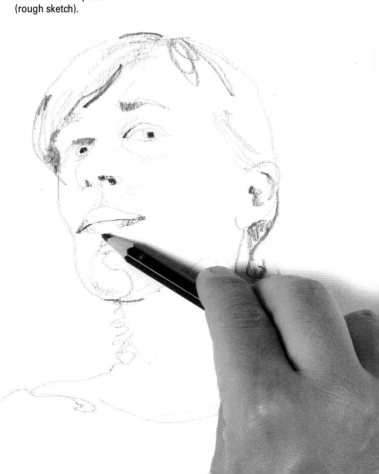

With line drawings done with graphite, the artist can achieve detailed work without losing the synthetic and gestural sense of the esquisse (rough sketch).

Pencils and mechanical pencils are excellent materials for developing sketches.

SCRIBBLING

Scribbles are lines drawn in a nervous and halting manner. They are strokes that the artist practices almost involuntarily, without being aware of them. Many artists practice scribbling as a fast drawing technique, for subconscious motivation, requiring speed and good mastery of the stroke. It is very useful for maintenance esquisses or rough sketches, that is, those the artist can experiment with or uses to "warm up" their hand.

The scribbling technique is done gesturally, varying the inclination of the tip, which barely rises off of the paper.

HATCHING WITH GRAPHITE

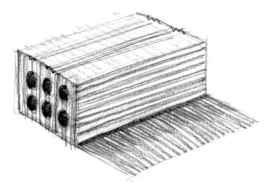

Hatches are orderly accumulations of strokes that are applied, forming a network of lines that are generally used for shading or to suggest different surfaces, tonal ranges, or textures. They are composed of perpendicular lines, crisscrossed diagonally, in spirals, waves, and other patterns. The most important factor is that the entirety of the work appear even. The density of the strokes depends on the intensity and number of lines. Strokes that are close together, separate, or crossed achieve the optical effect of shading.

The direction of each hatch must be in accordance with the object's planes or surfaces. The artist must choose the best direction for hatching in each case.

BASIC HATCHING

Parallel hatching is done by drawing parallel lines close together, defining a single area. The tone will be more or less dark depending on how close together the hatching is and how intense the strokes that compose it are. This hatching can produce a fading effect when the strokes are very soft and gradually become more intense, or vice-versa. It may also be done quickly using a zigzag pattern. Another very popular variety of stroke is cross-hatching, which consists of layering one hatching over another, lightly crossing the strokes and forming an angle of about 30 degrees.

Cross-hatching is ideal for achieving faded shading on curved or spherical surfaces.

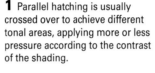
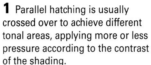

1 Parallel hatching is usually crossed over to achieve different tonal areas, applying more or less pressure according to the contrast of the shading.

2 The accumulation of minute linear hatching provides a rich range of tones, resulting in a good line complement.

1

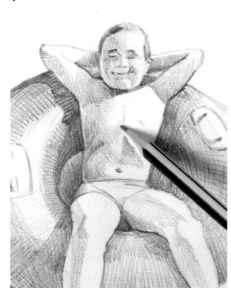

2

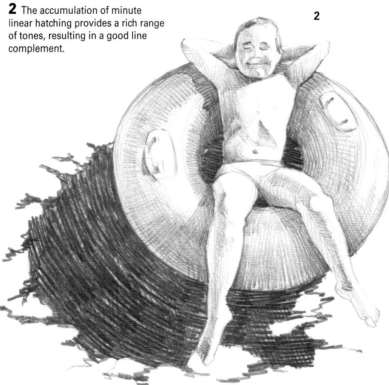

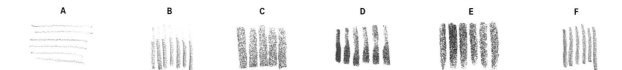

A B C D E F

STROKES ON SPHERICAL SURFACES

Spherical surfaces are not shaded the same way throughout; rather, they are shaded with faded tones. Thus, the hatch strokes that should be drawn are crossed and radial, that is, following the direction of the spherical plane. They will accumulate in the dark zones while appearing fainter and less perceivable in the illuminated areas. The insistence of the line crossings achieves a beautiful faded tonal shading.

Not only is the direction of the hatching important, but the line's thickness also matters. The pressure exerted by the pencil over the paper determines the tone of the shading. The example below is done using various samples.

DIRECTION AND ORIENTATION OF THE STROKES

Aside from the stroke's form and the distance between the lines, the direction and orientation of the strokes are also important, as they contribute to the object's texture and volume, making it more real and believable. This means that when the surface is cylindrical or spherical, the hatching should be done with curved strokes, and if the surface is smooth or straight, with parallel strokes. The changes in direction are also applied to define the different planes of an object, thus strengthening their limits, especially if they have different degrees of illumination.

1

1 Intense stroke hatching can be done by applying more pressure to the pencil.

2 The most illuminated areas are barely covered by weaker and more widely spaced strokes.

2

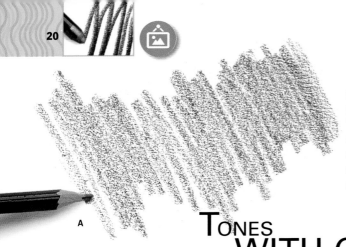

Using pencils and graphite leads to express light through tones is different from using them in a linear manner. The simplest way to achieve an even tone is to draw a hatching of closely spaced strokes with the inclined tip of the pencil. If a darker tone is needed when finished, the artist can add another layer over the top of it with another hatching, applying more pressure to the tip of the strokes.

A

Tones
WITH GRAPHITE

B

PARALLEL HATCHING WITH BROAD STROKES

The fastest way of shading and covering a wide tonal area is to incline the tip of the graphite pencil and apply parallel hatching, that is, a shading done with hatching of very broad, medium-tone parallel strokes, applied energetically over some areas of the drawing. A flat-tipped pencil applied over smooth paper immediately achieves an area with even tone, without leaving a trace of the pencil's lead.

A. A hatching of close strokes drawn with the tip inclined provides an even graying or shading.

B. The main shadings are applied by scratching the surface with the tip inclined to avoid the appearance of hatching. Then it can be blended using the fingers.

The tones applied with graphite depend on the roughness of the paper, which must be taken into account before drawing.

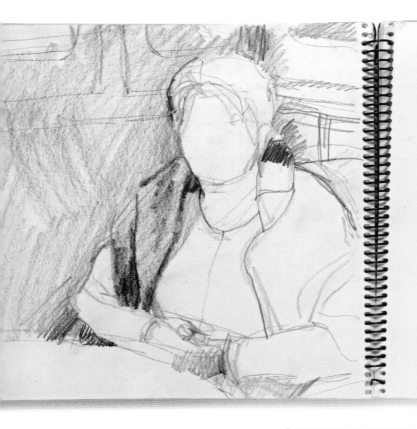

TONE AREAS WITH GRAPHITE STICKS

In models in which the contrast between light and shaded areas is very pronounced, the artist may use graphite sticks or woodless graphite to represent broad tonal areas. The tip should be slightly inclined to allow for different stroke intensities that will enable you to achieve light and dark shading. Thick, bold lines draw our attention, stand out, and appear closer, whereas light lines express a feeling of distance.

Applying graphite lead using its edge allows the artist to cover tone areas with great ease, with a quick zigzag.

CARPENTER PENCIL AS A TOOL

Beveled-tip pencils, which are characteristic of DIY and carpentry work, are a popular medium among drawers. They have a flat, broad tip that allows the user to draw strokes that range from fine and barely perceptible to broad and thick. This pronounced contrast of lines is achieved by simply rotating the wrist a bit. The pencil's broad, marked stroke allows for emphasizing a profile, while close strokes allow for quickly covering an area with a tone or shading. Leads with medium-soft hardness are useful for shading.

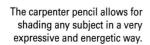

The carpenter pencil's beveled tip helps to achieve shading.

The carpenter pencil allows for shading any subject in a very expressive and energetic way.

WATER-SOLUBLE GRAPHITE

Water-soluble graphite was traditionally one of the more obscure materials of the fine art world; there was not much demand for it. However in recent years, several interesting new products have appeared, and now many more varieties of water-soluble graphite pencils and sticks are available.

Left: Tonal spots of water-soluble graphite can be diluted by simply passing a wet brush on top of them.

PENCILS AND LEADS

Water-soluble graphite pencils and sticks are usually available in five degrees of hardness: HB, 2B, 4B, 6B, and 8B. In addition to the traditional gray, other colors are available. The idea of combining wet and dry areas makes sense when the strokes are broad and the wash can generously expand over the paper.

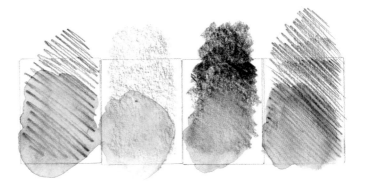

Water-soluble graphite lines are very easily diluted in water, and can even be mixed with color washes.

1 Water-soluble lead is used in the same way as conventional lead: by combining linear strokes with small areas of tone.

2 Water-soluble graphite is mixed with watercolor washes without contaminating the color. Do not repeat the brushstrokes; one layer is enough.

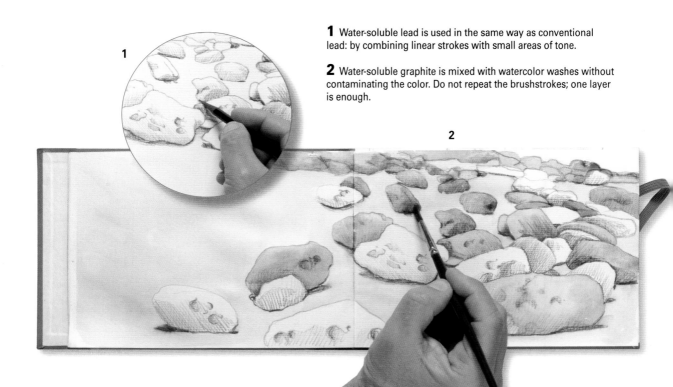

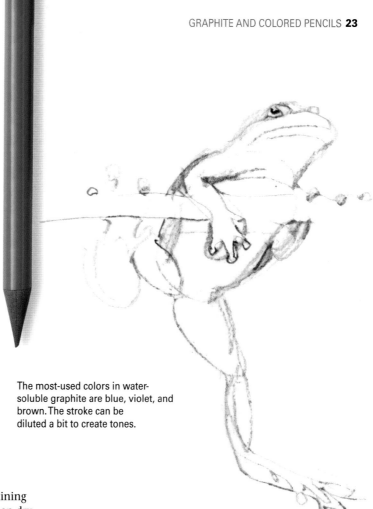

Colored water-soluble graphite is an alternative to gray, although these tools have a slightly different feel and stroke.

DRAWING TECHNIQUE
WITH WATER-SOLUBLE GRAPHITE

Making linear strokes with water-soluble graphite pencils is much like making them with traditional graphite pencils, except that the water-soluble ones are softer and offer a very intense line, so the artist should not apply too much pressure to the tip on the paper. Shading or coloring must be done by zigzagging, with close lines made by barely touching the surface of the paper with the tip of the lead. This way, one may avoid saturating the paper when the wet tip of the brush dissolves the color and transforms it into a wash.

The most-used colors in water-soluble graphite are blue, violet, and brown. The stroke can be diluted a bit to create tones.

IDEAL FOR SKETCHES
AND COMBINED WITH WATERCOLOR

Water-soluble graphite is very appropriate for outlining scenery, given that it acts like normal graphite when dry. Color may then be applied by painting with watercolor. If working with water-soluble gray pencils, the artist must be careful to avoid rubbing too much with the brush if the pencil marks are being used as a base for creating watercolors, because when the gray strokes dissolve they will stain the washes. When properly used, they provide a very effective combination.

Graphite pigment in shaded areas ends up merging with the watercolor, forming slight fadings.

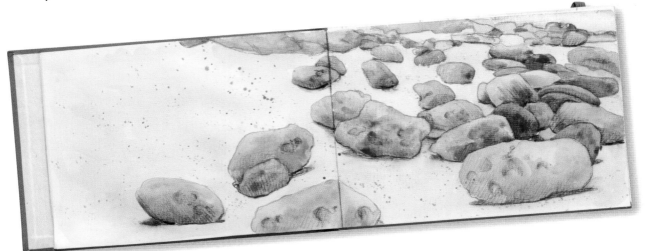

GREASE PENCILS

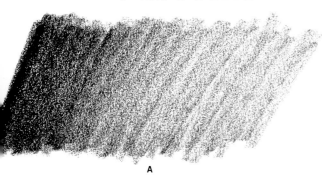

Also known as wax pastels or china marker, these are grease-based pencils designed to draw on polished or smooth surfaces, offering all artists depth, bright colors, and, with some formats, stroke precision. The wax gives them a very sticky feel and ensures their adhesion to paper. Wax pastels, which are similar to oil pastels, are also included in this category.

A

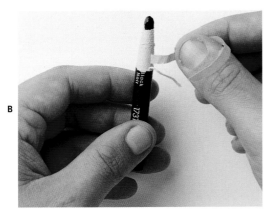

B

A. The china marker does not allow for fine shading or wide tonal ranges, as the stroke tends to be always greasy and thick.

B. The tip is not sharpened, but is rather left uncovered with a string that is used to strip off fine layers of paper that envelop the lead.

CHINA MARKER

The first characteristic that one observes is the hardness of its sharpened point despite it being somewhat greasy to the touch, in comparison to charcoal pencils. It has good pigment, which begins to draw as soon as the lead touches the paper and which can be blurred by rubbing it with a finger—although it requires harder rubbing than charcoal. The blurring provides very intense, and matte spots that strongly penetrate the paper, making it difficult to erase.

Sharpenable grease pencils (center and right below) are very precise because they can provide very fine, deeply colored strokes. Wax pastels and pencils allow the artist to execute bold and daring drawings.

The wide lead (5 mm) on the china marker allows it to apply color with more ease and to draw free and spontaneous strokes.

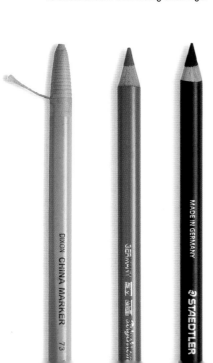

WAX PASTELS

Wax pastels come in the form of lead enclosed in a small tube of paper or even wood, depending on their thickness. The wax pastel stroke is saturated, firm, and dense. Its waxy consistency is good for developing bold, definitive strokes rather than tonal ranges. As it is difficult to erase, it allows for few modifications, and thus is ideal for outlining or drawing pictures that require a fluent, experimental stroke.

Given that its stroke is firm, it allows for few changes; this makes it necessary to learn to incorporate experiments or errors into drawings.

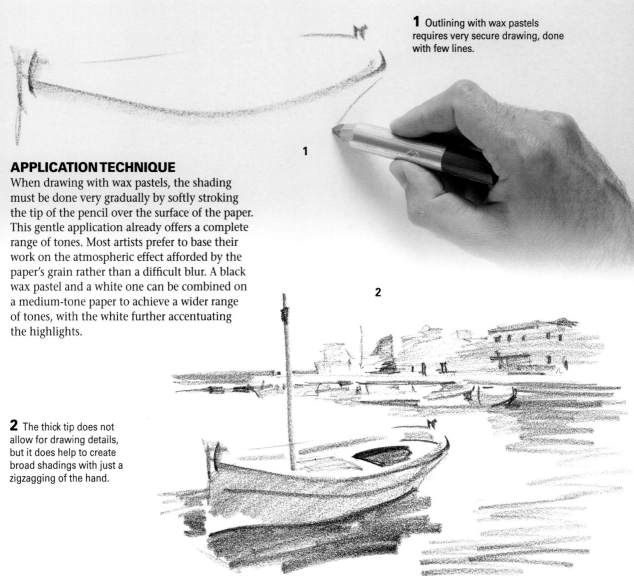

1 Outlining with wax pastels requires very secure drawing, done with few lines.

APPLICATION TECHNIQUE

When drawing with wax pastels, the shading must be done very gradually by softly stroking the tip of the pencil over the surface of the paper. This gentle application already offers a complete range of tones. Most artists prefer to base their work on the atmospheric effect afforded by the paper's grain rather than a difficult blur. A black wax pastel and a white one can be combined on a medium-tone paper to achieve a wider range of tones, with the white further accentuating the highlights.

2 The thick tip does not allow for drawing details, but it does help to create broad shadings with just a zigzagging of the hand.

Colored pencils are clean, practical, and easy to carry, making them one of the ideal media for drawing outdoors. They are made similarly to graphite pencils, and are used just like conventional pencils, providing a finish that is less oily, softer, and glossier. The largest manufacturers usually offer two main kinds: soft lead pencils and hard lead pencils.

Colored pencils allow the artist to work with the precision of a graphite pencil, while also adding color to the drawing.

Colored Pencil CHARACTERISTICS

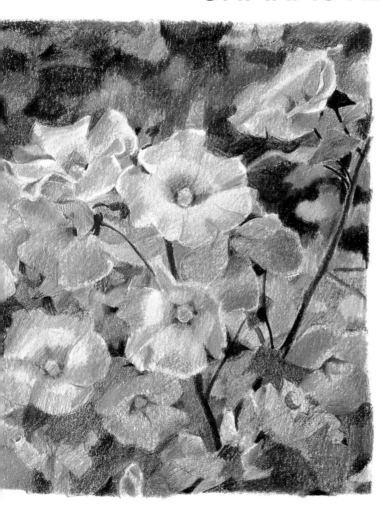

Colored pencils can provide one of the widest chromatic scales available in drawing genres.

HARD-LEAD PENCILS

The larger number of additives in colored pencil lead allow it to be sharpened to maximum sharpness, so that the artist can work meticulously. This makes it necessary to reduce the amount of pigment, and for that reason, it is not quite as easy to achieve surfaces of color that are saturated and completely covered. The pencil's colored lead is about 3.5 mm in diameter, and its body is usually hexagonal.

SMALL FORMATS

Working with colored pencils is a small-scale job. These pencils do not allow for large formats and offer their best results when the artist is working meticulously. The undoubted enchantment of this technique lies in this limitation, as it forces the artist to work attentively, delicately, and sensitively.

1

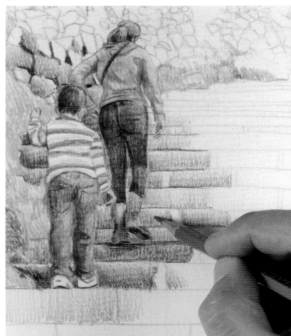

1 Colored pencils are not well suited to large-scale work and produce better results in detailed work.

SOFT-LEAD PENCILS

The larger amount of pigment in the lead makes them thicker, about 4 mm in diameter, and makes it necessary to reduce the number of other additives. The stroke is also thicker, and has more saturated coloring. The lead is more fragile, and its tip is quickly worn out. Its body is usually round.

They are soft enough to produce delicate colorings, and they can be sharpened to achieve more intense and linear strokes.

2

3

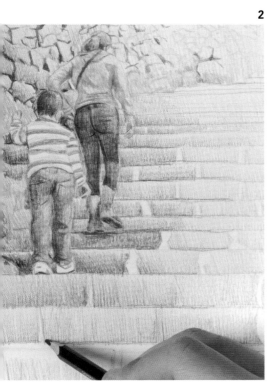

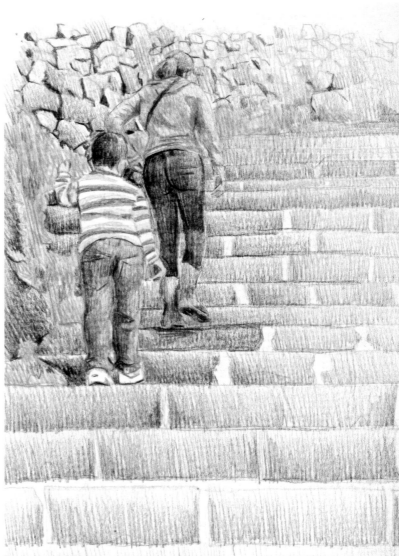

2 The combination of light colorings with the hatching is the main resource of the artist working with colored pencils.

3 They allow for a finish and meticulousness in the details that are impossible to achieve in the majority of drawing techniques.

The stroke intensity produced with colored pencils depends on the quality and quantity of pigment contained in the lead. The difference in the density of the stroke produced by a hard lead pencil and a soft lead one is evident, and it is a determining factor when creating different kinds of works.

COLORATION AND MIX OF COLORED PENCILS

The accumulation or mix of different colors produces areas of deeper color, thereby offering an interesting optical mix.

1 On black paper, one can begin by outlining the scene with a white pencil.

SATURATION OF STROKES

Drawing with colored pencils is also coloring. The best method is to begin with light colors and apply them with more or less separate strokes, without completely covering the surface of the paper. The overlaying or accumulation of strokes will determine the evenness of the color and its intensity. Tones can never be too saturated, but it is possible to achieve color areas that cover much space by pressing the pencil's lead flat against the paper, which is observed when working on dark-toned paper.

2 As the work progresses, one can apply more pressure to the pencil. It is useful to work with quality pencils, as they have higher amounts of pigment.

3 On top of the white layer, one can add hints of color by applying pressure so that the stroke is highly contrasting and luminous.

WHITE SPACES

If the artist intends to draw very light or whited-out areas, the use of pencils will be minimal. White pencils do not serve this purpose; rather, they are used to color around shapes that will be left in that color, just as with watercolor. This way of working requires one to envision the effect beforehand, cutting out shapes from on top of a darker background formed by a hatching of tighter strokes. Then, soft shadings may be applied that blend the various tonalities of white.

If you are working on a large area that you would like to be white—and your paper is white—you can let the paper be your white, and do not need to color it in.

WHITENING

Colored pencils have a particularity due to their lead composition: They are able to mix strokes by painting with light gray or white on top of one or several colors. The lead's somewhat waxy consistency overcomes the low coloring power of white or gray tones, causing the strokes to mix among themselves, leaving it barely affected by those colors. Soft leaded pencils with more intense colors even allow the artist to work on a dark-colored background in which the chiaroscuro effect is intensified, creating an interesting range of lighting effects.

White pencils achieve a uniform polished effect, whitening your color applications.
It also helps with mixing strokes of one color, strengthening their tonality and de-intensifying their coloration.

Polishing with white provides clear, whitened tones that are similar to pastel.

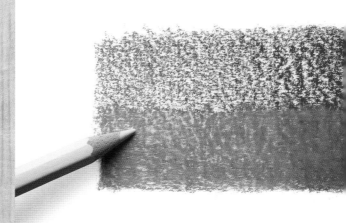

Mixing with GLAZES

In many respects, colored pencils work like watercolors—that is, they take advantage of the paper's brightness. Bearing in mind that pencil glazes are semi-transparent, you can apply them by glazing or by soft colorings that are overlaid until the desired chromatic combination is produced.

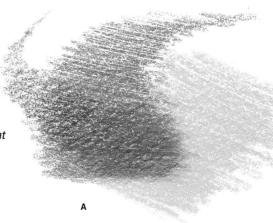

A

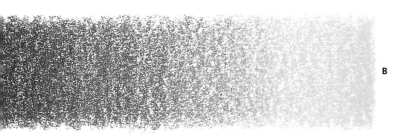

B

A. The colors that result from overlaying tones are the same ones mentioned in the color theory: The primary colors of yellow, blue, and magenta, when overlaid, produce the secondary colors of orange, green, and violet.

B. When mixing colors, make sure that the light tone is overlaid on the dark one, and not the other way around.

TAKING ADVANTAGE OF THE PAPER'S WHITE

The difference between achieving a surface by applying just one color or through a mix of glazings of two or three colors is that the second option provides more depth, chromatic solidity, and richness in hues and texture. As with watercolors, the secret lies in making the white of the paper work in one's favor. The gradual intensification of tones, hues, and contrasts is obtained by superimposing layers, painting from less to more.

1 More or less uniform color spots are produced by barely applying pressure with the pencil.

2 The hues and changes of tone are achieved by darkening an underlying color with another new color.

1

2

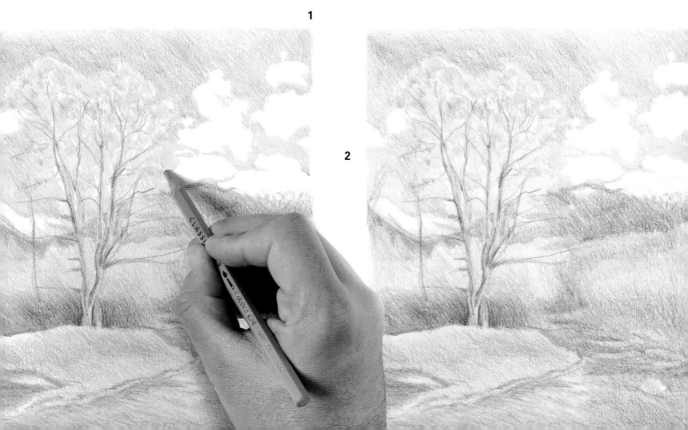

A THIN LAYER TO ACHIEVE FUSION

It is important not to apply too much pressure with the pencil, but rather to gradually intensify the shading, constantly rotating the pencil to wear down its tip evenly and avoid the appearance of irregularities in the strokes. With soft lead pencils, the artist can also work on light-colored paper such as ocher, yellow, or light blue. This way, the glazes end up merging with the background color, and the result is a harmonic range of colors conditioned by the tone of the paper.

ORDER OF COLORS

The overlays must follow a certain order:
Light colors are applied on top of dark ones
because light colors have less coverage and allow the base color to show, which is a necessary condition to achieve the resulting color.

Two or three—even four—different glazes can be overlaid without any problem, but it is important not to go overboard. One must avoid overloading the area with too many glazes that may produce such a dense layer of color that it saturates the paper's pores, meaning the paper will not permit any other overlaid color.

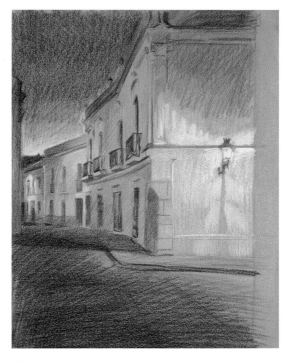

Glazings done with colored pencils
can be superimposed on colored paper—
in this case, ocher-yellow.

Here we have some examples of chromatic combinations and overlays developed in the exercise.

3

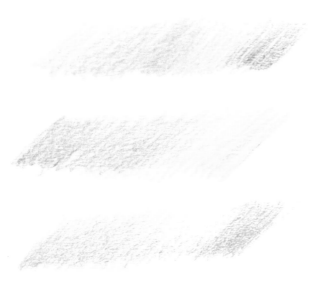

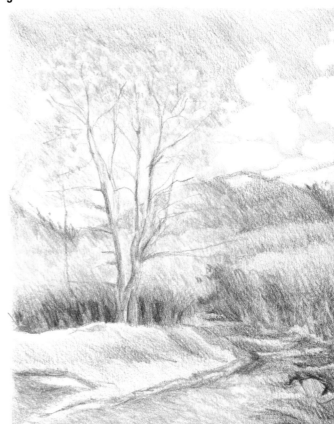

3 The drawing slowly emerges, from least tonal to most. The color spots, which are more or less flat, progressively create hues and fades that enrich the final result.

Optical Mix and Shading
WITH HATCHING

The mix of colors based on the overlaying of hatching strokes provides much richer colorings that liven up the drawing. These are different from uniform applications, because in these, the strokes of the tip of the pencil are evident. By superimposing various hatchings of different colors, the artist achieves an optical mix, because the lines only partially hide the underlying color, so the overlaying of strokes becomes a single, more or less even color when observed from an appropriate distance.

Colors are mixed not only through fusion, but also by using hatchings of more or less open strokes.

DIFFERENT KINDS OF HATCHING

Colored pencils are ideal for creating and overlaying hatchings. There are many ways of approaching a hatching or stroke drawing, depending upon the artist's intended effect. It is possible to use different hatchings, alternating between shadings and colorings, in the same composition. It is helpful to practice them, as each one provides a different effect to the drawing: from simple hatching in just one direction to feathering and cross-hatching, varying the inclination angles of the strokes to see their effect on the final result.

Overlaying hatchings produces an artistic finish. For this to render the proper effect, the tips of the pencils must be well sharpened to allow the artist to have absolute control over the stroke.

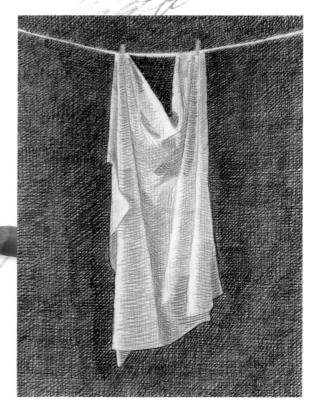

A canvas drawn with colored pencils mixed with very minute hatching.

BEGIN WITH A BASE COLOR

The first sketch is done with a color that can be absorbed by the hatching of colors that will be applied later on; a blue or the local color of the object may be used. The first strokes are very weak and are applied separately so that the whites of the paper provide brightness. On top of these first soft and transparent strokes, darker ones may be applied with a more marked chromatic saturation; these new strokes provide contrasts that mix among the color of layers underneath, thus forming tonal hues with great chromatic richness. Progressively, the lines of the strokes are joined so that the color is more opaque.

Ttransition between one color and its combination with others should be smooth and gradual.

1

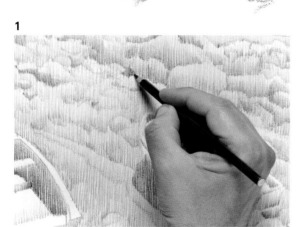

2

3 In feathering, the accumulation of strokes modifies the basic colors and a clear color effect is produced.

FEATHERING

This technique consists of softly drawing with one color over an area covered with another color, using strokes that are juxtaposed and always in the same direction to achieve a greater atmospheric effect, rhythm, and sense of harmony. The accumulation of vertical strokes modifies the basic colors, creating optical mixes of great richness similar to the technique of some Impressionist painters such as Degas, who assiduously used this method in his pastel work.

1 After an initial tonal assessment, hatches of strokes are applied, always parallel in the same direction.

2 In a secondary phase, the new, short, vertical strokes are juxtaposed and accumulated to nuance the base colors.

3

Water-soluble PENCILS

They are leads made with colored pigments agglutinated with waxes and varnishes that include a soluble ingredient that allow them to dissolve when they come into contact with water. In a certain sense, these pencils allow the artist to imitate the watercolor technique, but through a faster, simpler, and more secure process. The results are not those of watercolor, as the amount of pigment used in the spots is much less.

A

B

A. The main characteristic of water-soluble pencils is that the stroke partially dissolves with the brush.

B. The darker and more intense the stroke, the more visible it will be through the watercolor.

GENERAL MANNER OF USE

Normally, water-soluble colored pencils are used as if they were very soft conventional pencils. Then, water is added to this drawing base. The pencil strokes do not disappear completely, as they are merged with a color wash. Once the washes have dried, more colors and details can be added. To paint with them, it is important to use a fine grain watercolor paper, which should be fixed to the table with paper tape to avoid having it curl when it comes into contact with water.

Water-soluble pencil strokes can be diluted by simply passing the wet brush on top of them. Don't overdo it—one light touch is enough.

The moist brush tends to unify mixes done with the overlaying of hatching strokes, although it does not cancel them out completely.

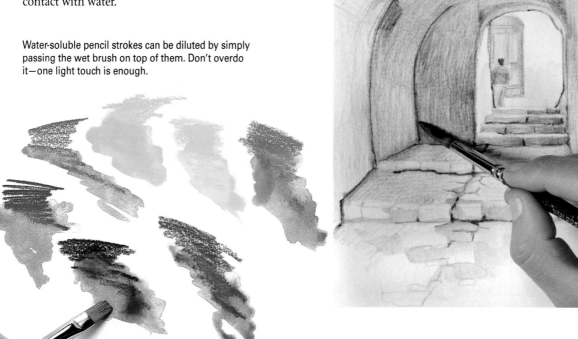

A SOFT CARESS WITH THE BRUSH

A brush moistened in water is passed over a drawing done with water-soluble colored pencils to obtain a watercolor effect. The brush must be soaked, and should be passed at most once or twice over the painted area; otherwise, there is a risk of completely undoing the pencil stroke. The interesting aspect of this medium is the simultaneity of the stroke with the diluted watercolor stain.

WORKING ON WET PAPER

There is the possibility of applying the water-soluble colored pencils on a paper previously wet with a sponge or soaked with a brush; with it, the strokes are dispersed and blend together. The line will not appear clearer, but rather broad and frayed, with an effect similar to that of colored fibers.

1

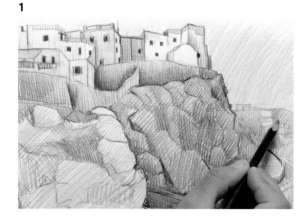

2

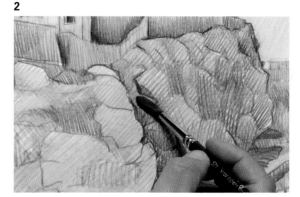

1 So that the strokes do not disappear after being moistened with the brush, the drawing should be created from well-marked hatchings.

2 When painting with watercolor, the artist loses the intensity of the paper's whiteness that shows through between the strokes.

3

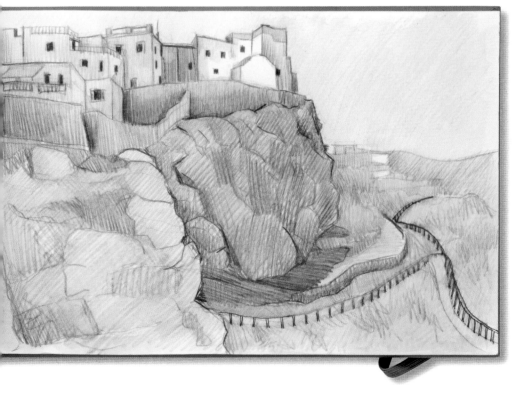

3 This way, the artist achieves a watercolor composition in which the strokes, although less intense, still provide strength and solidity to the work.

Wax PENCILS

They are leads made with colored pigments that are bound with waxes or varnishes, which allows them to dissolve when they come into contact with water. They offer the possibility of producing compositions of highly vivid tones, in which opacity and transparency are combined. They are usually covered with a fine plastic sheet or tube of paper in order to avoid having sweat from the hand dissolve the color and leave a stain. Although they were invented to satisfy the needs of graphic artists and illustrators, they were incorporated into the list of indispensable materials for artists a few decades ago.

Water may be used to mix two strokes made with a water-soluble stick. The dilution is produced much more quickly than with water-soluble pencils.

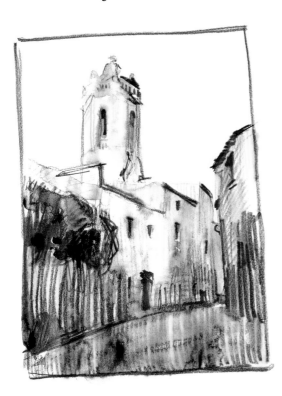

The attractive aspect of the technique lies in knowing how to combine the wash areas with the strokes that the artist decides to keep.

AN INTENSE STROKE

Water-soluble waxes are not suitable for subtleties; they are usually used for applying a firm and intense stroke, in works that require a sketch-like treatment. They offer quite an extensive color range, including sticks with metallic tones that can be interesting for certain works. Buying the pencils separately is less costly and allows one to choose colors as needed.

1

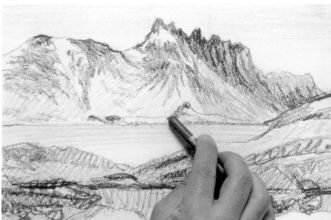

2

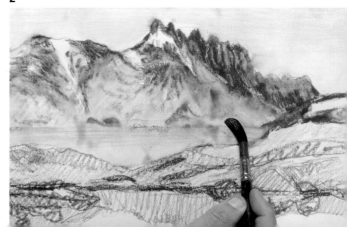

1 The oily and unsharpened tip of the waxes prevents the artist from making fine stroke hatchings, as occurs with colored pencils. For this reason, it is advantageous to apply them when shading in the traditional manner.

2 Then, a soft-haired brush is passed over it. The lines dissolve easily with a single brushstroke.

WATER-SOLUBLE WAXES AND OIL PASTELS

It is not necessary to create the entire work with waxes—we can use them for highlights or to create backgrounds. They can also be used for plein air (outdoor) painting, as they can be less cumbersome to manage than other elements of the watercolor artist's usual toolkit. Some artists even combine them with oil pastels. That way, the artist achieves a greater graphic variety when combining strokes that release the brush's water with others that are diluted when they come into contact with liquid.

Water-soluble sticks provide three different graphic options: the application of thick strokes on dry surfaces, dilution effects after watercoloring, and applying strokes to wet paper. When working with them, it is important to control the pressure exerted when applying strokes to prevent them from separating.

THE MEDIUM'S EXCLUSIVE EFFECTS

Water-soluble sticks are capable of offering many of the qualities of water-soluble pencils combined with those of oil pastels, so they allow an artist to create a whole spectrum of effects that are exclusive to this medium. They can first be applied with oily and thick strokes, and later the lines of the drawing can be softened by passing a water-soaked brush over them. The stick's hard strokes will endure and be visible through the wash.

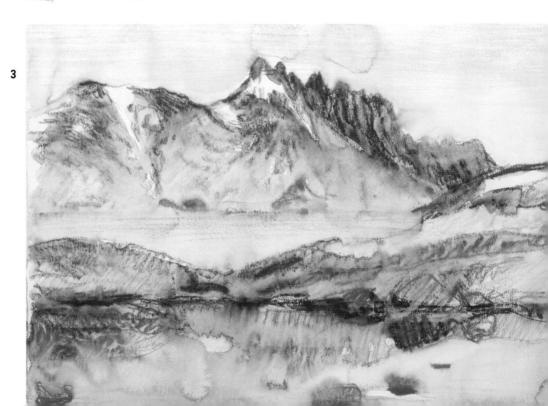

3

3 With the brush soaked in water, the color is diluted; it forms a finish of intense and atmospheric tones.

Charcoal is usually combined with black or white chalk.
This combination offers the best results when drawing on colored paper.

*R*ubbing techniques, such as those using charcoal and chalks, have always occupied an important place in the world of drawing. Thanks to their qualities, these media have become an excellent resource for both amateur and professional artists, as a fundamental tool for sketching that stimulates the treatment of themes in broad terms without getting lost in the details; they offer little adherence and are very easy to erase and correct with only a swipe of the hand or a rag. The contributions of charcoal and chalk are indispensable in monochromatic drawing or when working with a restrictive range of colors in which shading predominates over lines.

CHARCOAL, SANGUINE, AND CHALK

CHARCOAL

This is likely the first material used by humans to draw. It is composed of a branch of carbonized vine, willow, oak, birch, or heather that has no knots. The branch is then slowly combusted with almost no oxygen (to avoid setting it alight), until it becomes soft, smooth charcoal capable of providing an almost-black stroke. It is, without doubt, the star technique used by many artists due to its special qualities: its ease of correction, its versatility, and, above all, its great capacity for expression.

Charcoal sets are sold in different thicknesses, according to the size of the branches used in their production.

QUALITIES

Generally, charcoal sticks are cylindrical and are sold in different thicknesses according to the diameter of the branches used in their production: from 3 to 4 mm up to 2¾ inch (7 cm). The diameter determines the broadness of the stroke, although it is also possible to produce fine strokes using thick charcoal if an edge is used. The elemental nature of charcoal does not allow for great variations in quality depending on the brand; however, the selection of wood and the straighter branches and, above all, the care in manufacturing, distinguish the higher-quality charcoals.

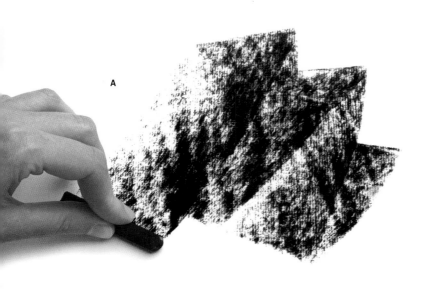

A

A. Charcoal is intense, spongy, and black. Either the tip only or the whole stick can be applied to the paper.

B. Working with the tip allows the artist to produce linear strokes.

C. It is very volatile and comes off easily when rubbed with fingers.

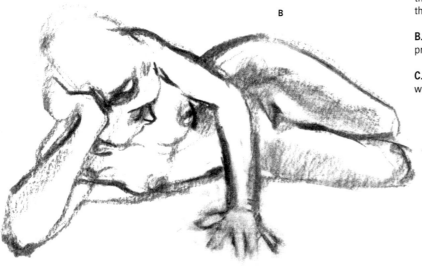

B

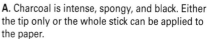

C

SQUARE-SECTION STICKS

Charcoals with square sections are among the softest types. They are generally thick pieces that are very useful in large-scale work and in the application of large spots. The external (hardest) layers of these sticks have been removed to offer total evenness of strokes. They do not scratch the paper or create discontinuities; however, they are less stable and less adherent than cylindrical sticks.

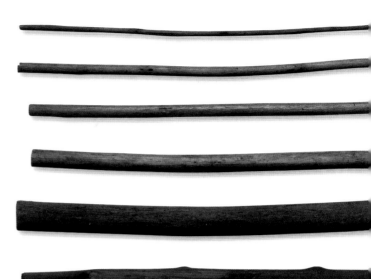

The thickness of the charcoal stick should be adapted to the drawing format used, with finer sticks being ideal for producing linear effects in medium-scale drawings.

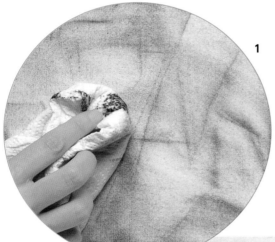

1

REDUCING THE INTENSITY OF THE STROKE

Charcoal has little adhesion to the paper's surface, as it is a dry substance and contains no glue, adhesives, or binders. The paper's surface roughness retains the carbon particles. To reduce the intensity of the stroke, one must first blow on it strongly to remove the initial blackness and contrast. Then, the artist uses cotton and blending stumps and, as a last resource, moldable kneaded erasers for charcoal.

1 The erased effect has been used here to mix the tones and achieve a very atmospheric representation.

2 The medium's instability allows for erasing, which is useful for correcting and blurring.

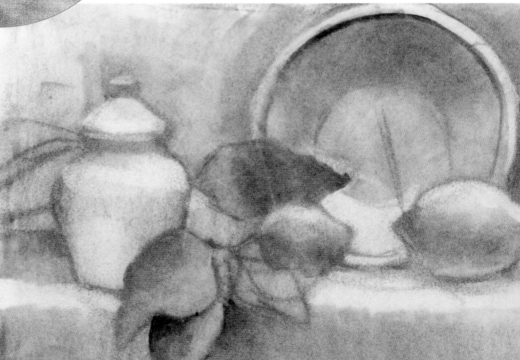

2

HOLDING, STROKING, AND DRAGGING

The charcoal is held carefully, with the stick inside the hand, without resting on the fingers. There are two basic ways of drawing with it: with the tip or with the whole side, in order to fill in or shade. By twisting and changing the pressure applied to the tip, the artist can produce fluid strokes, whether soft and indecisive, or daring and strong. The different ways of gripping the stick determine the type of stroke.

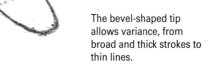

The bevel-shaped tip allows variance, from broad and thick strokes to thin lines.

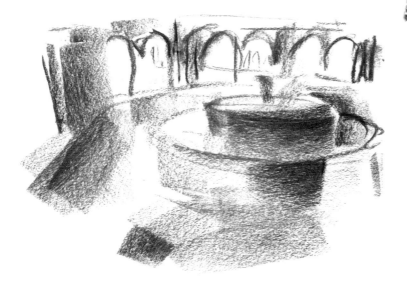

In this sketch we can observe the result of dragging a piece of flat charcoal on the paper.

LONGITUDINAL DRAGGING

Using the tip of the charcoal, one can achieve a linear and very intense stroke, although not always straight. For fine, straight strokes, the stick is dragged lengthwise.

If the whole stick is placed against the paper's surface, the stability is greater and the stroke is tight and secure, since it is almost impossible for the charcoal to tremble. Using a transversal placement, one can create wide shaded areas as broad as the length of the stick. Through continuous hand movements, we transform the transversal strokes into longitudinal ones.

A. The artist's hand is the basic tool for mixing, spreading, and blurring charcoal.

B. By laying the stick flat and applying pressure, the artist can produce straight lines with a fairly thin stroke.

A

B

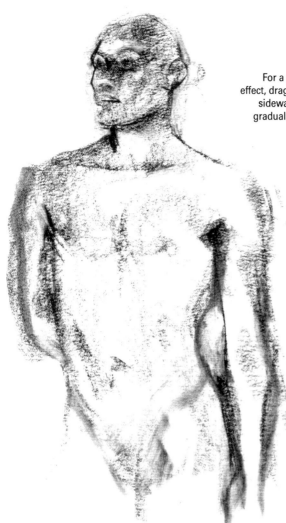

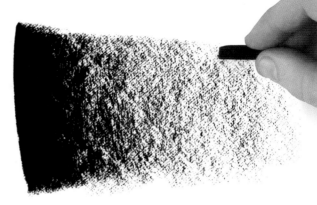

For a perfect faded effect, drag the charcoal sideways and apply gradually decreasing pressure.

SKETCHES WITH STICK FRAGMENTS

The charcoal stick can be broken with the fingers to obtain a piece of the desired size. For drawing, the ideal size is 2 or 2⅓ inches (5 or 6 cm). This length allows for creating any effect on paper. Charcoal drawing doesn't have to always be linear, as one small piece of these sticks dragged flat is enough to create interesting tone areas with a high level of synthesis.

In this work, with a piece of charcoal measuring a little over an 1 inch (2.54 cm), we can create a sketch that combines tonal areas with just a few lines.

GHOST LINES

Charcoal drawings are created by overlaying a multitude of juxtaposed lines that are gradually erased and corrected during the development of the work. This accumulation of discarded lines, or ghost lines, provokes an interesting tonal effect on the paper's background, sometimes providing even more expression and adding variety to the drawing. The definitive line is drawn firmly and intensely, thereby giving more authority to the line that will define the model's profile.

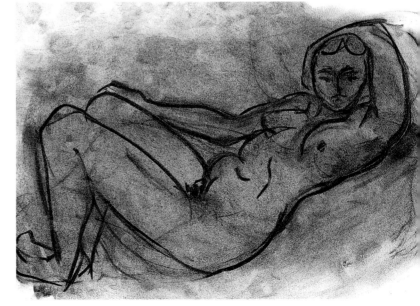

The ghost lines are still visible in this charcoal sketch, despite the intensity of the definitive lines.

With a medium that covers more than a pencil, charcoal can achieve many more tonal effects while maintaining considerable resources for detailed work. Because of its expressive qualities, it allows one to capture the atmosphere, light, and even color. Its main drawback is its dirtiness, for which reason it requires formats larger than those used with a pencil.

CHARCOAL TECHNIQUES

SOME CONSIDERATIONS REGARDING STROKES

First, the drawing is traced with medium-hard charcoal. An artist who makes a mistake while drawing can simply beat the paper with a cloth to remove the charcoal from the paper. Then the artist can re-draw on top of it, but should not mark the strokes strongly until the drawing is correct. For areas with large charcoal smears, such as black backgrounds, the charcoal is placed on its side, especially 2½ or 2¾ inch (6.3 or 7 cm) charcoal pieces.

1 The first approach to charcoal drawing is usually done with linear strokes intended to enclose the model.

2 Linear strokes are usually combined with shaded areas, tonal smears that are blended with the fingertips.

3 Little by little, the development of the shading gains importance over the line. The keys are fading and contrast.

1

2

3

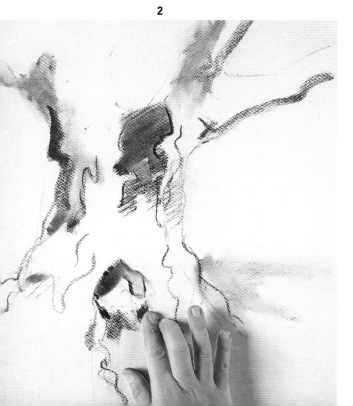

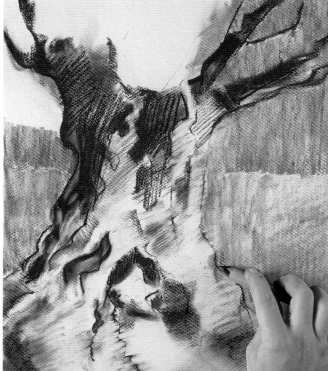

PULVERIZED CHARCOAL

Pulverized charcoal is used by many drawers for shading, and it is applied on paper by forming a ball with a cotton rag, or simply with the blending stump with the tip completely covered. It is useful for applying the first blended spots in large-scale drawings and the first touches of shading that are later completed with strokes done with the stick.

Pulverized charcoal is used to smear or blur large-scale drawings.

Drawing created with pulverized charcoal, on top of which a few linear touches have been added with a charcoal stick.

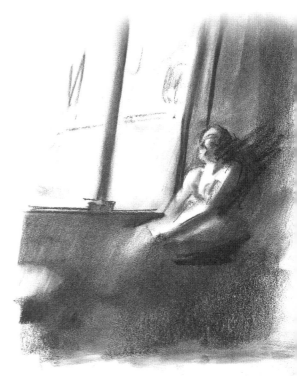

PAPER FOR CHARCOAL

It is necessary to work with porous paper so that the charcoal powder sticks to the fibers of the paper and permeates them. If we draw over a very texturized layer, the stroke appears with a granulated and uniform semi-tone effect that makes the drawing more interesting. The rougher the paper, the more intense the strokes, because more particles will have permeated the sheet's irregularities. When working, one must try not to get oil on the paper with one's fingers or with normal erasers, as they produce stains that are impossible to remove—they cannot even be covered up with black spots.

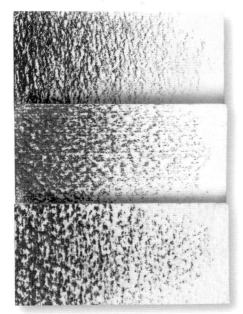

Three samples of watercolor paper with different grains and the effect of the charcoal spots on them. Surface feel is also referred to as "tooth." Paper with more tooth is more textured and feels rougher to the touch.

Charcoal strokes over three papers with different textures: fine-grain paper (A), thick-grain paper (B), and laid paper (C).

A B C

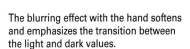

TONAL VALUE
WITH CHARCOAL

One of charcoal's virtues is its great ability to create tonal values—that is, the tones created with it can be blended, increased, or faded. This versatility and instability make it an ideal medium for beginning drawing, as it allows for all kinds of corrections and stimulates the treatment of themes in broad terms and without getting lost in the details. The image is lost and rediscovered many times during the development of the drawing.

The blurring effect with the hand softens and emphasizes the transition between the light and dark values.

CHIAROSCURO

In the charcoal technique, the brightness and light areas are provided by the paper, and the dark ones are obtained by applying charcoal powder. Light areas are reserved and charcoal is applied over the darkest areas, blending it to achieve medium tones by lightly rubbing it with the fingertips. The light values are adjusted by removing charcoal with a blending stump, eraser, or cloth. Once the light has been studied and the contrasts with the shade are optimal, the work is finished by applying graphic elements, small linear marks, with which contrast is added and the shape is defined in some areas.

Although the faces of a cube are shaded by applying spots of different intensities, for a sphere it is essential to shape the shading with the blending stump.

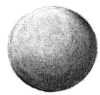

The mixing compresses the charcoal and increases the darkness and density. This is fundamental to achieve the chiaroscuro effect.

The chiaroscuro effect allows for defining the model, its volume and relief, by shading, nuancing, and lightening the spots with the blending stump until the shapes are completely modeled.

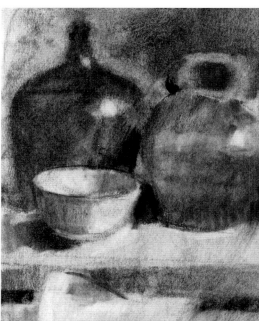

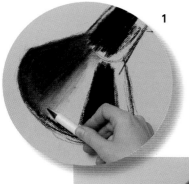

1 In the chiaroscuro effect, first the darkest values are placed, and the brightest areas are left without covering.

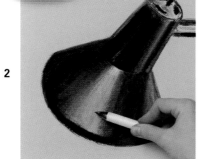

2 Then, with the blending stump, the spots are extended and the intensity is adjusted, always working from dark to light.

CHARCOAL BLURRING

Charcoal allows the artist to work on an image in a repetitive and accumulative manner. The artist works and erases, progressing with each new layer of pigment, developing the drawing using broad spots that mix with each other; with even just a bit of blur, very atmospheric drawings can be created. One of the dangers of blurring, if it's used excessively, is that the drawing may look artificial. The absence of strokes gives the drawing a very pictorial finish, which is why many artists choose to apply just a few final spots that highlight the drawing's fundamental features.

FINISHING AND FIXING

To produce a highly finished work, we have blended, mixed, erased, and re-drawn several times. The artist must be careful not to allow excessive pigment to darken the drawing or diminish its character, its freshness. The last phase of the work involves spraying the charcoal with the fixative, as this will protect it. With the fingertips, the artist must softly graze the drawing to check that charcoal no longer comes off. Otherwise, it should be sprayed again, and then no more charcoal should be added nor corrections made.

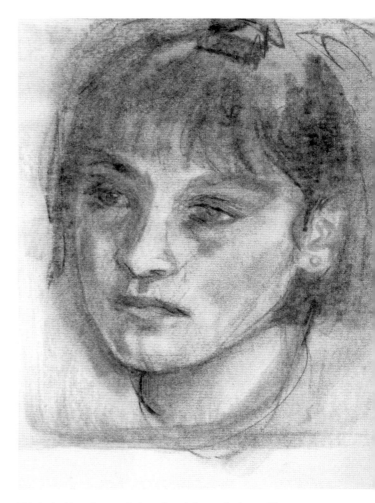

This is the blur effect applied to a face. It is usually done with a cloth or the palm of the hand.

Artists should fix their works created with charcoal with a spray, staying at least 12 inches (30.5 cm) from the paper.

Sticks of compressed or vine charcoal, made from pressed or agglutinated charcoal, have a consistency similar to that of charcoal; however, with the former, the artist can achieve more intense and contrasting strokes. They are a composite of pulverized pigment (lampblack) and a binder. The components may vary widely and may incorporate soot, clay, and even graphite and, in many cases, barely contain charcoal. For this reason, they are considered to be closer to pastels or chalks.

COMPRESSED CHARCOAL

Compressed charcoal comes in the form of cylindrical sticks with a high degree of pigmentation.

1 The first model was created using only charcoal; it provides velvety and smooth grays.

MORE STROKE STABILITY

1 The leads can have cylindrical or square sections. They tend to be more oily than charcoal sticks due to their higher pigment content. Their intense stroke produces dark and velvety tones. The difference lies in the greater density and stability of the stroke (the binder fixes it to the paper), as well as in the greater hardness and homogeneity of the leads and sticks, which are less brittle than those of charcoal. The majority of manufacturers offer sticks in three or four different thicknesses.

COMPLEMENT TO CHARCOAL

Compressed charcoal is not useful for sketching—not even for preliminary sketches for oil paintings—because it is difficult to correct with a cloth and can blacken the colors of the first layer of color. It is generally used in combination with charcoal, which is much more precise, and to complement it with a range of darker shades. It's unmatched in the rich black offered by its lines and the softness of its dark tones when blended with a finger or blending stump.

2

2 In the second model, deeper blacks are incorporated using a stick of compressed charcoal.

The stick of compressed charcoal can completely saturate and cover the grain of the paper with a deep black.

The intensification of the shading is done gradually, overlaying a new stroke over the previous one.

CHARCOAL SUBMERGED IN OIL

If a stick of charcoal is submerged in linseed oil for several hours, the result is an oily charcoal that does not require fixing. The preparation is simple: The charcoal sticks are placed vertically in a glass container that is then filled with oil and hermetically sealed. They are left for 24 hours. They are removed from the container, allowed to drain, and then enveloped one by one in aluminum foil or transparent plastic to prevent the oil from drying out completely. The result is a darker stroke that's similar to compressed charcoal, but that doesn't come off as easily as dry charcoal.

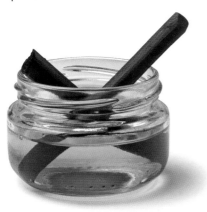

Carbon that has been submerged for hours in a jar with oil provides a stroke similar to that of compressed charcoal.

1

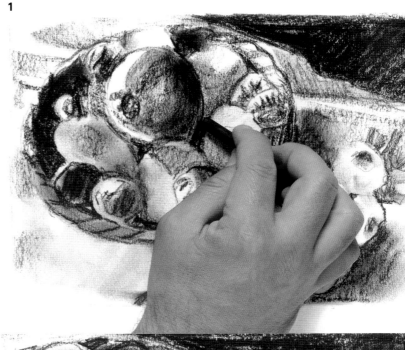

1 With a stick of compressed charcoal, the artist can perform small tonal studies. One must work carefully because the strokes cannot be corrected as they can with charcoal.

2 By dragging the stick over the paper, one can obtain much coarser, more pronounced shading.

2

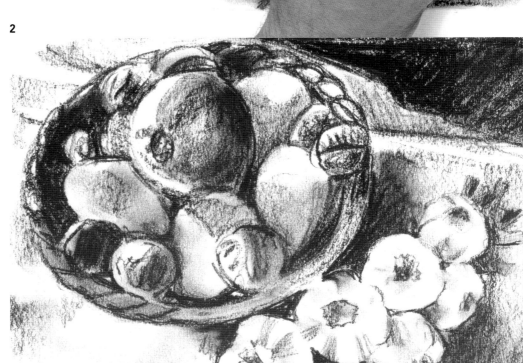

CHARCOAL
PENCIL

Charcoal pencils are made of very fine sticks of compressed charcoal protected by an outer wood layer in the shape of an easily manageable pencil. Gradations of hardness vary depending on the amount of clay included. They are brittle and difficult to sharpen (whittling the tip with a blade is best, followed by honing on sandpaper—but take care), and their effect is reminiscent of pastel pencils. To use, barely apply any pressure, using soft, linear strokes.

The black stone pencil is the predecessor of the modern charcoal pencil.

The stroke of a charcoal pencil is very intense and strongly dyes the paper when a blending stump is passed over it.

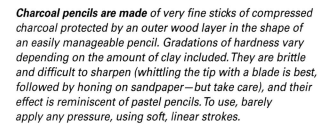

BLACK STONE

The predecessor of the charcoal pencil is the "black stone" or "stone of Italy," a clayey shale of blackish color and fine grain that can be easily cut and sharpened, and that was used as a drawing tool during the entire Renaissance, especially in preparatory studios of portraits and landscapes. At the beginning of the nineteenth century, it was replaced by charcoal and lead.

Charcoal pencils are generally an ideal complement to the stick when creating small format works. They are splendid for creating linear outlines and pronouncing tonal contrasts.

Also known as the Conté crayon, the charcoal pencil is as manageable as a conventional pencil, although its stroke is much more intense and can be blended.

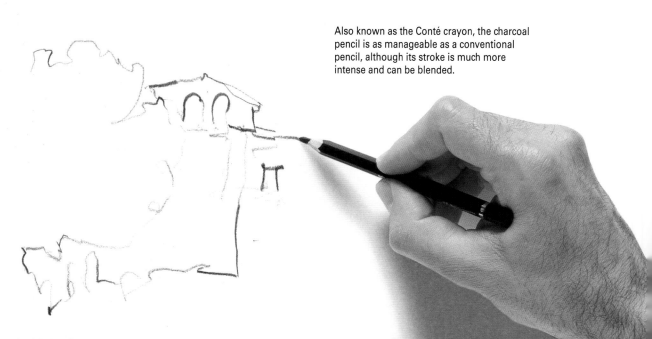

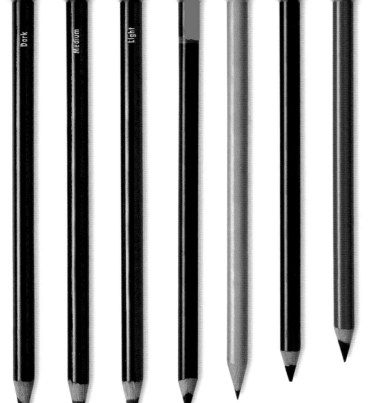

Compressed charcoal pencils (image to the left) are sold in three different hardnesses, whereas Conté pencils, which are oilier, have less variety.

EXACT IN THE DETAILS

The latest generation of charcoal pencils contains a small amount of graphite, which gives them a slightly oilier stroke. This makes them less dirty and smudgy tools than those that used to be manufactured years ago. They are appropriate for applying touches and details in the last phase of drawing with a charcoal stick, as they provide a denser and darker stroke than charcoal. When well sharpened, they allow for working on small-format work with utmost detail.

CONTÉ CRAYONS

Some artists enjoy working with the the Conté pencil or crayon instead of the compressed charcoal pencil. The Conté's components provide a stroke with greater stability and blackness, and allow for deeper and more permanent blacks. The lead is hard, waxed, and easily sharpened with a blade. It is ideal both for working with strokes and for shading. Its disadvantage is its oiliness, which prevents it from mixing with charcoal on the same support. Therefore, its use should be limited to sketches.

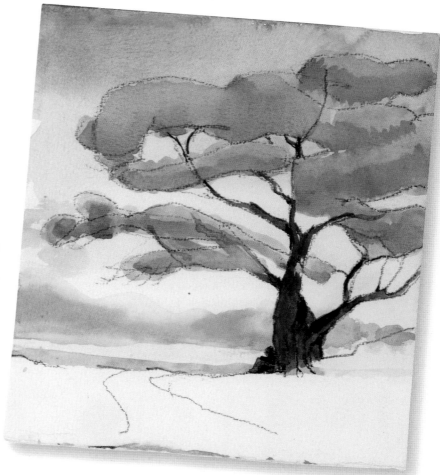

The Conté crayon can be incorporated into works done in watercolor, to which it provides interesting features.

Small-scale work with charcoal
PENCILS

Charcoal and pressed charcoal pencils are usually combined in one drawing to obtain greater depth of tones, but in small-scale sketches or drawings, the drawing can be done completely with charcoal pencil. Its great pigmentation power requires one to work with very soft strokes, creating shadows and reinforcing with soft graying done with the tip inclined, or with firm and intense lines, achieving tone areas with the overlaying or accumulation of hatching.

Given the pigmentation power of the charcoal pencil, it is generally used inclined, extending the shading with a sequence of more or less tight lines.

SHADING WITH TILTED PENCIL

The use of the tilted pencil is suitable for drawing shaded areas. Greater or lesser pressure applied to the sides of the lead will produce shades of different values. If the stroke is soft, the artist can choose to blend it with a finger or blending stump. If the shading's hatching is too evident, it is better to avoid blending, as the shading can end up being overly dark and dense.

1 A well-sharpened tip will provide very precise and correct work.

2 The lines are very fine, not very pronounced, whereas the shades have been done with parallel strokes. The greater the darkness desired, the more pressure exerted with the pencil.

1

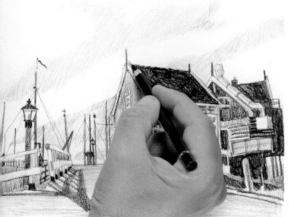

2

DRAWING WITH HATCHING

When one draws linear strokes with charcoal pencil, one produces the tonal differences of the light and shadow areas by unifying or separating the lines of the parallel hatching—very close together or criss-crossed for shadow and separated for light—or by thickening the strokes in the dark areas and thinning them out in the lighter ones. Stroke hatchings can take multiple forms: strokes forming lattices of variable density, series of parallel strokes, sets of curved and short strokes or series of spirals, etc. These are very frequently used sets of strokes that add tonal value to the drawing without abandoning the linear approach.

Objects can also be shaded with overlaid and crossed linear hatching.

To achieve definition and contrast, the artist must bear in mind what kind of stroke will be applied in each area. Here are some options:

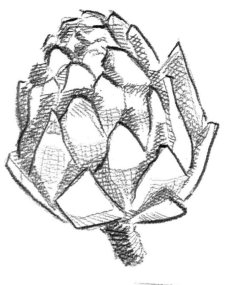

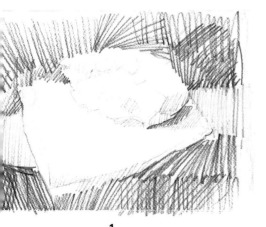

1

STROKE DIRECTION

The line strokes should be ordered in a way that helps provide a sense of volume in the drawing. Thus, the strokes should follow the same direction as the surface that you are trying to represent. Aside from this, one must intensify and tighten the stroke hatchings over the more shaded areas and extend the hatching of light lines over the more illuminated ones.

1 The direction followed by each hatching helps to contrast or differentiate the object's shape.

2 The hatchings appear much tighter and thicker in the background, while the crust of bread is created with soft, grayed hatching.

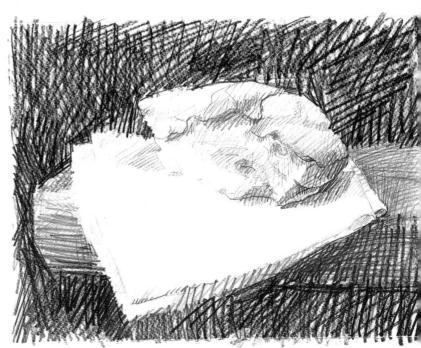

2

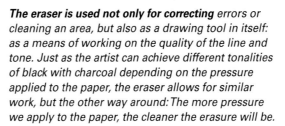

The eraser is used not only for correcting *errors or cleaning an area, but also as a drawing tool in itself: as a means of working on the quality of the line and tone. Just as the artist can achieve different tonalities of black with charcoal depending on the pressure applied to the paper, the eraser allows for similar work, but the other way around: The more pressure we apply to the paper, the cleaner the erasure will be.*

Kneaded erasers, which come in different shapes and sizes, are the softest. Their malleable, sticky consistency makes them suitable for trapping pigment in powder used in dry and volatile procedures.

DRAWING WITH ERASERS

Each type of eraser produces a different erased effect. Green rubber erasers are the best suited for erasing hatching done with a graphite pencil.

EFFECTS WITH ERASERS

There are several effects that can be achieved with a kneaded eraser, and they are not especially complex. First you use a charcoal stick to draw a gray area that covers the surface of the paper. Then, clear different white spaces with the eraser, varying the position and pressure in order to check the effects: For example, with the tip sharpened with a bevel we can produce thick lines, while applying the eraser flat against the paper can produce broad borders, and applying it edgewise creates fine strokes. Likewise, a ball can be made with the eraser, and it can be passed over a charcoal base or tone, which then becomes slightly blended.

1 The entire surface of the paper has been covered with an even shading created with a graphite lead. The brightest areas of the model are represented by removing part of the gray with an eraser.

2 The drawing is completed with the application of new shades that are more contrasting, combined with linear strokes.

1

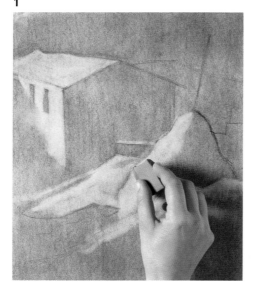

2

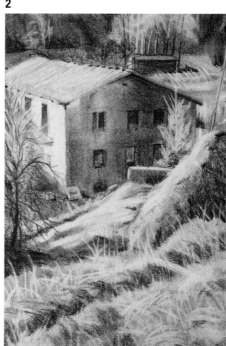

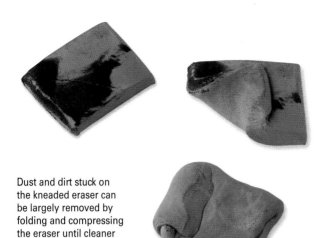

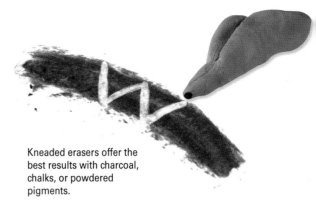

Dust and dirt stuck on the kneaded eraser can be largely removed by folding and compressing the eraser until cleaner surfaces are exposed.

Kneaded erasers offer the best results with charcoal, chalks, or powdered pigments.

KNEADED ERASERS FOR CHARCOAL

For the graphite pencil, soft erasers such as those you used in grade school, can be used. They are very useful on smooth and glossy surfaces; however, they are less effective on charcoal or chalks. These erasers can damage the paper, and can even dirty it. Therefore, kneaded erasers are preferable, since they also offer a great advantage: malleability. When they get dirty, one can knead them with one's fingers and fold the dirty parts inward. They can then be used once again to erase or to open up a white space.

Erasing done over a graphite drawing with a mechanical pencil that has an inlaid eraser, which allows for making fine, linear whitenings.

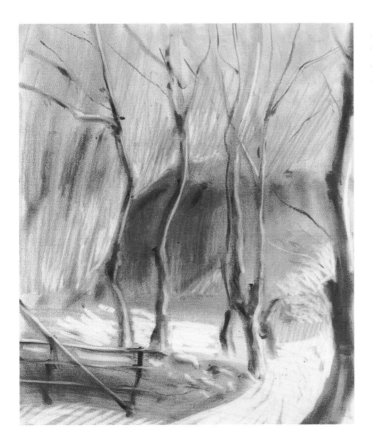

Erased effect over a tonal drawing done exclusively with pigment of sanguine powder.

CHALK

Chalks are similar to pastels in their consistency and appearance, but they are a bit harder and oilier. They appear warm and opaque, and have the same blending capabilities as charcoal; nevertheless, chalks are more stable and can be mixed with charcoal or with a compressed charcoal pencil. The variety of chalks includes sticks with different tonalities and hardnesses, as well as pencils of different quality.

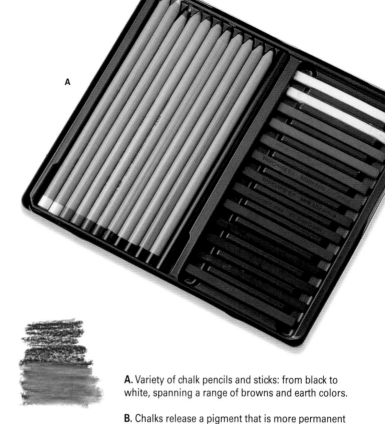

A

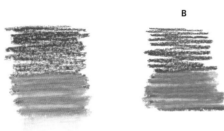

B

C

A. Variety of chalk pencils and sticks: from black to white, spanning a range of browns and earth colors.

B. Chalks release a pigment that is more permanent than charcoal, but is easily blended.

C. Charcoal and chalks are compatible, and their mixture results in earthy, harmonic tonalities.

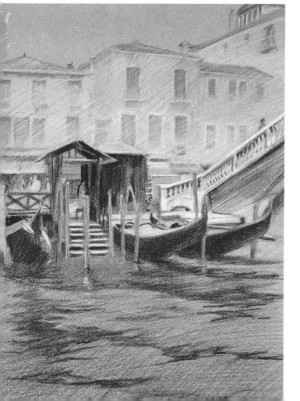

STICKS WITH EARTH TONES

Chalk is a white- or gray-colored limestone formed during the Cretaceous period. It has a very fine grain that leaves a trace when rubbed against an abrasive surface. Today, chalks are sometimes referred to as hard pastels, and often come in squared sticks un a range of earth tones and sepias (as well as black and white). They are also available in pencil, lead, or round stick format and are used for drawing chiaroscuro in the traditional manner.

Chalks are usually overlaid on top of the first spots created with charcoal, and offer a much wider chromatic and tonal range without losing their monochromy.

The basic selection of chalk sticks includes black, white, and three or four brown tonalities.

COMPLEMENT TO CHARCOAL DRAWING

Traditional chalks are limited to the colors white, black, sepia, bister (a muted brown), and sanguine. These colors have a perfect tonal balance that makes them very suitable for monochromatic drawings based on harmonic shadings and fadings. This multiplies the number of options and allows the artist to fine-tune the selection of the color that is most appropriate for the drawing. Chalks are suitable for working on colored paper, preferably of a medium or dark tone.

There are also chalk leads that can be inserted inside mechanical pencils.

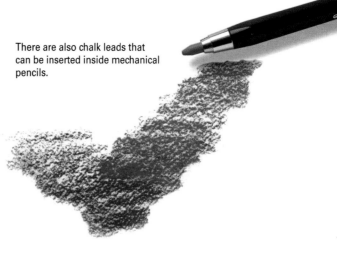

Aside from being blended by hand, they can be modeled with a malleable eraser applied flat on the paper.

If more pressure is applied to the eraser, white space is opened up using the erased effect. Very straight reserves for erasures can be made by using a piece of paper.

WHITE CHALK

White chalk is widely used among professional artists. This white color is usually not of Cretaceous origin, but is rather composed of white pigment (generally titanium oxide), agglutinated with clay and sometimes a small amount of pulverized pumice. It is used to create drawings with charcoal or compressed charcoal, as well as in combination with other chalks (mainly sanguine and sepia). White chalk can be used as a substitute, but it is more unstable and its pigmentation power is much lower.

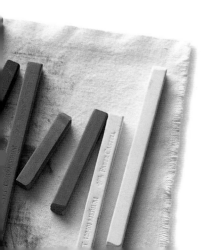

White chalk is used to bring out light in charcoal or chalk drawings. It is used on medium-tone paper, without which the strokes would not be visible.

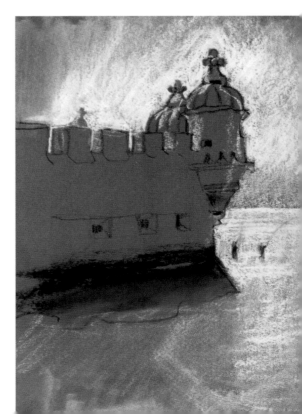

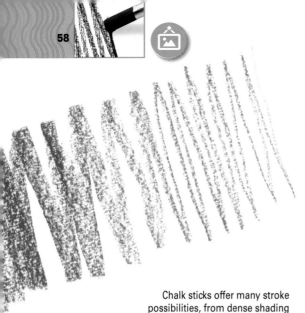

Basics of drawing
WITH CHALK

The chalk stick has a more delicate style than charcoal; its results are a bit less energetic, but much sweeter. As with charcoal, the chalk stick allows for drawing using its entire surface, and its stroke can be adjusted or merged very easily.

Chalk sticks offer many stroke possibilities, from dense shading to fine, delicate lines.

THE ADVANTAGES OF CHALK

As chalk is a hard pastel, in general, it is best suited for works in which the drawing takes precedence over the color. Even so, hard chalk's chromatic effects can stand right alongside those of soft pastels: Hard chalk can be blended, mixed, and overlaid, and can cover the paper as much as any other pastel. Although the strokes remain very pronounced, they can disappear if blended with the fingers.

1

1 It is better to draw the first strokes and shades with charcoal, so that erasures and corrections can be made. Then, one can begin to incorporate black, ocher, and sienna chalk strokes.

2 Shading done with black chalk can offer a great intensity that increases with blending.

3

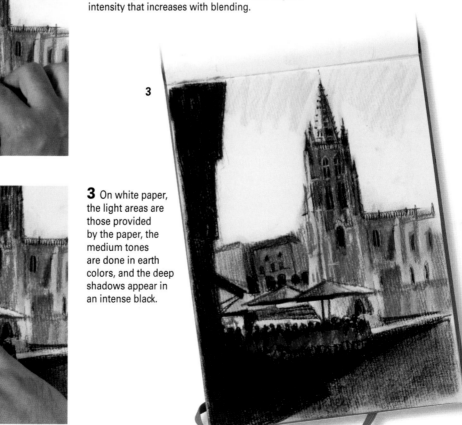

2

3 On white paper, the light areas are those provided by the paper, the medium tones are done in earth colors, and the deep shadows appear in an intense black.

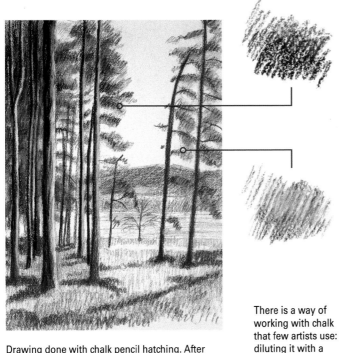

Drawing done with chalk pencil hatching. After being overlaid, two colors can be merged by simply passing the white chalk pencil over them.

There is a way of working with chalk that few artists use: diluting it with a moist brush.

MIXES WITH CHALK

Despite the thickness of the stick, chalk is a very elegant and delicate medium. It is soft enough to allow for mixing their colors with strokes or fine shading, as well as for working using lines and strokes that can accumulate into hatchings to achieve convincing shading, which can be unified by simply rubbing them with a cloth or blending stump. Also, since chalk is less granulated than charcoal, it can be mixed by overlaying color layers in such a way that the bottom layer remains visible. Then, with the fingertips, the artist rubs the strokes until the two tones merge.

Sketch of an urban landscape with diluted chalk, with a water-soaked brush. Despite the use of the brush, the stroke does not completely disappear.

SHADING CAN ALSO BE USED TO DRAW

Shading is not simply a color effect—it also helps to create form. Indeed, it contributes to drawing or outlining the motif through marked contrast. The presence of lines or strokes may even be unnecessary. In this kind of exercise, there is an emphasis on the direction that the stroke takes at all times, as well as on the changes in pressure applied to the stick to intensify the shadows in some parts of the drawing.

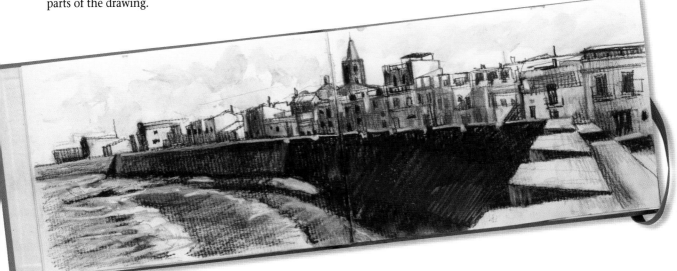

Sanguine, A SPECIAL CASE

Within the chalk group, one of the most used colors is sanguine, which stands out with its own personality. It is a derivative of chalk, a color between brown and terracotta red, made with iron oxide. This natural pigment is not used for manufacturing paint due to its low dying power; however, its color tone is highly valued by a vast majority of drawers, whether used alone or in combination with other media. Its success lies in its warmth, as well as in the fact that it is very sensitive to the paper's texture.

Each manufacturer uses somewhat different pigment in their sanguine sticks and pencils, thereby providing different tonalities.

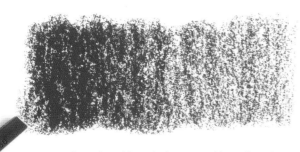

Sanguine sticks stain the paper with a soft touch and allow for broader fadings than those created with graphite.

SANGUINE STICKS AND PENCILS

Sticks with square sections are used more than pencils. They come in forms and sizes identical to other chalk or hard pastel sticks. They offer a much wider spectrum of strokes than pencils, because they can be laid on their edges to produce a line, or on their side to create a tonal area. The common denominator of all of them is the earthy reddish color of their stroke, making it—along with graphite's gray and charcoal's black—one of the preferred tools in the artist's repertoire for traditional drawing.

Sanguine is able to offer rich tonal gradations and to produce both deep shadows and hatching of fine and delicate strokes.

It comes in stick and lead formats of different thicknesses, shapes, and sizes.

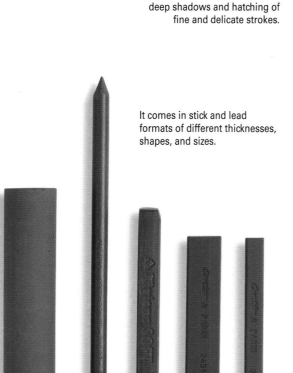

SHARPENING THE SANGUINE PENCIL

Many sanguine pencils are used as complements to work done with charcoal lead or chalk, so they are generally applied in a soft and delicate manner. With a blade and a bit of patience, the lead of the sanguine pencil can be honed to its maximum sharpness. Then, a metal case for lead helps to protect it.

The lead of sanguine pencils is thick and solid enough to allow for a perfect sharpening.

1

1 Sanguine offers its best results when used for skin tones on nude figures.

A WARM TONE FOR SKIN TONES

Sanguine, like other chalk, allows for very fast execution and offers, as its main feature, a medium tone that is neither too light nor too dark. It also provides the possibility of being mixed with other chalk; however, it occupies a preferential place among artists in nude figure drawing because it affords a wide variety of hues for skin tones. Its success lies in its warmth, as well as in the fact that it is very sensitive to the paper's texture.

2

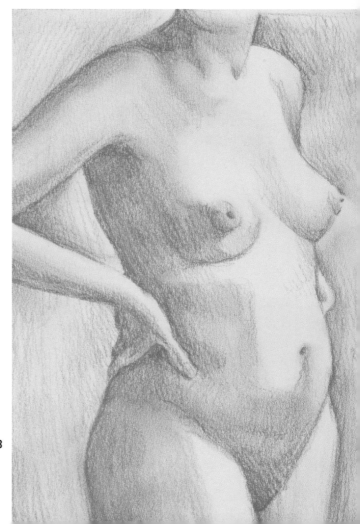

2 The strokes can be blended with the fingers to achieve the shaping of the skin tone.

3 The volumetric construction of the human figure requires delicate treatment, the result of the accumulation of soft strokes.

3

BASIC COMBINATIONS WITH CHALK:
MIXES AND HIGHLIGHTS

The possibilities of working with charcoal are very broad, and when another drawing medium is included, such as chalk, the results are even more impressive. Charcoals are dry media that break apart when they come into contact with the paper, providing interesting modeling effects. The accumulation of powder on the medium facilitates the fusion of colors with a single swipe of the finger.

Chalk is soft enough to allow for mixing and fusion among different colors.

PERFECT HARMONY

Today, the range of chalk available to the artist is very large; however, traditionally, it was limited to white and black chalk and the range of earth colors (sanguine, ocher, bister, and sepia), which provided drawings with light and shadow. These tones are very harmonic and combine perfectly among themselves. With black chalk, charcoal, or compressed charcoal, the artist can create the most intense and darkest shadings of the drawing, while the earth colors are used to represent medium tones, that is, the more moderate shadings.

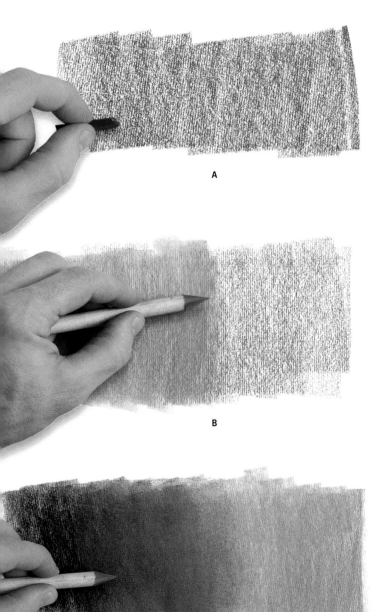

A

B

C

A. Shading with chalk is created by rubbing the side of the stick against the paper.

B. The fading spreads the particles of pigment and makes the shading much more compact.

C. The colors can be mixed with the blending stump, creating very solid fadings with a great deal of coverage.

On colored paper, two contrasted chalk colors, such as white and black, are all that is needed to achieve a reliable sense of volume.

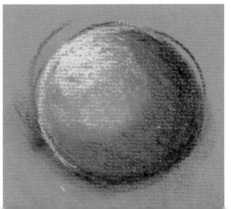

TWO-COLOR TECHNIQUES WITH BLACK AND WHITE

Throughout the history of art, the combination of white and black chalk on a medium-tone background has been used frequently. The method is very effective for bringing out contrasts. Black is generally used to develop chiaroscuro effects, and the white emphasizes the impact of the light. In general, both colors are applied differentially, creating areas clearly delimited by the color of the paper, which acts as an intermediary between one color and another, facilitating a progression between lights and shadows. It is best to avoid overusing mixes or blendings between the colors, as the result will be a matted gray.

3 Intermediate tones are presented by the background color provided by the paper.

1

1 The two-color technique is always done on a medium-tone paper—in this case, gray. Drawing is done smoothly when working with black charcoal.

2 In a monochrome drawing done with gray scale, white chalk coloring is applied without exerting too much pressure.

2

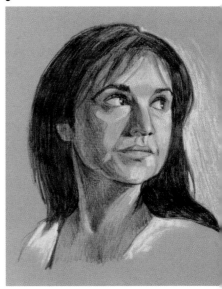

3

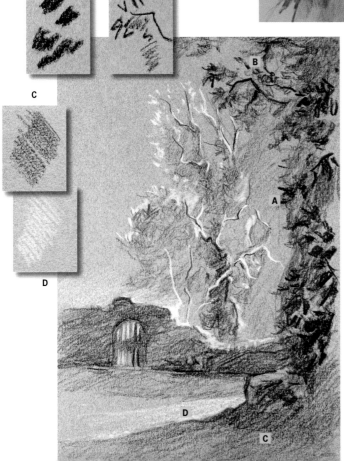

A B

C

D

HIGHLIGHTS ON MEDIUM GRAY PAPER

The main reason for working on colored media is to be able to use white pencil or pastel. On a medium-toned paper, white chalk produces some very intense light effects. The pronounced contrast between the white and the black brings out the chiaroscuro effects, which is especially valued when the scene appears illuminated by sunlight or a strong artificial light.

Drawing created with broken strokes created with the two-color technique; includes four samples of the variety of strokes used in the development of the work.

THREE-COLOR TECHNIQUE

White Conté chalk or crayon has long been used to bring out the light or semi-light tones so that the subject acquires a more three-dimensional appearance. It is a technique that complements other monochromatic drawing methods done with dry techniques, such as charcoal.

The shaded areas are created with black and sanguine chalk, while white chalk is used to represent light.

In this drawing, three chalk tones have been used: black, ocher, and sanguine. The combination is harmonic and is halfway between monochromatic and colored drawing.

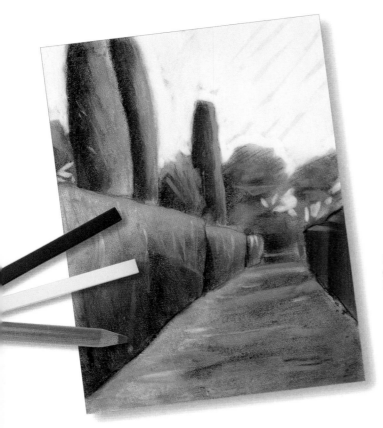

COMBINING THREE COLORS IN PORTRAITS

When black, sanguine, and white are combined on the same support, a very warm range of colors is achieved. It is most common to use a black chalk stick for the deeper dark colors, sanguine or sepia for intermediate tones, and white for bringing out light. In some cases, a black chalk may be replaced by a bister or sepia one. The result is an image that appears to have been done in full color. This technique is generally used in drawing portraits and to achieve some effects in landscape drawing.

1

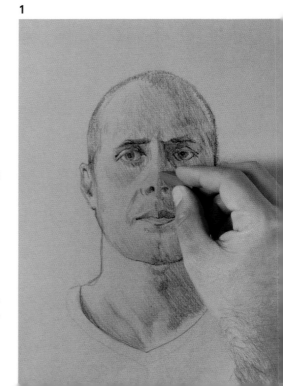

1 When working with the three-color technique, the best option is to create the drawing with black chalk, and the medium tones with sanguine.

DON'T OVERDO THE MIXING

It is not advisable to overdo the mixing or blending in any work using the three-color technique, nor to overlay the three colors at the same time. Otherwise, the result will be muddy and too grayed—the colors will begin to get dirty until they turn to whitish gray, and will appear less saturated as you continue to mix them. It is preferable to mix the colors two by two, creating quick, light fadings, and in some instances, to apply them without blending.

The three-color technique is not limited to chalk; it is also applied in pastel work.

There is no need to be strict with the colors— ocher or gray pastels or chalk may be used— but one must aim to ensure that the result features a wide display of earth colors.

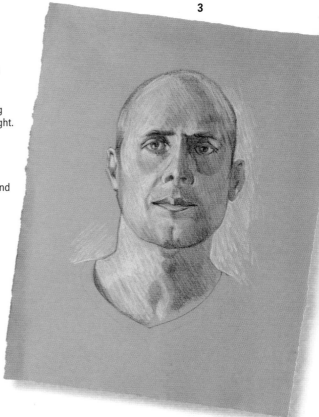

CHOICE OF COLORS ON TONAL PAPER

The process of applying tonal value and shading is very similar to work done in monochromatic drawing, with the difference being that the tonal scale will be much wider than it would when working with just one color. On white paper, the three-color technique is usually done with black, sanguine, and ocher; on medium-tone paper, ocher is substituted for a white chalk.

2

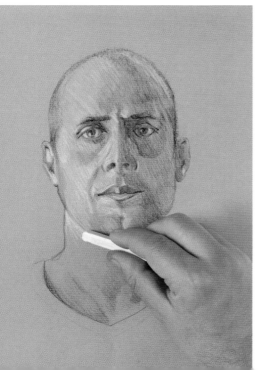

3

2 White chalk used delicately is useful for modeling skin tones and spreading transitions of soft light.

3 Combining the three chalk tones results in a three-dimensional head and realistic skin tones.

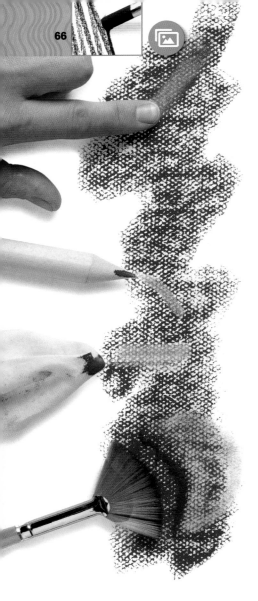

The blending stump is mainly used on drawings done with graphite, charcoal, or chalk, in efforts to make less-pronounced strokes, to mix tones, or to transform the shading into smooth fading. The blending stump integrates the strokes, eliminating the white spaces between them. By creating graduated tones, the artist can achieve a perfect representation of the object's volume.

Blending STUMP

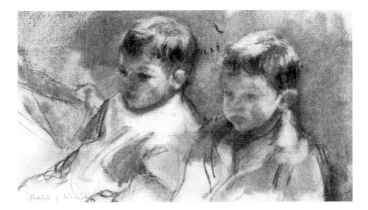

Drawing done with charcoal and blended with a blending stump. This instrument gives the drawing a very out-of-focus, atmospheric finish.

AN ALTERNATIVE TO BLENDING WITH FINGERS

A blending stump is a slightly porous, compressed, and rolled paper that is finished with two sharpened conic tips at each end. It is used for blending and mixing charcoal, sanguine, pastels, etc. It is an alternative to blending with fingers, as your fingers always contain some oil and do not allow for working on large surfaces. With the blending stump, artists have more precision because they can reach into tiny corners, which is impossible to do with the finger.

There are different alternatives to blending with the fingers, but the blending stump likely offers more precision than the two other alternatives, which are the cotton rag and the fan brush.

A. The tip is used to soften contours or create lines, by slightly rotating the hand to allow the color that is contained on the surface to come off.

B. Dense shading requires repeatedly rubbing the tip, slightly tilted, over the area.

C. In large areas, the blending stump is rubbed longitudinally on its wide edge.

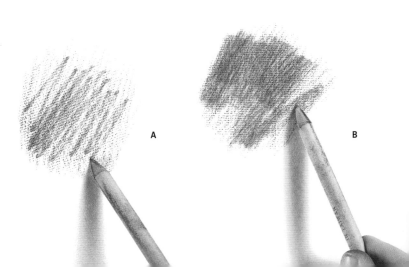

A

B

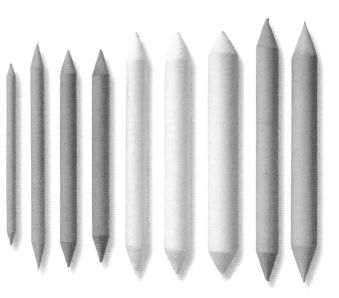

TYPES OF BLENDING STUMPS

In addition to coming in thick or thin formats, blending stumps come in different degrees of hardness. It's best to have two or three of the same size (thick, medium, and thin), and to use them based on the width or degree of detail of the area in which they will be used. One of the two extremes can be used for blending intense areas, and the other extreme for softer blending, as if it were a pencil with two different colors.

Blending stumps come in many different sizes and are made from rolled and compressed absorbent paper.

A MORE MALLEABLE TIP

Blending stumps are sold with the tip hardened, so they must be prepared before use. This involves hitting each of its edges with a hammer, exerting medium strength, so that it begins to soften little by little but without breaking or cracking. An alternative is to wear down or erode the tip with medium-grain sandpaper.

One way of softening the tip of the blending stump and making it less hard and more porous is to erode it with sandpaper.

After enclosing the model and creating the first shading, the artist has blurred the model by passing the blending stump over it on its side.

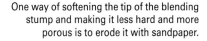

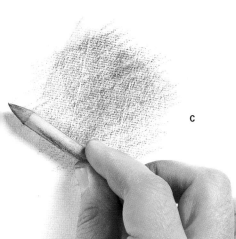

C

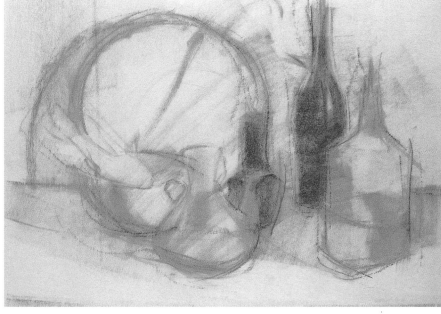

BLENDING STUMP AS A DRAWING TOOL

The effects or types of blends provided by the blending stump mainly depend on the way the artist holds it. To fade extensive areas, one must move it in wide twirls over the paper. In very detailed areas, it can be used as if it were a pencil. To soften intense strokes or profiles of a model, the artist can use the tip at an angle. Finally, to blend large areas, the blending stump should be placed longitudinally on its wide edge, along its entire length.

DRAWING WITH BLENDING STUMPS

The blending stump can even be used as if it were a pencil. Its tip is loaded with puverized charcoal so that it becomes saturated with it, and then the stump can be used to draw directly on the paper. The end result is a smooth drawing without hard borders. The blending stump does not create a clear, fine line, but rather a thick, faded trace, for which reason its drawings have a purely valuative use. It can be used as a tool to create effects, or as a practical tool for use in drawings.

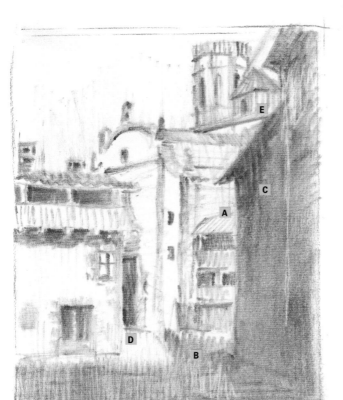

Rural scene done with blending stump and powdered charcoal. This tool offers a smooth, worn stroke without large tone contrasts. There are different individual hatching effects that appear in this work.

1 To draw with the blending stump, first rub a bar of charcoal with sandpaper.

2 Then, rub the tip of the blending stump in the charcoal so that it traps the pigment.

3 Finally, with the tip of the loaded blending stump, draw strokes over the paper.

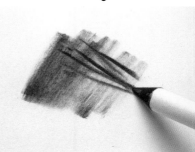

HAND GESTURES

The forearm movements during the blending process are not random. They should follow the direction of the volume of the objects being blended; when working on even backgrounds or smooth surfaces, the movements must be circular.

On broad surfaces, the artist can also create zigzaggy lines with the tip of the stump tilted. In areas with details or outlines, the tip should be used, making short and insistent curved strokes.

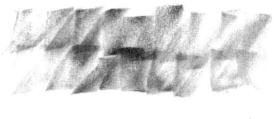

The different graphic elements that the blending stump is able to produce depend upon the tilt of its tip with respect to the paper, the pressure applied, and the type of forearm movement.

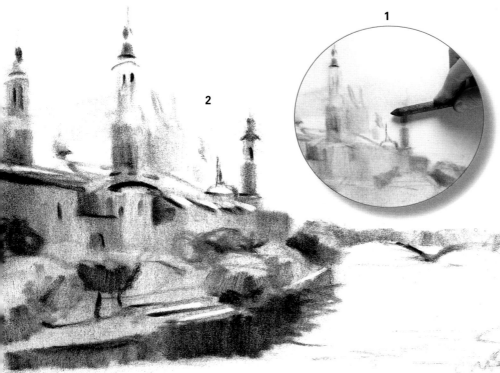

1 Use of the tip of the blending stump should be alternated with longitudinal dragging to achieve greater contrast between the darker lines and the smooth gradation of the sky.

2 The more pigment is on the tip of the blending stump, the more intense the strokes and shadings will be.

CLEANING THE BLENDING STUMP

As the blending stump gets dirtier while drawing, you will have to clean it and sharpen its tip with fine sandpaper. Be careful not to get the blending stump or the paper dirtier than necessary. At the end of each session, the excess pigment can be removed by rubbing the tip on a clean sheet of paper (if abrasive paper, all the better).

To clean the blending stump, we simply remove the pigment from the tip by rubbing it with a clean piece of paper while rotating the stump.

Strokes drawn with pastel are very intense, are saturated, and can be blended and modeled by simply rubbing them with a finger.

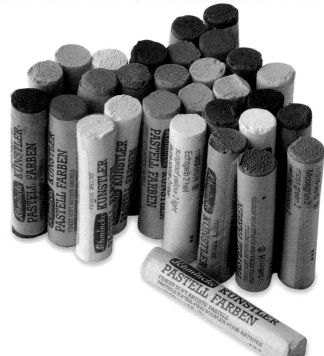

*L*ike charcoal and chalk sticks, pastel is a direct pictorial medium, because other tools are usually not used to apply it to the support. The techniques used to apply pastel are ssimilar to those for charcoal and chalk, but with its brilliant array of colors and intense pigments, pastel is closely related to painting as well—indeed, pastel works are often referred to as pastel paintings.

PASTEL DRAWING

Hard Pastel STICKS

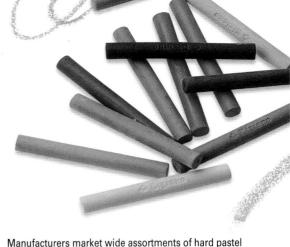

Also known as hard chalk pastels or colored chalk, they come in the form of thin, square-shaped sticks, although a type of stick with a cylindrical shape also exists. They are manufactured by lightly heating a pigment that has been previously agglutinated with ceramic clay and glue. This hardness, which is very similar to that of the chalks described above, facilitates the tracing of lines that are much finer than the thick strokes of charcoal or dry pastel.

Manufacturers market wide assortments of hard pastel sticks to the general public.

1

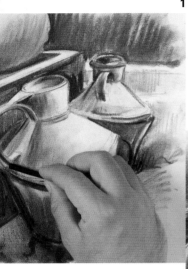

1 Hard pastels can give a touch of color to any drawing done with charcoal. First, create a monochromatic drawing with charcoal, and then fix it with spray.

2

FUSION OF HARD PASTELS AND CHARCOAL

The incorporation of hard pastels into drawings previously done with charcoal can make it more lively and multidimensional. Remember to spray the drawing with a fixative spray before applying the colored pastels so that they do not drag the charcoal pigment and make the colors appear too dirty. You are not trying to completely cover the charcoal, but rather to combine the gray areas with small areas of color.

2 The next step is to incorporate chalk coloring. The stroke must be smooth and not cover too much space, so that it mixes with the gray charcoal areas.

3 Colored chalk provides a slight intonation to charcoal drawings, and appears lightly blended so that it mixes into the shadings.

3

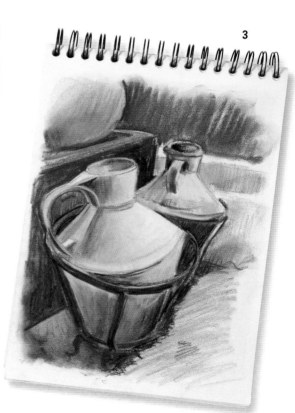

Even light colors can be mixed with charcoal, by simply dragging the stick laterally over the top of them.

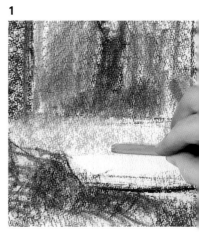

1 In the initial phases of the drawing, we used the flat stick and regulated the pressure applied to it in accordance with the intensity of the color.

2 Pastel strokes can be mixed in with a blending stump so that they become more dense and the color increases their intensity.

3 In the final drawing phase, we added the details and, lastly, restated the linear elements.

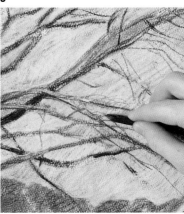

WORKING WITH HARD PASTEL

Hard pastel is used correctly when it results in accumulation of shading or coloring, accompanied by just a few defining strokes that are applied at the end of each exercise. So, the best option is to begin coloring with the side of the stick and then finish up the details with the tips. Work with hard pastel can seem less saturated than work done with other types of pastels, but this can also be an advantage, as it provides great brightness to the drawing.

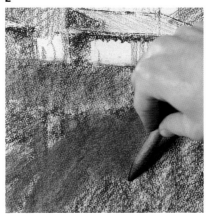

4 The combination of shading with subtle overlaid strokes results in a drawing full of light, texture, and minute details.

Given the greater hardness of these chalk sticks, they are more easily sharpened with a blade, if sharpness is desired.

Strokes and Washes with HARD PASTELS

Strokes and washes created with hard pastels are done similarly to those applied with water-soluble pencils, although both the chromatic quality and the final result are certainly different, because the colored strokes achieved with pastels are thicker and cover more. The procedure is done by drawing with the tip of the stick in a zigzag movement or with parallel hatching. The volatility of the stroke applied even allows for diluting it with a water-soaked brush.

Hard pastel sticks allow for a drawing created with intense strokes that are overlaid and mixed to achieve a greater variety of tones.

CREATE TONES WITH SUPERIMPOSITIONS

Hard pastel sticks allow the artist to juxtapose many stroke hatchings that make the colors vibrate. To achieve this effect, we use only the tip of the stick, accumulating different-colored strokes over the same area. The underlying colors, and even the color of the paper, appear between the strokes, creating a sense of freshness and naturalness in the chromatic harmonies. It is a technique applied using hatchings, so it is good to avoid mixing and blending.

1 Stroke hatchings are part of pastel drawing. The different chromatic areas are created by overlaying intensely colored strokes.

2 The pastel stick can be sharpened or its pointed angles can be used to draw much more precise lines.

3 Pastel drawings done with strokes have great energy and provide a dynamic and expressive treatment of subjects.

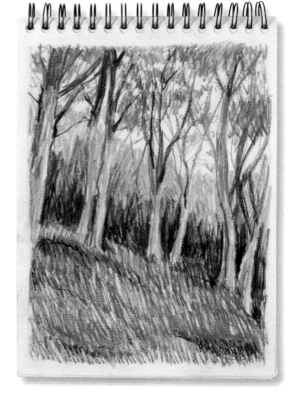

WATERCOLOR PASTELS

Hard pastel is a dry drawing medium that functions by rubbing—that is, the pigment particles fall off when rubbed against the paper. One alternative is to to dilute the powdery pigment with a moist brush, following a process similar to that used with watercolors. With watercoloring, the stroke does not completely disappear; rather, the shadows tend to become softer and appear more compact. After watercoloring a pastel drawing done with chalk, the artist should fix it with a fixative spray once it is completely dry.

A. Diluting the pastel strokes with water does not make them disappear completely; rather, they are mixed into the resulting wash.

B. Dark colors alongside other lighter colors can be dissolved seamlessly.

C. Over a completely dried wash, pastel strokes can once again be superimposed.

D. Pastel strokes can also be applied on paper that is wet, or only moist.

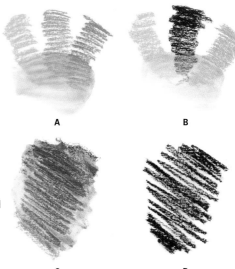

A

B

C

D

1

2

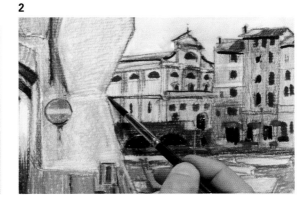

1 When diluting pastel with a wet brush, it is better to apply soft colorings that do not cover much.

2 A wet brush is passed over each tonal area, unifying the strokes and pronouncing the mixes among different colors.

3 The final drawing has softer, more fluid color areas with less presence of strokes.

3

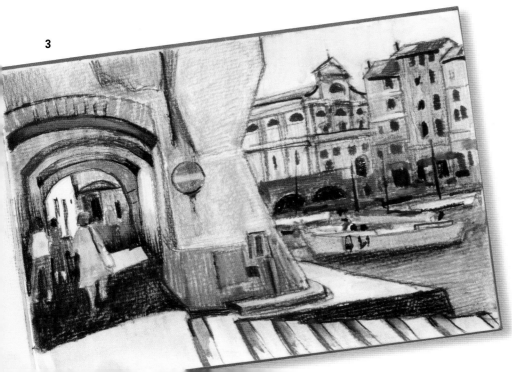

By breaking up the pastel, we can obtain the pure pigment that it is made from.

Soft PASTELS

Painting with soft or dry pastel sticks is the closest thing to working with pure pigment. Other pictorial procedures require a vehicle or medium (linseed oil, gum arabic, or glue) to adhere the pigment to the support. Pastels are pure, dried pigment that is finely ground and agglutinated with a very light gum, which allows it to come off with a light touch.

1

A "PASTE" THAT IS EASY TO MAKE

The name of pastel painting comes from the word "paste" (Latin, *pasta*), which refers to the binder which with it is made: a paste composed of powdered pigment (the coloring agent), a bit of water, gum arabic or gum tragacanth (which is the binder that gives cohesion to the sticks) and a variable amount of chalk (white filler added to the pigment) to lighten the color. Artists who decide to make their own pastel sticks will not find it very difficult.

2

1 To make pastels, mix pigment with water, add gum tragacanth, and mix with a flexible palette knife.

2 Knead it and give shape to the paste by rolling it with fingers until a stick is formed.

3 Allow the sticks to rest for one or two days on top of newspaper—and then they are ready to use.

4 Handcrafted sticks become top-quality materials. The texture of each of them depends on the pigment and the amount of binder used in its manufacture.

3

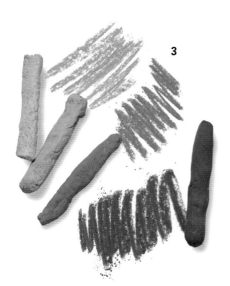

4

Pastels are a very delicate medium: One simple touch can stain colored paper, which allows for working with superimpositions and transparencies.

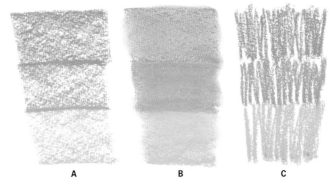

A B C

There are three basic ways of coloring with pastels: by dragging the pastel laterally (A), extending a blend (B), and drawing hatchings made of linear strokes (C).

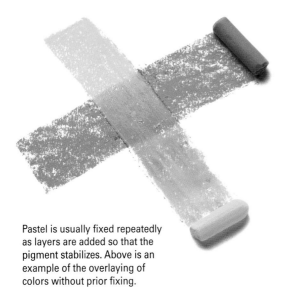

Pastel is usually fixed repeatedly as layers are added so that the pigment stabilizes. Above is an example of the overlaying of colors without prior fixing.

CHARACTERISTICS OF SOFT PASTELS

Soft pastels tend to break apart easily, leaving intense color stains on the paper. A pastel's softness is a sign of its quality, as it indicates a higher presence of pigment and a maximum quantity of it delivered in each application on the support.

Despite this, almost all manufacturers incorporate white chalk in their compositions to give opacity to the colors. There are three basic ways of applying pastel: by spreading the color with the pastel flat, by blending, and by making strokes with the tip of the pastel. You should combine these three techniques in each work for a variety of surface texture and saturation.

Pastel work allows for the combination of broad, impasto color areas with lighter areas using transparencies or linear strokes.

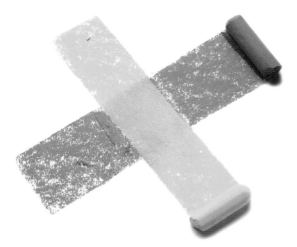

Fixing increases adherence to the support and impedes newly added colors from dragging the previously applied colorations.

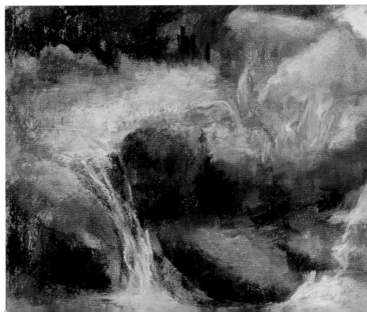

Along with the quality of the pastel sticks, another crucial factor in the final result is the choice of paper. The most appropriate papers for working with pastels should offer a certain amount of ruggedness so that they retain the pigment deposited. It is best to discard those with surfaces that are too fine, as the strokes will easily slide over them.

Any paper with a bit of texture or tooth can be used for pastel. The thicker the texture is, the higher the color saturation will be.

Specific supports and
BACKGROUNDS

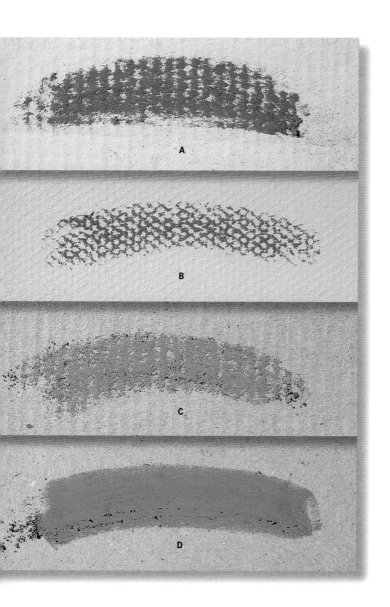

COLORED PAPERS

There is no problem with doing pastels on white paper; but many artists prefer colored paper because its coloration highlights the different pastel applications as a result of the contrast. The most recommended paper tones are siennas, ochers, and grays of different intensities. These neutral color backgrounds usually harmonize well with most subjects, themes, and color scales. Other papers to consider are those with more vivid colors: blues, reds, yellows, carmines, or oranges, of different intensities and saturations, which are usually used for more expressionist styles.

At left are some samples of pastel strokes on four different kinds of supports, shown actual size: laid paper (A), Canson® paper (B), texturized cardboard (C), and a board of compressed wood (D).

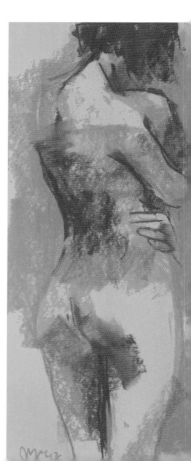

An intense orange background vividly brings out, by contrast, the scale of blues surrounding the figure.

Sandpaper can be an alternative support for pastel. It retains a large amount of pigment, which makes applying impastos easier.

SUPPORTS WITH TEXTURE FOR PASTELS

Pastels can be used on other, non-paper supports, provided that they are adequately prepared. Sandpaper is an uncommon but effective support if finer-grit varieties are used. Likewise, wooden surfaces can be prepared with a layer of acrylic primer that is applied with irregular brushstrokes. Special acrylic preparations for pastel painting even incorporate suspended pumice particles so that the final surface is more abrasive.

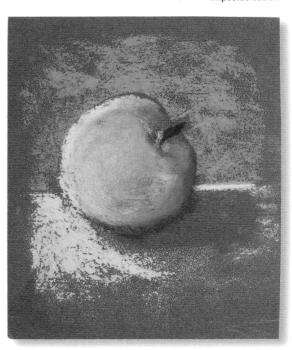

1 Artists can paint on a wooden board if they first apply an acrylic preparation with striated brushstrokes that bring out the texture.

2 The layer of paint is left to dry, and it is then ready to be worked on with pastels. The result is layers of color with a thick and irregular texture.

1

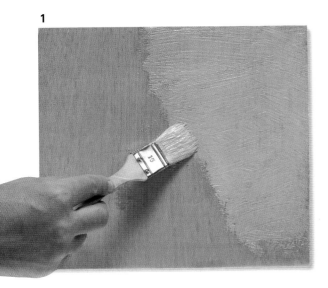

2

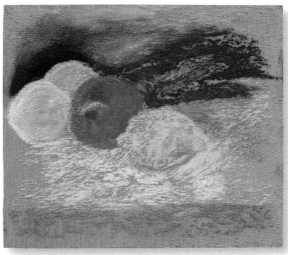

BASIC PASTEL PAINTING
TECHNIQUES

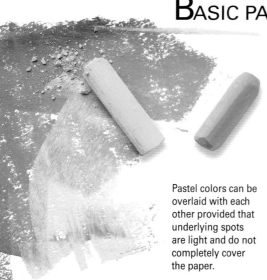

As has been noted in previous exercises, the process of creating a pastel painting is more similar to drawing with charcoal or chalk than to working with any other pictorial procedure. As such, it is a technique based on rubbing with the pastel stick, spreading pigment, and the way in which we manipulate it using our fingers or blending stumps.

Pastel colors can be overlaid with each other provided that underlying spots are light and do not completely cover the paper.

Pastel painting involves using the fingers to create smooth fusion between lines and tones.

MODULATING WITH PASTELS

There is no one single way of painting with pastels. The artist can opt to emphasize strokes or larger shaded areas; very diverse results are obtained from both alternatives. Furthermore, the possibility of blending greatly increases the painter's options. The most common way of working with pastels is to modulate the surface with varying types of adjacent strokes. Once a primary chromatic impression of the image has been defined, you can touch up and adjust the colors, tones, and details, leaving the darkest touches and the highlights for the end.

The fusion of two colors is created by superposition— laying one color over another—smoothly or with dense applications of color, as shown here.

The basis of pastel work is a combination of dragging the stick for large areas and using linear touches for detail.

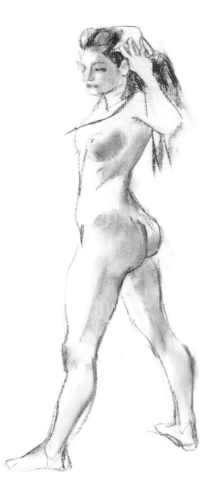

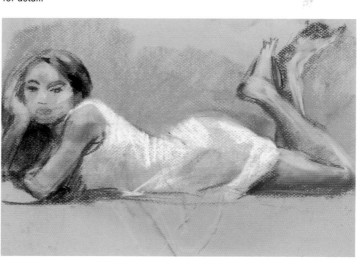

DIRECT STROKE AND HATCHING

The artist can use the pastel stick directly, without mixing or blending, using a series of linear strokes or intense dragging done directly on the paper, which brings out both form and color contrasts. It can also be applied with a combination of hatching to create works in which the linear emphasis does not detract from the color's harmony. Following this method, mixes are created by accumulating strokes of different colors in various directions.

A. Overlaying and mixing of two colors by dragging the sticks.

B. Mix of two colors achieved by overlaying two hatchings in different directions.

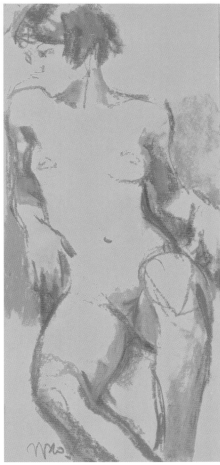

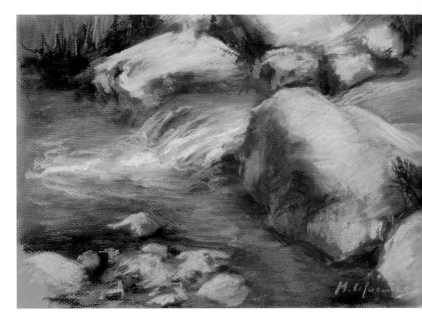

Above, work done with direct pastel strokes that are clearly visible in the water's current. To achieve an effect like this, the artist overlapped the water flow with white pastel.

Work with direct strokes is done without any blending or mixing. This method provides great strength and contrast to the drawing.

Pastel drawing done with a combination of different hatchings.

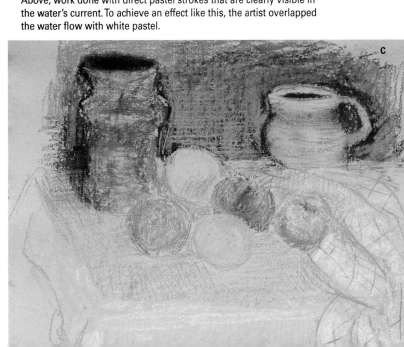

Applied Fusions, Fading, and Blending

Blending is as easy as rubbing with a finger, a blending stump, or cotton over areas or strokes applied with the pastel. The blending effect allows you to achieve soft fadings among various colors or tone fusions, so that some colors or tones integrate smoothly with others.

TOOLS FOR BLENDING

Blending pastel strokes is generally done by hand: The palm is used for large-format papers and the fingertips for smaller formats. The hand is better able to control the pigment, and it stays in direct contact with the work. Rags are also normally used when preparing a background color on the paper, creating large, blurred, and even color areas. To blend details, we can use blending stumps or the classic cotton swab for ears. The latter are helpful for perfecting details and retouching very fine strokes.

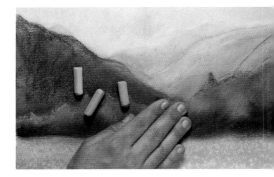

By rubbing the hand on a sparse pastel spot, one can extend or unify the color.

The below portrait was made through a mix of these five basic colors, warm ocher and pink tones and a cool blue:

1 **2**

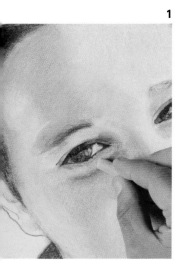
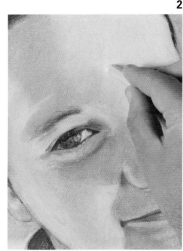

1 Mix two colors by shading softly, first with one color and then with the other, and rubbing with your finger.

2 The more illuminated areas are left untouched (the color of the paper shines through). You can apply a white stick to lighten other colors and avoid abrupt tone changes.

3 The final result shows that when blending flesh colors, the colors can be extended to fill in lighter areas with soft fades and very little contrast, thanks to the low amount of pigment dispersed on the white paper.

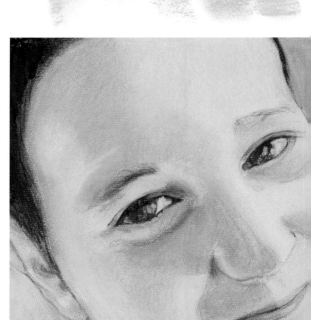

3

MIXES WITH BLENDING

An area that has already been blended can be painted over with new strokes and mixed again; that way, the artist can achieve hues or even different colors (depending on the amount of pigment added). This procedure can be done during any phase of your drawing. It is useful for creating mixes or for fading between one color and another.

A. It is preferable to blend with your fingers, but it is also possible to do so using a blending stump or a cotton ball.

B. By rubbing the strokes with your fingers, you can obtain an even blend.

A

B

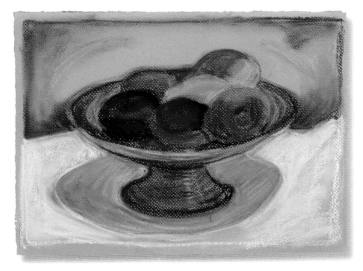

The colors are mixed together seamlessly in this pastel to create transitional areas. Done carefully, these fusions are continuous and do not show any sign of strokes.

Blending stumps can help when working on small-format works where there aren't many colors.

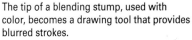

The artist's hand is the basic tool for practicing blending.

The tip of a blending stump, used with color, becomes a drawing tool that provides blurred strokes.

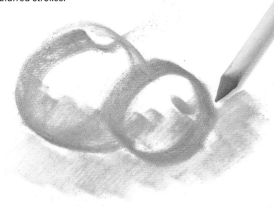

Working with densely colored impasto spots is the most pictorial option offered by pastel painting. Both the process and the final result are reminiscent of the characteristic manner of oil painting. Mixing, fusion, overlaying of layers, and impasto and finger work are fundamental in these kinds of compositions.

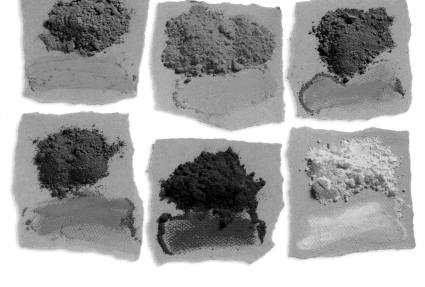

Pastels are nearly pure pigments. When one applies strong pressure with the stick against the paper, the pastel shows its maximum brightness, almost like the original pigment itself.

Dense color SPOTS

In this work, the volume is perfectly expressed thanks to the dense pastel spots.

SPOTS THAT COVER THE SUPPORT

Basically, this practice consists of creating shapes from spots created by applying the flat stick against the paper and allowing the contours of these spots to define the profiles of the shapes. Color contrasts create volume and contours; the harmonies enrich and provide life and relief to the theme's combinations. The best way to get the most out of colors is to exert pressure on the stick against the paper so that it covers completely, with a high degree of saturation; this way, we prevent the color of the paper from coming through.

1 The sea is created with dense spots of blues that will help to define the relief of the vegetation of the foreground.

1

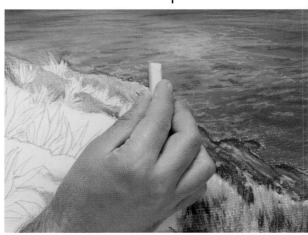

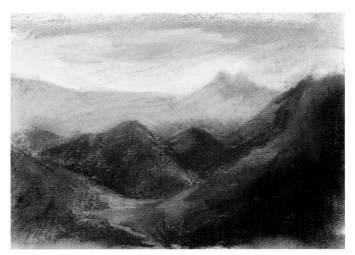

White pastel sticks are generally used to lighten underlying colors, to brighten, and even to apply impasto or blend. Note the background of this landscape.

When painting with pastels, you should play with different grades of color coverage to create contrast and texture.

LUMINOUS AND SATURATED LIGHTENING

Pastel work created with smudged areas that emphasize color contrast has a brightness that is difficult to achieve with hatching and lines. This is due to the abundant incorporation of pigment that is applied to the support by applying pressure with the stick. Areas can even be repainted with light colors such as yellow, orange, light blue, and white, creating very intense contrasts. Be careful, however: As is common in these covering procedures, overusing white can produce negative results, such as graying out the colors.

2

2 In this work, lines and strokes play an important role in defining the subject and details, but composition is created mainly with larger blended shapes.

3 Dense and covering applications of color do not leave space for the paper's color to come out, and provide the painting with a solid and colorist appearance.

3

Pastel PENCILS

Most pastel painting enthusiasts like to combine three different types of pastels in their work: hard pastels or colored chalk for the initial phases of the work to create linear strokes and graphic elements; soft pastels for more pictorial effects and to quickly cover wide surfaces; and finally, pastel pencils, which are used to outline details and retouch and finish up the drawing in the last stages of its development. The latter can also play a major role in small-scale works.

PENCIL LEAD

The pastel pencil has a wider lead than the conventional pencil. This is due to the fact that it contains a much higher amount of pigment and less glue. As a result it is more fragile and brittle; the larger diameter in necesary to protect the lead. Although the the lead is harder than that of soft pastels, it is best to avoid knocking or dropping these pencils, as they can break into several pieces inside. Likewise, because of the pencils' fragility, it is preferable to sharpen them with a special sharpener for pastel pencils instead of doing it with a regular pencil sharpener or blade.

Pastel pencils can be used in the first phase of the sketch of any model as a substitute or complement to charcoal.

Pastel pencils can achieve more detail than regular pastels, but are not as fine as colored pencils.

They are much softer than conventional colored pencils and are generally used in the final phases of an exercise done with pastels.

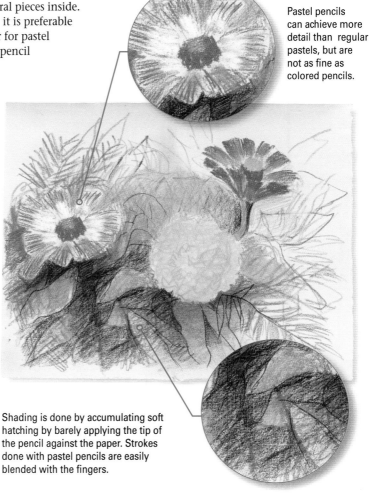

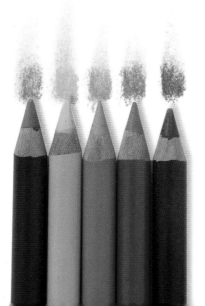

Shading is done by accumulating soft hatching by barely applying the tip of the pencil against the paper. Strokes done with pastel pencils are easily blended with the fingers.

One must be careful when working with pastel pencils, as their tips are very brittle; we recommend not using a blade or regular pencil sharpener to sharpen them.

APPLICATIONS WITH PENCILS

Drawing with pastel pencils is not the same as drawing with conventional colored pencils. The stroke is rougher and thicker, so is unsuitable for minute details. The strokes are sketchy and not suited to hard pressure due to lead breakage. They provide their best results when combined with conventional pastels in medium-sized works, which is where they demonstrate their versatility in line work, hues, and retouching.

1

1 The relaxed nature of the human figure sketch is ideal for pastel pencils; they are used for the preliminary drawing.

2

2 The interior modeling is done with pastel pencil strokes. Don't focus on the details; just work on bringing out the most relevant outlines of the spine.

3 The sketch resulting from this process is fast and delicate, and is characterized by the rhythm provided by the linear hatchings of the pastel pencil.

3

O_{IL} PASTELS

Also known as wax oil crayons, these are colored sticks that use paraffin and animal fat as binders. Paintings done with this material are unalterable, because of the high amount of oil binder, which prevents the painting's layers from cracking. The painting can, however, become severely deteriorated if exposed to high temperatures.

Oil pastels are used much like dry pastels.

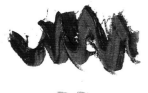

Depending on whether you are working with a sharpened, blunt, or completely worn-down tip, you can achieve strokes ranging from very fine to thick.

MORE TRANSPARENT COLORS

Oil pastels do not cover as much surface as dry pastels. Each color tends to present a different degree of transparency, with the darkest colors being somewhat more opaque than the lighter ones. This presents a contradiction that should be taken into account: you cannot paint with light colors over dark ones. Before beginning any work then, it is worthwhile to check, by performing a simple test on a piece of paper, which colors are the most transparent and which provide the most coverage, and plan out your areas of darks and lights.

Strokes made with oil pastels are thick, intense, and granulated, and allow for little precision and detail unless the tip is very sharp.

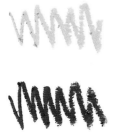

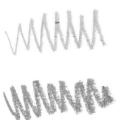

Strokes are accumulated, one on top of the other, to create a waxy and thickened surface that is reminiscent of oil painting.

When the layer of paint applied with oil pastel is heated—for example, with a hair dryer—it can even be manipulated with a palette knife.

OIL PASTELS AND ENVIRONMENTAL TEMPERATURE

Oil pastels' malleability varies with temperature, to the point that a pastel stick can become a sticky mass if held in your hand for prolonged periods or when working in the sun or in a hot room. This is important to remember, because the sticks deposit more paint on the paper when the environment is warm than when it is cool. Thus, heat is a factor that must be taken into account, especially when working outside.

Despite the lighter colors being semitransparent, oil pastels can offer good results when working in layers if you keep in mind which areas you want to keep light.

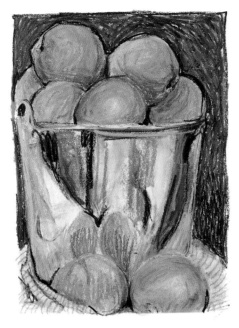

Strokes created with oil pastels impart great vigor to the composition.

Oil pastels are suitable for working with intense strokes. Their main obstacle lies in their limited adherence to paper that is very overly texturized or satiny, or that has been primed with a layer of paint; but this problem is solved by working exclusively with medium grain paper. Oil pastels are suitable for creating special transparency effects, impastos, and texture.

Basics of color with OIL PASTELS

APPLY PRESSURE TO THE STROKES

With oil pastels, it is best to allow the strokes to mix as a result of the pressure applied and not by finger blending (although this is another possibility). The richer, thicker textures are achieved by forcefully rubbing the stick against the surface of the paper, almost completely covering the color of the support, applying them as if they were an impasto.

They provide their best results with broad, colored planes.

Strongly apply pressure when using oil pastels so that the layers of color completely covers the paper's "pores."

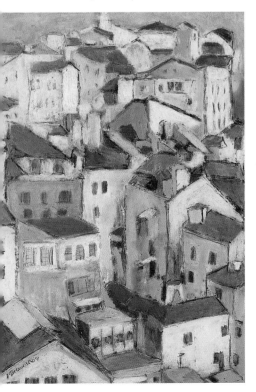

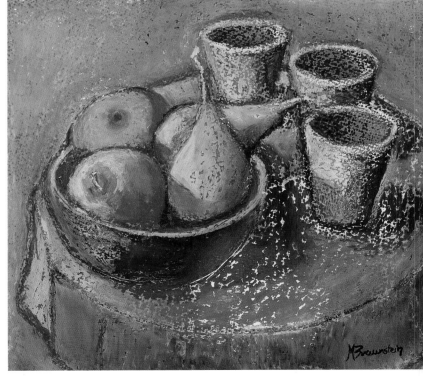

WHITE WAX

White wax is used not only as a color, but also as a means of fusing colors: When colors are rubbed with white wax, the transition from one color to another becomes smooth and continuous. It is also a medium frequently used by artists to thicken and lower the saturation of the colors, making them denser and more solid. Given that its stroke does not provide much coverage, it can be used in some cases to lighten a color.

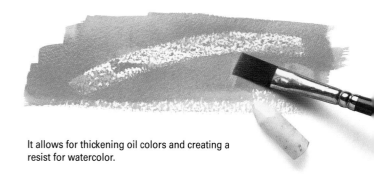

It allows for thickening oil colors and creating a resist for watercolor.

1 With white wax, you can thicken, slightly lighten up, and mix colors as if you were using a blending stump.

2 A drawing covered with a layer of white wax appears bright and somewhat unsaturated, and shows smoother transitions among the tones.

1

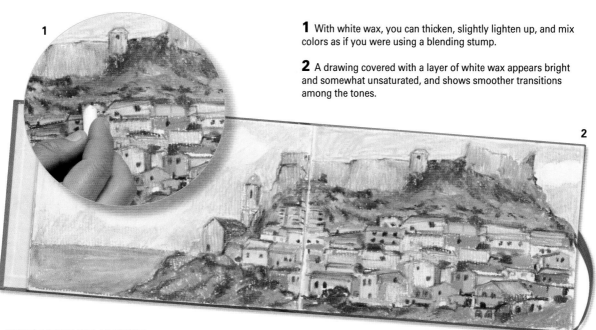

2

WATERCOLOR RESIST

Oil pastels can be combined with other media that have water as their vehicle. Oil's rejection of water—its resist—allows the artist to create drawings that will not disappear with the overlaying of layers of watercolor painting, but rather will appear vigorous and expressive in the final work.

1

1 First, apply a hatching of strokes with oil pastels so that they reject the watercolor wash.

2

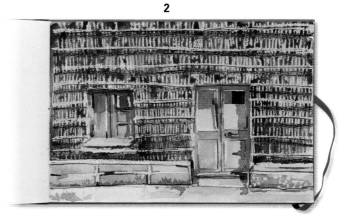

2 When working in watercolors, artists create resists with light-colored oil pastels—in this case, pastels have been used to create the texture of the canes of the hut.

Dilution of
STROKES

Although oil pastels are dense and viscous, they are soluble with organic solvents (turpentine, turpentine substitute, etc.) or in vegetable oil. This means that, just as with water-soluble pencils, watery effects can be created by passing over the surface of an oil pastel with a brush that is imbued with one of the substances mentioned above.

A

A. Wax spots can be moistened in turpentine and mixed together by rubbing them with a finger.

B. Dissolving the strokes with a brush facilitates mixing among the colors.

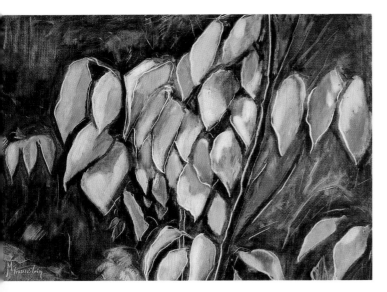

B

Diluted oil pastels are suitable for creating transparency effects and washes that can be combined with sgraffito (eraure or scratching to reveal underlayer) effects.

Some samples with strokes of different intensity diluted with a soft brush soaked in essence of turpentine.

MIXING COLORS

By softly shading, we can achieve interesting chromatic combinations that are then diluted by passing a turpentine-soaked brush on top of them. When the color layer is thick, it can also be manipulated by hand if it was previously moistened with dissolvent; then, the color spots can be mixed with each other by rubbing them with one's fingers. In addition, since the colors are very sensitive to heat, the temperature of the fingers contributes to the mixing.

REPRESENTING LANDSCAPES

By diluting an oily medium such as oil pastels in an organic dissolvent such as turpentine, we can create a greasy substance that is easily handled with a brush. Using turpentine or turpentine substitute to dissolve oil pastel strokes is especially useful in working with landscapes, to capture atmospheric perspective or a sense of distance. The layer of color becomes a greasy substance that can be handled with a brush in the same manner as if it were an oil painting, although it is much more transparent and has less consistency.

Oil pastels can be dissolved in alcohol, turpentine, turpentine substitute, or even vegetable oil.

1

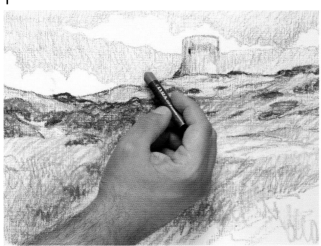

2

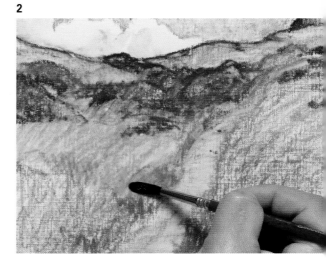

1 The drawing is started in the traditional manner, by adding strokes and shading.

2 Using a soft-haired brush soaked in turpentine, the artist dilutes the strokes with barely a touch.

3 The strokes are mixed together and provide a more pictorial finishing that is reminiscent of a watercolor or even a diluted oil painting.

3

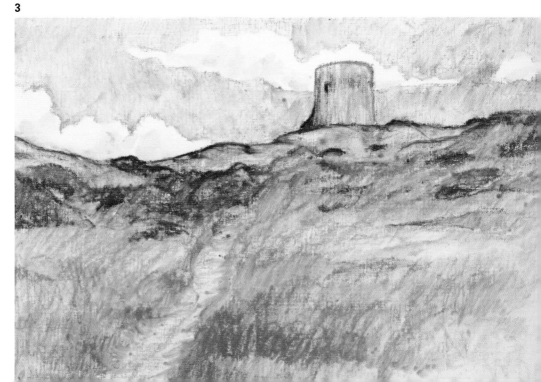

Experimenting with OIL PASTELS

The work done with oil pastels is very diverse and malleable, as it is a procedure that can work symbiotically with other tools and techniques to achieve effects that could not be obtained alternatively. Mixes or seemingly incompatible media should not be feared—what's important is experimenting and the outcome.

Different strokes with light colors of oil pastel. By shading on top of them with dry pastel and blending, we trap the pigment's powder with thick strokes.

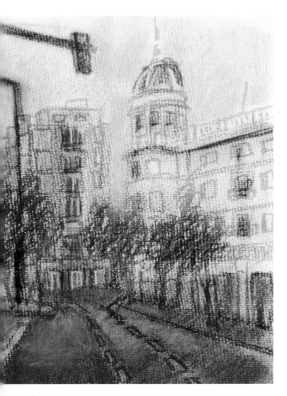

Urban scene in which strokes done with oil pastels are combined with coloring done in dry pastel.

OIL AND DRY PASTELS

There is a certain incompatibility between dry and oil pastels on the same support; however, used intelligently, they provide interesting results. The artist has the possibility of creating the drawing with an oil pastel and then coloring it with fine applications of dry pastel. While the background of the paper traps a fine layer of dry pastel, oil pastel strokes, which are much stickier, capture a greater amount of pigment and appear more contrasted than the background color.

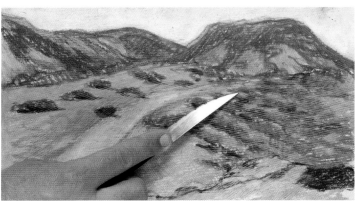

Right, a serrated knife serves as a scraping tool to make hatchings over the surface of the work.

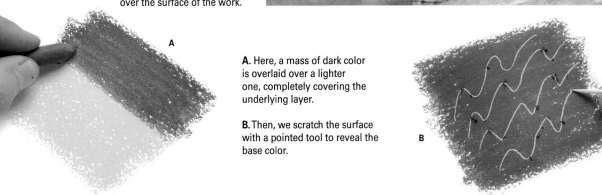

A

A. Here, a mass of dark color is overlaid over a lighter one, completely covering the underlying layer.

B. Then, we scratch the surface with a pointed tool to reveal the base color.

B

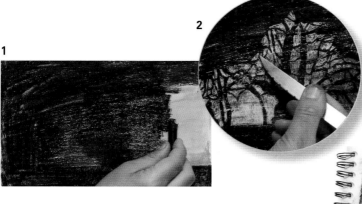

1

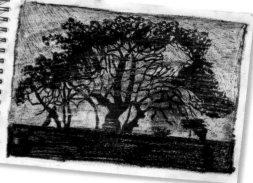

2

1 A preliminary spot of colors is applied and then covered with a thick layer of black.

2 The layer of black is lifted off with a blade or other sharpened tool.

3

SGRAFFITO ON BLACK

This technique works very well on smooth paper. It involves painting any model with oil pastels and then covering the whole thing with a thick layer of black pastel. With a sharp or pointed tool, we then scratch the surface to remove the black layer. Each time a line is scratched, the wax from the layer of the overlying color is removed, leaving the pigment of the underlying layer visible, although sieved with an interesting hatching of sgraffito lines, an intense scratching that adds an attractive texture to the work.

3 When the layer is removed, the drawing is uncovered and the underlying colors are revealed.

LINE DRAWING WITH SCRAPING

With a well-sharpened black oil pastel, create a line drawing on the paper. It must be precise, synthetic, and well marked. Then, completely cover it by different colored strokes. Next, with a metal palette knife or spatula, rub the surface until the fine wax deposit left by the colors is removed, but not the colors that have stained the paper. The result is a bright drawing that presents a linear stroke on top of a colored background.

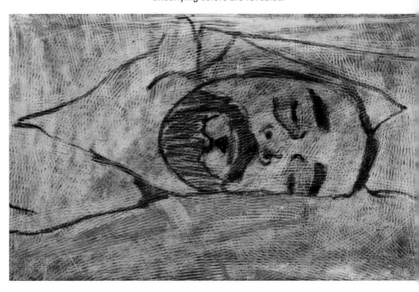

The top layer of color can be removed using a metal palette knife, regular knife, or even fingernails; depending on the colors and tools used, the effects will be different in each case.

Line drawing done using oil pastels with the scraping technique.

Compositions created with black Chinese ink and metallic pen nibs are a favorite of drawers, especially those who enjoy details and textures.

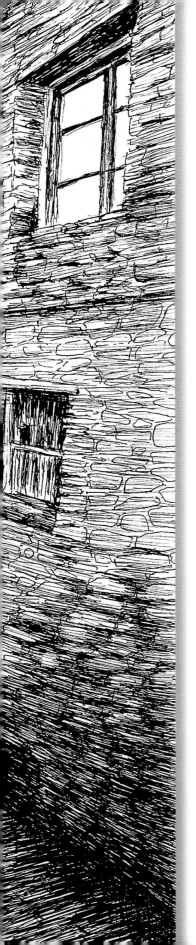

*I*nk is one of the oldest drawing media; it is commonly used in Asia, particularly by Chinese artists. Whether black or colored, it has an incomparable graphic strength and quality, whether used alone or in combination with other techniques. Although black Chinese ink is the one with the longest tradition, the ones most used by amateur and professional artists—colored, acrylic, and aniline inks—play an increasingly larger role among today's art supplies. They are a medium that is close to watercolor, although their strength lies more in contrasts than in delicate nuancing.

INK DRAWING

By appling ink with the brush, we can produce interesting linear drawings imbued with much gestural and expressive strength. In monochromatic drawings done exclusively by brush, the most frequent choice is to use Chinese ink, which is made from lampblack dissolved in oil, gum arabic, and binders. The objective of these drawings is not to try to depict the motif with details, but rather to capture its essence in a more or less expressive manner.

DRAWING WITH
INK AND BRUSH

Portrait done with linear strokes of Chinese ink. It is characterized by its simplicity and by its variability in the thickness of the line.

WORKING WITH CONTINUOUS LINES

With an ink-loaded brush, the contours of the subject are quickly outlined, almost without lifting the bristles from the paper. You allow the brush to unload all of its color on the paper, so that the linear marks depict the subject with fine strokes in light areas and with thicker strokes in areas representing shadows. This is called modulating the line, and it is a way of representing a figure or object without having to extend the shadows.

The array of graphic elements provided by ink applied by brush makes this method especially good for creating gestural drawings.

As the brush releases the excess ink, the brushstroke becomes lighter and more streaked. This effect must be taken into account when drawing.

In gestural drawing, the amplitude of the brushstroke is constantly varied to differentiate illuminated areas from shaded ones.

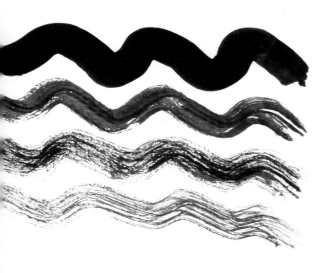

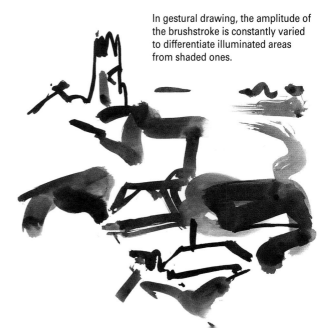

Here we have two examples of brushstrokes: In one of them the brush is loaded with an abundant amount of ink (A), and in the other the brush is only moistened with this color to produce the dry brushstroke (B).

A

B

The brush with little ink on it produces a striated and texturized stroke that is very suitable for landscape representations.

THE GESTURAL ASPECT SHOULD PREDOMINATE

To achieve a gestural drawing with ink and brush, one must learn to draw a scribble outlining the shapes in a hurried manner. Strokes done with a round brush, which are the most suitable in these cases, should not be rigid or uniform; on the contrary, the tip of the brush should respond to the forearm's hurried movements.

DRY BRUSH

The dry brush technique seeks to create atmospheric and streaked brushstrokes. It is very suitable for emphasizing textures and giving a less solid, more volatile consistency to the brushstrokes. You can achieve this by applying the ink-moistened brush after having unloaded the excess color on a separate sheet of paper so that the brushstroke is dry and does not provide much cover.

Use the brushes to their full extent to achieve well-differentiated stroke thicknesses.

Tonal Drawing
WITH CHINESE INK

Black Chinese ink offers an unbeatable opportunity to understand the role of dissolving paint in water. The clearer grays are created by diluting the ink in a large amount of water; that way, the whiteness of the color appears as a result of the transparency effect, and provides light to the wash.

Alley created using different tonal washes of ink combined with some overlaid strokes of black chalk.

Original Chinese ink comes in solid bars that must be rubbed on an inkwell made from a special, finely textured stone.

EXTENDING INTENSE SPOTS

A resource that is frequently used in ink spots is to first apply an intense color to an area, and then wash the brush and load it with clean water only. Next, wring out the hair strands a bit and extend the color by passing the brush over the color spots to create fadings. The more a color is spread, the lighter the tones of the fading are and the smoother the transition from dark colors to light ones will be.

The level of dilution of the ink in water and the type of brush used are critical factors for achieving different tonal effects.

Direct use of the brush loaded with undiluted ink is an effective method of creating strong contrasts. Black areas counteract the background's watercolor washes.

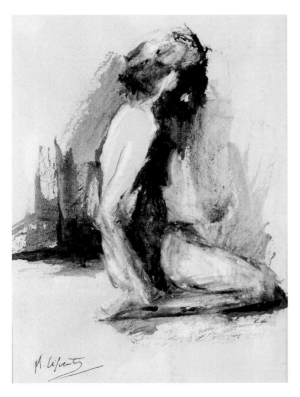

In this sketch, the ink has been applied with a deeply angled brush to generate somewhat dry, medium tones with very ragged borders.

PAINTING WITH THE BRUSH AT AN EXTREME ANGLE

There are many different ways to apply tonal washes to a drawing. Instead of applying brushstrokes with the tip of the brush, you can tilt the brush completely so that the bristles drag longitudinally over the paper, spreading the wash in a more imprecise manner, which produces bare patches and ragged outlines. It is a way of breaking the uniformity of the washes.

Black Chinese ink has a high staining power and can be widely spread over a moistened surface.

INK AND DROPLETS

Working with ink is much more fluid and uncontrollable than painting with watercolors. Washes are usually applied with determination and energy. You need not worry if small stains or droplets appear, or if the color expands uncontrollably over the moist paper; these effects that escape our control usually make the drawing more interesting.

The ink tones are achieved by accumulation—overlaying one wash over another every time a layer finishes drying.

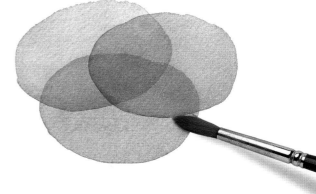

When the support is inclined, the droplets are reinforced as a graphic resource.

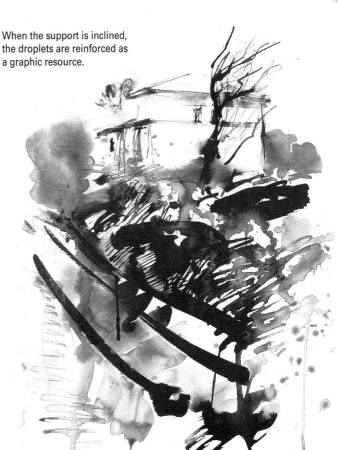

Sepia INK

Sepia is an ink with a brownish-gray color resembling the secretion of the cuttlefish, a marine cephalopod similar to the squid, whose ink has been used in art the times of Ancient Rome. It enjoyed its maximum popularity during the Renaissance, but its use since the end of the eighteenth century has dwindled due to the emergence of other pigments with similar tonalities or characteristics, such as bister and Chinese ink.

ORIGINAL SEPIA INK

The cuttlefish's "ink" is extracted from a special bag-shaped organ found inside the fish. When the fish feels threatened, it releases a dark ink that clouds the water and allows the fish to escape from its predators. Originally, this ink was dissolved in alcohol for painting, but since it is an organic substance taken from a fish, it would quickly ferment and release an intense odor. Currently, the sepia color used by artists is generally made with a mix of organic and inorganic pigments that imitate the coloring and staining characteristics of the original.

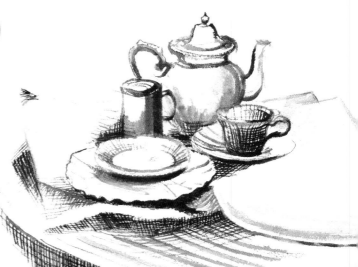

The accumulation of different sepia tones allows the artist to reaffirm shapes and volumes.

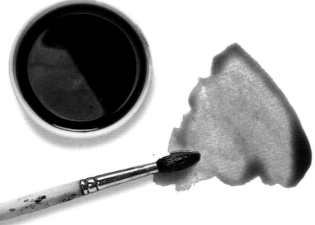

Sepia ink has been used since the Renaissance. It is an alternative to the absolute black provided by Chinese ink.

WASHES WITH SEPIA INK

The pigment of sepia ink allows for a great number of tonal variations and is fairly resistant to light; it is used in watercolors, for glazing, and as ink.

Washes with this ink are always created starting with a light tone and working toward a darker one, as the paper itself provides the white that lightens the washes. This addition of tones should be done on a dry background or wash so that each addition of darker dun colors will reaffirm shapes and volumes.

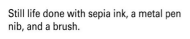

Still life done with sepia ink, a metal pen nib, and a brush.

SEPIA INK AND STROKES

The interesting shading effects provided by sepia ink can be combined with just a few lines applied with a chalk stick, pen nib, or reed pen. Black Chinese ink can also be applied to achieve greater contrast and emphasize the stroke with rotundity.

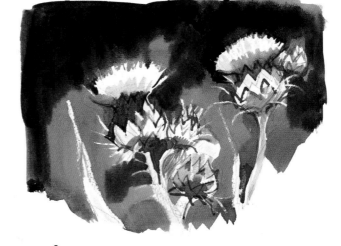

Tonalities of sepia ink range from the softest duns to the darkest browns.

1

2

3

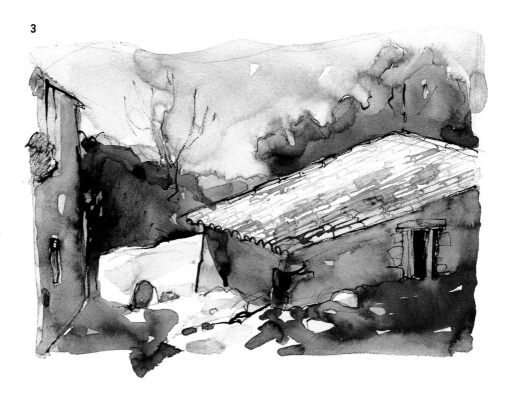

1 With a sepia-colored wash, the main shadows of the model are created, leaving the brightest areas the color of the paper.

2 The wash is allowed to dry completely, and a linear drawing is made with sepia ink mixed slightly with Chinese ink, so that it appears darker.

3 New additions of sepia ink are applied to counteract the shading of the foreground even more.

DRAWING WITH
METAL PEN NIBS

Metal pen nibs began to be used at the end of the eighteenth century. They offer a fine, clean stroke that varies slightly in thickness. Works done with pen nibs have the particular charm of a line that is extremely sensitive to even the slightest movements of the hand, both in its swaying and in its pressure on the paper.

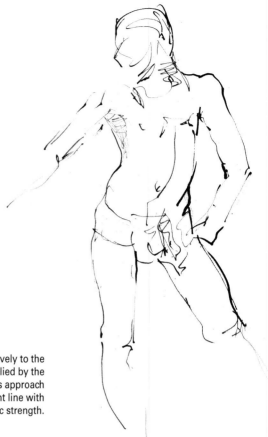

DIFFERENT TYPES OF TIPS

The market offers various metal tip models, some with flat bodies, rounded, or flat tips; special tips for calligraphy; tips for parallel strokes, etc. Combining different metal tips in a drawing is usually a way to give the representation more stroke variety and expression. Some of the tips allow one to create more relaxed drawings.

The pen nib responds sensitively to the movements and pressure applied by the hand. A hesitant, nervous approach can produce a faint line with great graphic strength.

STROKES WITH
METAL PEN NIB

Working with the nib implies constantly loading it with ink in the inkwell, and being aware of the amount that it can hold and how much time each load lasts. It provides a fine stroke, but if pressure is applied to it, the line can be somewhat thicker, although not much—only enough to give emphasis and character to the drawing.

The market offers a wide variety of pen nibs; this image shows three with angled tips and three that have thick strokes.

Pen nib drawing is based on the overlaying of strokes of different densities that are accumulated until different intensities of shadow are achieved.

A B C

A. Strokes crossed at an angle are some of the most characteristic hatchings of pen nib drawings.

B. Classical gray tone involves applying hatchings of parallel strokes or shading with simple zigzag strokes.

C. When applying the stroke, you can vary the pressure exerted on the paper to increase the line's thickness.

HATCHING WITH PENS
The grace and graphic density of pen drawing lies in the wise distribution of lines against the white of the paper, as well as in their interweaving, forming a mesh of pen hatchings created by the artist in the darkest areas of the composition. To achieve the sense of tone, we create pen hatching, that is, shadings created from the accumulation of overlaid, generally parallel strokes.

1 An artist who is not sure of the stroke can begin by drawing with a pencil, and then reinforce it with the first applications of Chinese ink done with a metal-tip pen.

2 As the exercise progresses, some outlines are reinforced and more depth is given to the shadows with overlaid lines.

3 Pen hatching and the accumulation of hatchings provide the drawing with the necessary depth and sense of volume.

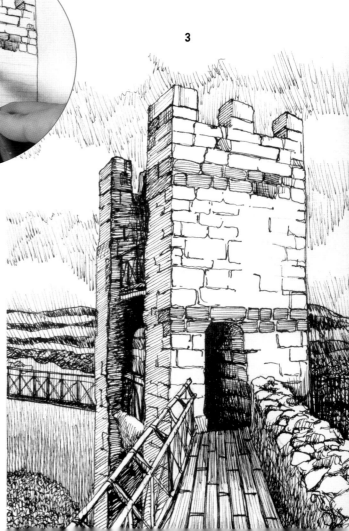

Dry reeds with a beveled tip on one end are good tools for ink drawing. Work done with reed pens more effectively conveys all of the virtues and expressivity of the stroke, allowing for greater variation depending on the side of the tip that is applied to the paper.

Strokes
WITH REED PENS

To achieve variety in the stroke, we can use three ink dilutions of different intensity.

DIFFERENT STROKE INTENSITY

Reed pens are usually used with two or three ink tones. One is more watered down, for objects that are more distant, and another is a more intense stroke for drawing more pronounced outlines in the foreground. There is a third option, which involves working on more contrasted lines when the tip of the reed pen is highly loaded with ink, and working on faint lines when the ink is almost exhausted. This produces a weakened, grayed stroke reminiscent of markers.

TORN TRACES

Working with reed pens involves not only a combination of fine and thick linear strokes; rather, these strokes can be combined with ripped, blended, or jagged strokes, which are the result of dragging the tip of the reed pen at an extreme angle. The thickness depends upon the side of the tip that is applied to the paper. There is also the possibility of rotating the tip while dragging, thereby achieving an intense and jagged trace reminiscent of dry brush work.

The background elements are created by diluting ink in water, while in the foreground the strokes are more intense.

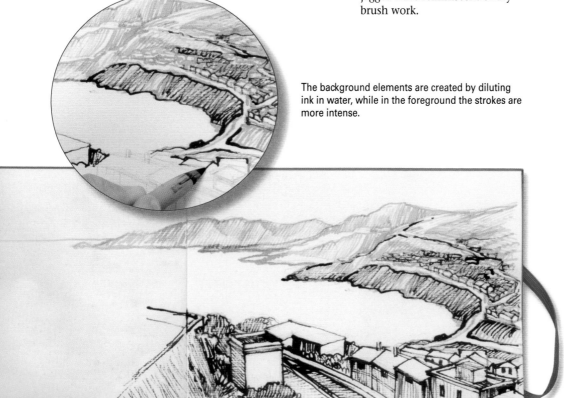

1

2

1 When the reed is tilted at an extreme angle, the tip drags in a way that leaves very striated marks on the paper.

2 This work combines washes done with brush and water-soluble ink, dragging done with the side of the tip, and linear strokes drawn with the sharpened tip of the reed.

This medium of energetic drawing allows for creating all kinds of strokes and marks on the paper, not just linear strokes.

REED PEN STROKES ON SILK PAPER

People tend to believe that reed pen drawing is strictly monochromatic, but that is untrue; both colored inks and supports that have been previously watercolored can be used, or even a collage of pieces of silk paper. This type of paper is very fine, smooth, and barely has any texture after being glued to the support, for which reason it can be considered an ideal chromatic complement.

The stroke does not have a constant thickness, but rather presents many variations, giving this medium a wide graphic variety.

DRAWING WITH FOUNTAIN AND BALLPOINT PENS

Ballpoint or fountain pens, traditionally considered to be a writing tool, have become a very common drawing medium among many artists. Their fine, intense stroke makes them an ideal substitute for pen nibs for drawing equisses and sketches and as a tool for approaching more elaborate drawings, among them the portrait or self-portrait.

OIL-BASED BALLPOINT PEN

This tool has a spherical tip that releases color with great precision. Its ink is greasy and oily; it does not dissolve in water; it has a very fine stroke; its line is unalterable and presents no changes in thickness or intensity. Shadings are done by accumulating strokes or overlaying more or less tightly drawn hatchings. When using grease pens, it is not suitable to use the same paper used in dry techniques; it is necessary to use cardboard or paper with a satined or fine surface.

With a fine stroke, they allow for drawing with great detail resolution.

1

1 The first lines done with the fine-point ballpoint pen tend to be structural, for outlining or filling; they seek to consolidate the drawing done by pencil, although they are also used in this instance to apply some shadings.

2 The first strokes are done with an oil-based ballpoint pen with a fine tip. The pressure exerted on the paper must be minimal so that the lines appear very soft.

3 It is always better to start out using a lighter touch and progress to a heavier touch, because, in contrast to other media, the ballpoint pen cannot be corrected.

2

3

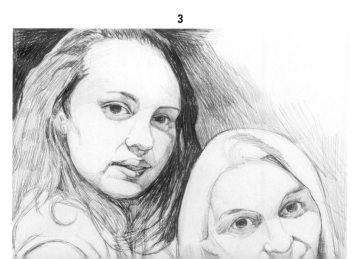

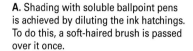

Ballpoint pens are one of the most graphic, accessible, and easy-to-carry media.

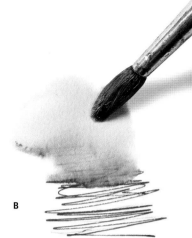

FOUNTAIN PENS AND BALLPOINT PENS WITH LIQUID INK

Both tools release a water-based ink, either through a hollow, cylindrical metal tip or through a flat tip shaped like a pen nib. They offer the same results as the grease ballpoint pen, although the pen nib allows for some variety in the stroke thickness when pressure is applied on the tip against the paper. The biggest advantage lies in its ink: Once it has been applied to the support, it is soluble, which opens up an interesting range of tonal possibilities and combinations with other procedures, including watercolor.

A. Shading with soluble ballpoint pens is achieved by diluting the ink hatchings. To do this, a soft-haired brush is passed over it once.

B. When the ballpoint pen strokes are gone over with a brush, they end up disappearing completely.

A

B

1 Water-soluble ballpoint pens offer a well-structured linear drawing.

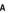

BALLPOINT PENS FOR SKETCHING

The artist who does not have his or her usual drawing tools can always use a ballpoint pen to make sketches of nature. This tool, although it is not on the list of the most popular drawing materials, offers great results for representing all kinds of models, especially architectural ones. The strokes can later be washed to break up the line and create clear tonalities.

2 Once the esquisse has been finished, the lines can be dissolved by passing a moist brush on top of them, or by integrating them with light watercolor applications.

2

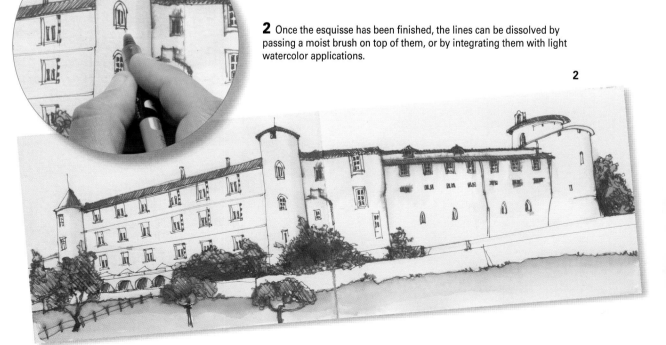

__Drawing with colored ink applied by brush__ presents a transparency similar to that of watercolor, with the only exception being that the colors are more fluid and less covering. Given that their staining power is greater, they create a thick layer of color that makes it difficult to achieve a wide scale of intermediate tones.

COLORED INK

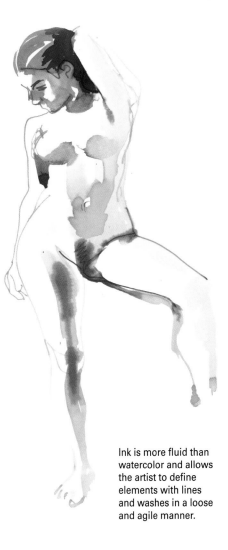

MIXING COLORED INK

Colored inks can be mixed among themselves, but you must be very careful to avoid muddling the colors and turning them into muddy tones. Chinese ink flows more easily than watercolor, and there is a risk of accidentally mixing the two; for this reason, it is recommended that small ceramic or plastic bowls be used, allowing you to have different tonalities of previously mixed colors available.

A B C D

Colored ink can be applied by creating fadings between two colors (A), with a dry brush (B), over a base of moist paper (C), or overlaid wet-on-wet (D).

Ink is more fluid than watercolor and allows the artist to define elements with lines and washes in a loose and agile manner.

AQUEOUS RESULTS

The main attraction in work done with colored ink lies in being able to alternate between strokes of ink diluted in water and strokes applied with more saturated colors. In many cases, the brushstrokes are applied wet-on-wet, directly mixing the color on the paper so that when two different colors come into contact they spread randomly and create watery, luminous results with great tonal richness.

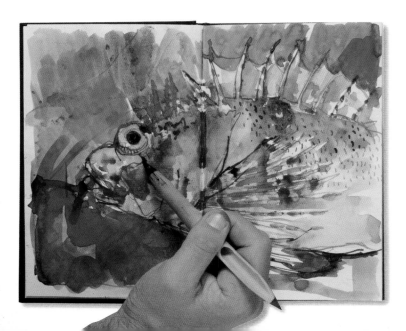

The intense colors and the wide array of existing inks provide optimal results when combining applications done by brush with others done by pen nib or reed pen.

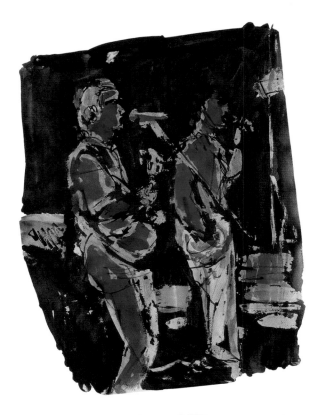

WHITE INK

Far from contradicting the concept of drawing ink, white ink offers a completely opaque consistency when applied without being diluted. It should be used on dark paper, and it offers its best results when combined, skillfully, with black Chinese ink. This way, while the white ink is used for brighter areas, the medium tones are provided by the paper's color, and the black ink is used to cover the more intense shadows.

Ink is a medium that is very similar to watercolor, although its strength lies more in contrasts than in delicate nuancing.

1 With a metal pen nib loaded with white ink, the artist can achieve a very intense stroke that is overlaid on a tonal paper.

2 Black ink is usually combined with white ink to represent the darker shadows.

3 The contrasts obtained with hatchings of black ink emphasize the values and highlights of the white ink.

1

2

3

TECHNIQUES
WITH ANILINES

Anilines have a much greater staining power than watercolor and conventional inks.

Anilines, also known as liquid watercolors, *have great staining power and offer extremely saturated original colors, for which reason it is necessary to dilute them in water before coloring any model. It is preferable to use distilled water, as it improves both the fluidity and quality of the wash.*

In fashion illustrations, anilines are commonly used to color the figures.

Work done using anilines of different colors over which discolorations made with a bleach-soaked reed pen have been applied.

Anilines are the only technique that allow the artist to combine a very saturated chromatic staining with linear whitenings done with bleach.

WHITENING WITH BLEACH

Bleach contains sodium hypochlorite, a substance that oxidates anilines to the point that they turn white. This system allows for incorporating white lines into paintings done with anilines. To do this, simply moisten a fine brush with bleach and brush the colored surface so that it becomes discolored. You must work with great precision, avoiding accidental droplets and being careful not to splash the adjacent areas.

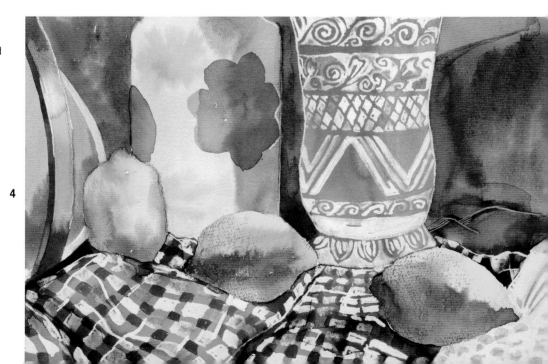

1 Brushstrokes are applied with a bleach-loaded brush; we see how the blue aniline tone quickly begins to discolor the work.

2 Work very carefully and avoid overloading the brush, in order to avoid splashing adjacent areas.

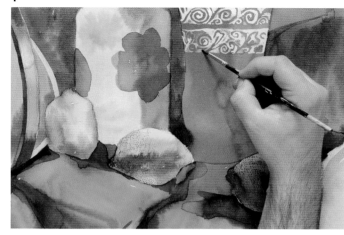

3 Fine linear touches can also be made with a metal pen nib.

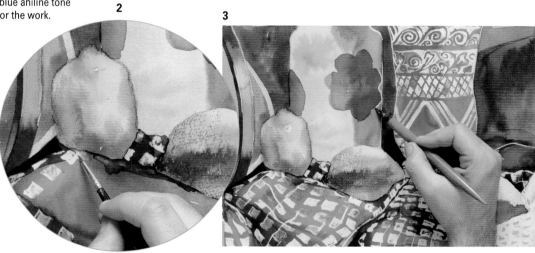

4 It is like creating a drawing backwards: The lines are resolved not before beginning the work, but rather once the work has been finished.

Drawing with an
INK DIFFUSER

After practicing basic drawing techniques with colored inks and anilines that are applied with the wash technique, you are now ready to work on line. Instead of using a brush, pen nib, or reed pen, try directly applying the diffusing nozzle or the pipette of the jar containing the ink. This method provides an intense, thick line that is very appropriate for depicting some profiles. The result is a rhythmic succession of great graphic value.

The pigments of acrylic inks are ground much more finely than in other media, which gives them such a characteristic color intensity.

ACRYLIC AND CALLIGRAPHY INKS

Among the different inks available on the market is Liquitex® acrylic ink, which is generally used in airbrushing, serigraphy, and screen printing. It is an extremely fluid acrylic paint made from superfine pigments with high pigment concentration, providing greater opacity than anilines. It is not another acrylic, as its formulation is different: The color is creamier, permanent, and very concentrated, and it does not produce obstructions. Like acrylics, it is resistant once it has dried. Calligraphy inks also incorporate more opaque inks, many of which are of vegetable origin, that are sold in a wide variety of colors. They are designed to fill the ink barrel of fountain pens.

Not just any line will work—it should be full and definitive, and offer a pronounced counterpoint to the rest of the painting's components.

Strokes done with a mix of yellow and magenta fountain pen inks, in different proportions.

Jar of calligraphy ink composed of plant extracts, from the Swiss brand Abraxas.

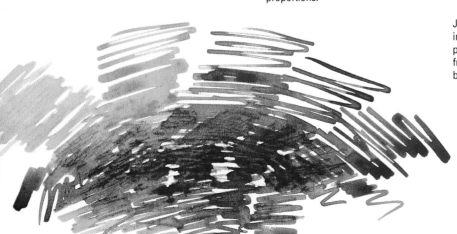

A CREATIVE AND RHYTHMIC RESULT

The line, which suggests the outline of the shapes, can become the ideal complement to provide greater graphic variety to a work done by superimposing spots of colored ink. The stroke suggests materials and shapes beyond the obvious depiction, which is appropriate for creative and non-academic representations. One must be careful to avoid creating a detailed and minute depiction in order to achieve a free and gestural tracing.

The lines done with acrylic ink in this case are key for bringing out the shape on top of a few chromatic stains made from washes.

Allow yourself to make gestures freely, without reflecting or correcting. This produces a stroke that is almost calligraphic—intense, electric, and capable of transmitting great vital energy.

1 Drawing done directly with a jar of sepia-colored aniline by extracting the ink with the nozzle.

2 It is completed with new applications of acrylic ink, distributing the sienna color with a dropper that has a built-in stopper.

1

2

On wet paper, you can do a simple abstraction exercise with colored inks and anilines.

Experimenting WITH INK

Departure from traditional drawing techniques—mixing ink with other media to achieve greater chromatic variety or interesting texture effects—is a source of great interest for enthusiasts of less figurative painting and those who seek expressive results with more effects.

RANDOM SHAPES

When applying one of the liquid inks, if you choose, you can leave part of the creative process up to chance. This way, the result won't be dependent upon what you do on the paper, but will result from the intentionality (somewhat random) of the wet-on-wet washes. These can form textures or color displacements that not only break apart the homogeneity of the pictorial surface, but also add an interest that is organically supported. In these cases, the color and its mixes become the true protagonists of the work.

INK AND OIL PASTEL

A monochromatic drawing is done with Chinese ink on white paper. Brush applications and stroke hatchings done with a metal pen nib or reed pen can be combined. The ink is allowed to dry completely and is then colored with oil or wax pastels. Given the translucence of the strokes done with these colors, the black Chinese ink remains visible under the oil pastel layers.

Black Chinese ink is mixed with watercolor to obtain faded spots and drops.

1 We apply layers of colored oil pastel over the drawing done with black Chinese ink.

2 The translucent nature of the oil pastel strokes means they won't hide the intense strokes of the underlying black ink.

TEXTURES WITH PARAFFIN

Pastels can be combined with Chinese ink washes with a paraffin candle, which serves to create resists or enhance the engraving on the paper's surface. You can simply rub the support with one end of the candle to get the paraffin on the parts that protrude most. Then, when you paint over it with ink, the areas covered with wax reject it, leaving clear spaces through which the white of the paper can be seen. To achieve positive results, it is preferable to work on special watercolor papers, since they have a certain relief on their surface.

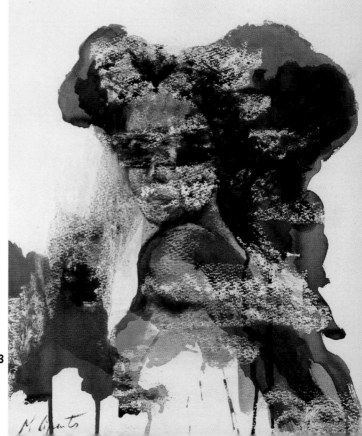

1 The details or finer lines are applied by preparing a resist with a stick of white wax.

2 The granular texture is achieved by rubbing a candle— that is, a stick of paraffin—on the paper beforehand.

3 When we apply the ink on top, both the wax and the paraffin reject the wash, leaving the areas where it has been applied white.

DRAWING WITH MARKERS

Invented in the twentieth century, the marker is the drawing medium most recently adopted by artists and designers.

The finish of marker drawings may vary depending on the ink used, but it tends to be semi-opaque or transparent, with a noticeable brightness.

It's a good idea to have a range of different colors to avoid mixing as much as possible.

COMPOSITION

A marker is a plastic or metal cylinder that contains a synthetic-fiber sponge soaked in ink. Surface tension causes the ink to rise to the tip of the marker, through a mix of felt or polyester scored through with minute holes that allow the ink to flow from the inside to the end of the tip.

QUICK DRYING AND STROKE CONTROL

Marker technique is delicate and complex; however, it provides an enormous number of creative possibilities in the representation of any kind of model, on par with the most traditional drawing methods. It is a very efficient and practical medium for creating colored or black-and-white sketches. The ink dries in only a few minutes and allows for a rapid control of the stroke and coloring of broad surfaces in a clean and uniform tone.

Inside, the marker has a wick soaked in ink that is in constant contact with the felt tip.

Water-soluble markers are applied with opaque strokes. They are the only markers that allow the artist to work on colored surfaces using light colors.

JUXTAPOSING PARALLEL HATCHING

The range of professional markers offers a wide selection of colors with different tones of the same color. The most common way of working with them is to draw more or less compressed parallel hatchings. The colors that are of the same scale or that are very close on the color wheel can be mixed very subtly to create fadings, smooth transitions of one color to another.

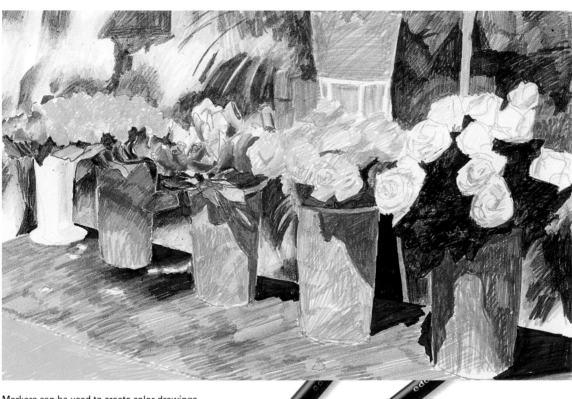

Markers can be used to create color drawings that are vivid and bright.

Colors that are close in tone can be mixed in a very subtle manner, creating light fadings.

SOME TECHNICAL CONCEPTS REGARDING
WATER-BASED MARKERS

Although markers were originally designed to be used in
illustration or advertising projects, artists found that this medium
was very agile and direct in pure line drawing. It allows the artist to
work quickly with diluted inks without having to constantly reload
the tip, as is the case with reed pens or pen nibs.

EACH OBJECT'S OWN COLOR

Working with markers is similar to working with colored pencils,
but the process presents some important differences, especially
with regard to the initial drawing or structural sketch. Using a
darker color for the drawing, such as a gray or black, can end
up distorting the final chromatic effect if the color showing
through is too visible.

1

2

1 A natural color is used when outlining
with markers so that the outline will
integrate well with the drawing as a whole.

2 In the first drawing lighter tones are used
by the artist, who works in synthesis without
working on the details.

3

3 As the work
progresses, strokes
with darker colors
are incorporated,
underlining or
completing the
previous work.

WORKING FROM LIGHT TO DARK

It is advisable to follow a certain order when coloring. First, begin with the lighter colors; with smooth, uncontrasted tones we can sketch out the shapes. Then the intermediate tones are applied through hatchings of tight strokes. On top of this base of color, new hatchings of darker strokes are overlaid. We follow this order because light colors are very transparent and do not cover the dark ones.

1 Once the drawing has been resolved with different earth and pink intensities, we work on the medium tones and contrasts with the darker colors.

2 The broad color areas are covered with parallel hatching or stroke hatching, which can then be slightly diluted by passing a moist brush over them.

1

2

DRAWING WITH WORN-DOWN MARKERS

If a marker gets worn down, do not automatically throw it away. When the ink has run out, it is clear that it will longer provide a uniform, intense, and well-pronounced stroke. Even so, worn-down markers offer a faint, blended, and smoother stroke that is usually used to achieve very smooth shadings, or stains with little coverage done with an undistinctive line, with blended edges.

1 Worn-down markers provide an incomplete, spongy, and semi-transparent stroke reminiscent of that provided by some drawing techniques, including charcoal.

2 The strokes are spongier, less full, giving the drawing a relaxed and blended personality.

1

2

Markers made from an alcohol base offer the greatest chromatic variety. In addition, they also have a variety of tips with sizes and shapes that are suitable for different strokes.

Alcohol-Based MARKERS

Alcohol-based markers have a fiber tip that is sold in various thicknesses.

The mixes are direct and the strokes can be overlaid on top of each other to achieve more opaque hues.

WORKING BY ACCUMULATION OF TONES

The ink used in the markers generally comes from a colorant diluted in an alcohol called xylene, which evaporates and dries quickly. Once dry, its color is indelible, which is why it is not diluted in water. As a result, the artist can usually work on overlaying different chromatisms without causing mixes or displacements. The tones are usually fairly transparent, which is why these markers offer their best results when used on white surfaces, as they give a suitable brightness to each color. There is one inconvenient aspect: They do not tolerate sunlight well and discolor if they are left exposed to it for some time.

The wide stroke produced by the marker's beveled tip allows the artist to cover wide color areas with a simple hatching of tight strokes.

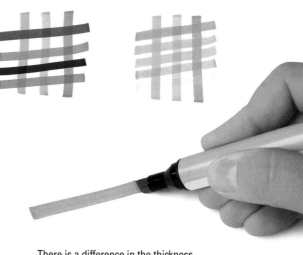

There is a difference in the thickness of the marker's stroke depending on whether the artist uses the flat, beveled side, or the end of the sharpened tip.

A. The superimposition of fine layers of colors is appropriate when working with alcohol-based markers.

B. Mixes done by overlaying colors vary depending on whether the light color is laid over the dark one or vice-versa.

OVERLAYING BY TRANSPARENCY

The most common way of working with markers is to overlay spots of transparent colors, one over another. This technique is most highly recommended for artists using colors in the same scale or trying to darken a color. The tone of the markers does not depend upon the pressure applied by the artist or the thickness of the stroke, and as a result, each color can have only one intensity. For this reason, we need an assortment of scales wide enough to achieve various hues of each color.

One of the alcohol-based models available is the double-tip marker, which is characterized by the great stroke versatility it offers.

Used with energy and vitality, strokes made with markers are halfway between colored pencils and ink drawing.

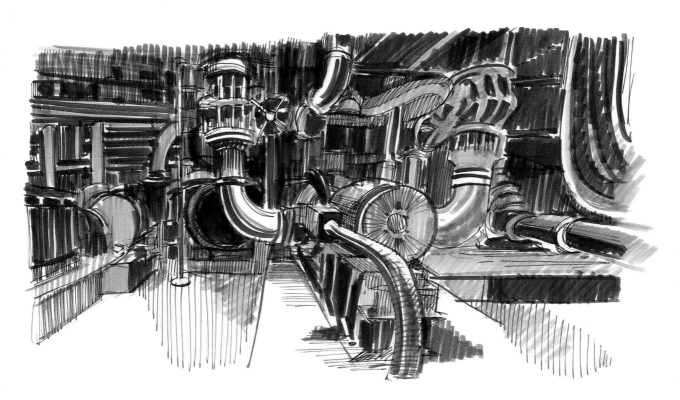

Water-soluble markers provide effects that are similar to those of watercolor if the artist simply passes a moist brush over them.

Like water-soluble pencils, markers with water-soluble ink produce results similar to those of watercolor. Nevertheless, in the case of markers, the ink is much more intense and less transparent, as well as less suitable for wash effects. Let's take a look at how they should be used to get the best results.

Mixes with water-soluble
MARKERS

DILUTING STROKES

Water-based markers can be diluted by simply passing a wet brush over them. Using absorbent paper is recommended because it facilitates a quick fixing of the color to the surface. The method is simple: It consists of drawing a model based on lines and strokes, and then gently passing a moist brush over the strokes so that the marker's ink comes off, forming washes.

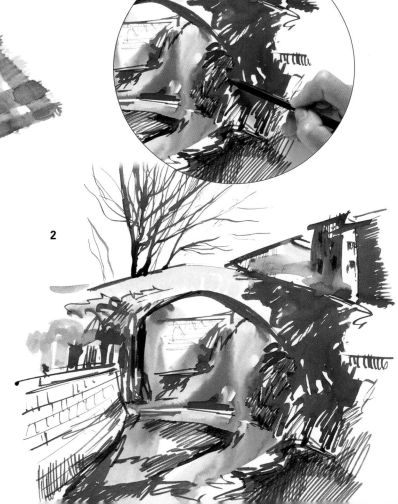

Water-based markers can waterlog or mottle paper that is not absorbent.

1 Drawing with markers is similar to using ink or watercolor washes.

2 Strokes made with water-based markers, whether unalterable or saturated, are an excellent complement to watercolor spots.

LOCAL DILUTIONS

By combining strokes and washes, you can work with markers spontaneously; we try to allow the ink captured in the strokes to be released and slide freely along the surface of the paper, creating interesting glazing and areas where the color of the wash is distributed irregularly. Just one piece of advice: The dilutions should be localized, and it is not advisable to apply too much water when attempting to extend the color. You should also not go over the marker strokes too much with the brush, as you run the risk of completely removing them or even ruining the paper.

Range of strokes done with markers and water-color spots, used to create the landscape reproduced below.

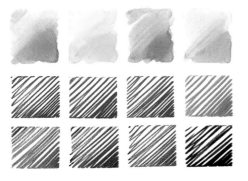

Brush watercolor smooths the hardness of the marker's stroke and unifies masses of color.

Rural scene done with water-soluble markers. Despite the action of the moist brush, the marker's stroke should not be completely diluted.

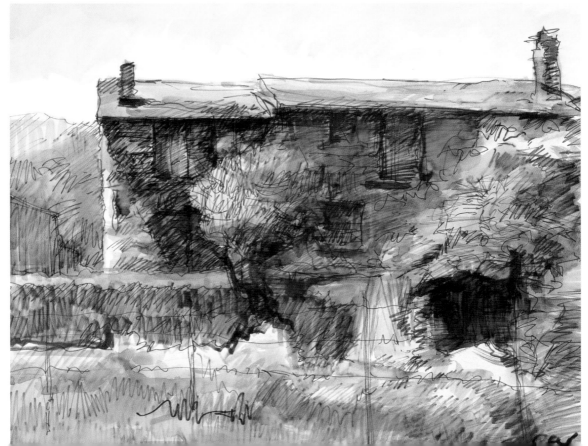

Other DRAWING TECHNIQUES: CREATIVE AND CONTEMPORARY

When amateur artists begin drawing, they try to be as to be as faithful as possible to real life; over the years, however, the artist's objective will be to experiment and find the keys to their own language, to obtain a personal, untransferable style. For this reason, we end this first part of the book dedicated to drawing by noting some resources that all artists can use to explore their own creativity.

A very creative representation is achieved by combining different-colored cuttings of silk paper with simple strokes in black Chinese ink.

COLLAGE AND BLACK INK

It is possible to transform the representation of a traditional still life by creating a collage of colored silk paper, such as the one at top left. These colors are not shaded and modeled; rather, they are abstactly applied, expressionistically vivid, and very saturated. After gluing the cuttings with latex, we allowed the glue to dry completely. With a reed pen or fine brush we drew the model with a rhythmic, sure stroke, seeking a certain degree of deformation.

MARKERS, CHINESE INK, AND REED PENS

The loose effects of markers allows artists to pursue a more emotional and dramatic approach as opposed to more classical, realistic representation, in. Here, in an effort to produce the color base, we have created a still life with markers and a few strokes of dry pastel. Then, the outlines were insinuated with fine strokes of Chinese ink applied with a reed, emphasizing the shadow under the plate with the tip of the reed completely inclined.

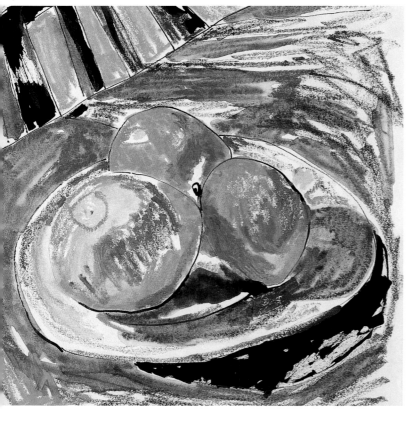

In this drawing, the dynamic strokes of markers are combined with the pronounced lines of Chinese ink.

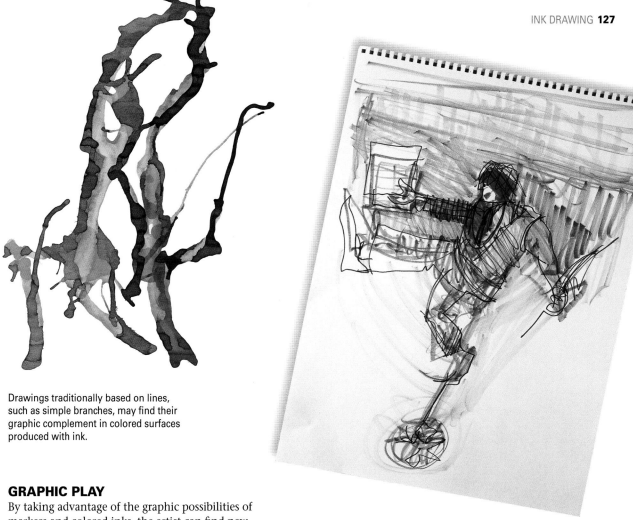

Drawings traditionally based on lines, such as simple branches, may find their graphic complement in colored surfaces produced with ink.

GRAPHIC PLAY

By taking advantage of the graphic possibilities of markers and colored inks, the artist can find new creative ways to explore expressivity. You can seek different solutions that are more graphic and less classically representatational. As a general approach, we should note that creative exercises are generally based on the synthesis of exaggerating or abstracted shapes and expressionistic colors and/or media application.

The combination of water-based markers with markers and fine strokes of permanent black marker offers a field of graphic study that is seldom explored.

Plant representation treated with a very minimalist approach, with brief, striated, and gestural strokes done with Chinese ink and a wide spalter.

TECHNIQUES PAIN

TING

Painting media have always been much more diverse and complex than drawing media. This greater diversity is the result of the many possibilities of mixing offered by colors and the variety of binders and different techniques that increased significantly during the twentieth century, thanks to the emergence of media unknown until then—among them, acrylics or synthetic paint. As a result, contemporary artists have a wide array of colors, supports, and tools of different qualities that did not exist prior to the industrial era. This section provides a complete compilation of materials and techniques that make up an extensive guide necessary for any artist.

The basic concepts that govern all painting work are closely related to color and composition. Color has its own logic, which the painter must be familiar with and adapt to his or her intentions. The composition imposes order on chaos, and allows for every chromatic application to make sense in relation to the whole.

*P*ainting cannot be understood without the comprehension and exploration of color and its immensely varied applications: the delicateness of watercolor, the creaminess of oil, the versatility of acrylics, and the immediacy of gouache.

However, to delve deeper into painting, it is necessary to go back to its origin: to the knowledge of pigments, materials, and techniques that formed part of the experience of our predecessors, who, in spite of not having access to today's technology, perfectly mastered the materials they used in the painting process.

Therefore, before delving into the chapters dedicated to painting procedures, it is necessary to have an overview of pigments, their properties and qualities, and their importance in the manufacturing of colors.

KNOWLEDGE of PIGMENTS

Since time immemorial, artists have found suitable coloring media in nature. They began by finely grinding clays and earth of different colors until they produced a powder that could be mixed with a binder and worked with a brush.

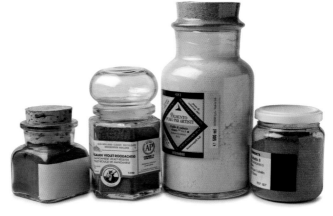

Jars of pigments for artistic painting that are sold in fine arts stores.

PIGMENT, THE BASE
OF PAINT

THE BASE OF PAINT

Pigments are the base used to create any color imaginable. Different from colored inks or anilines, pigments are finely ground colors, minute particles of material that do not dissolve in the medium, but rather become dispersed throughout it. The pigment is well mixed with the medium before being used to ensure consistency of the color—that is, the same level of dispersion.

THE ORIGINAL ELEMENT

Pigments are used to manufacture paints of all kinds, both industrial and artistic. Paint has two basic components: the vehicle and the pigment.

The vehicle, or emulsifier, is mixed with the pigment and provides fluidity and resistance, and it affords the sliding properties of the paint's covering. The painting procedure depends on the vehicle. This way, by mixing pigment with gum arabic and glycerin, we can produce watercolor; mixing it with flax oil, we produce oil paint; and finally, if we mix it with highly polymerised resins, we produce acrylic paint. Thus, pigments are the original element, the base of all paints.

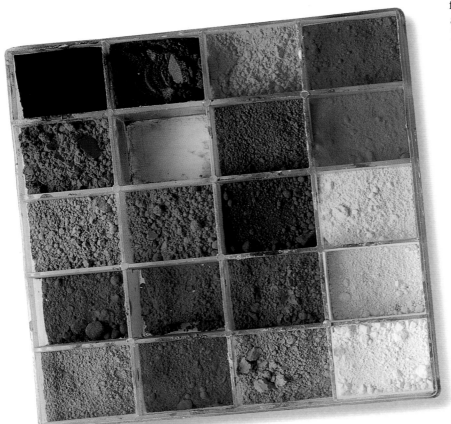

Powdered pigments are the raw material that nourishes all paints.

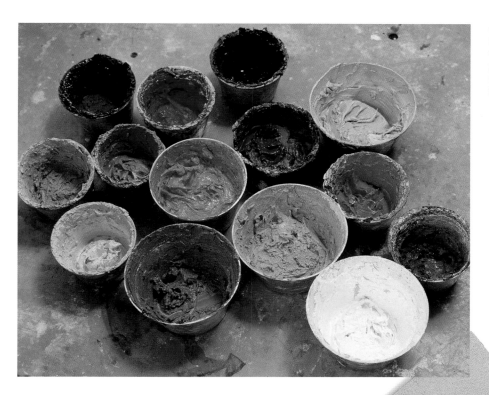

Once mixed with the binder, the pigments take on a characteristic pasty consistency that leaves them ready to be used.

PAINTING WITH PIGMENT

To paint soft, smudgy areas, you can just apply a cotton ball coated in powdered pigment. The smudges can be controlled by using the well-cut edge of a piece of paper or cardboard. This way, you prevent the pigment particles from crossing the borders of the reserve. The result is a smooth, faded tone with a sharp edge.

The application of pigment with a cotton ball smooths out the tone transitions, creating fades.

Smudges can be directly applied with the powdered pigment using a cotton ball and a paper edge for the resist.

Pigment TYPES

Almost all pigments sold in fine arts stores can be found in powdered form. Pigments are divided into two large families or groups: inorganic and organic. Paints in either group can be natural or synthetic.

INORGANIC PIGMENTS

Among the inorganic natural pigments, we can find all of the earth colors (siennas, reds, ochers, slate grays), as well as mineral pigments, which are less common than the former and include vermilion and malachite green. Inorganic artificial pigments are produced in laboratories; some of them, for example Naples yellow, have been used as long as natural ones.

ORGANIC PIGMENTS

Organic pigments have a plant or animal origin. Traditionally, the painter's palette was mostly composed of these kinds of pigments, but only a few have withstood the passage of time. The most well known are ivory black, which is produced by the calcination of bones, and Indian yellow, which was obtained from cow urine. During the nineteenth century, many organic pigments ceased to be used and were replaced by other, synthetic organic ones. Advances in chemistry provided an uncontested boom to the extent that today, the majority of pigments are created in labs.

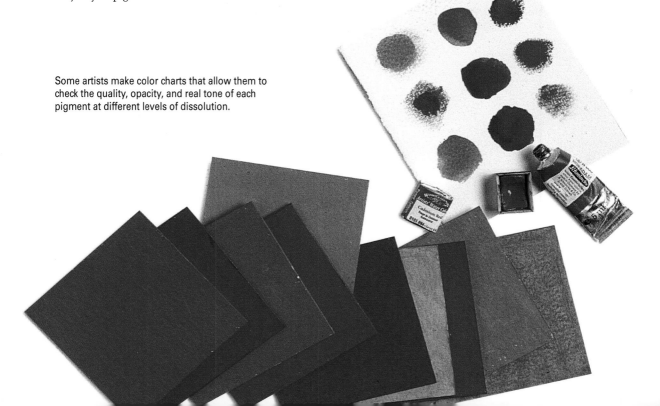

Today's powdered pigments are mainly produced industrially, which makes it possible to have an extensive color chart with well-differentiated tonalities.

Some artists make color charts that allow them to check the quality, opacity, and real tone of each pigment at different levels of dissolution.

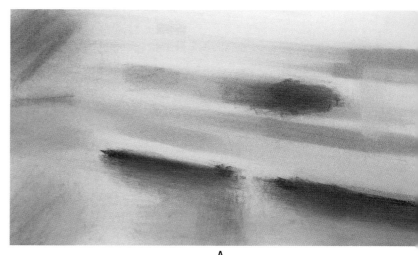

A

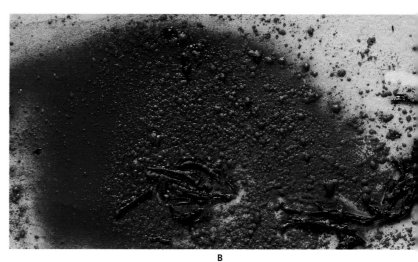

B

HIGHER QUALITY AND LESS TOXICITY

The industrial and scientific revolution triggered a great expansion in the range of synthetic pigments, which are produced or refined from natural substances subjected to chemical processes or heating. During the twentieth century, the quality of many of them was improved, and paints with high degrees of toxicity were removed from the market, especially pigments derived from lead.

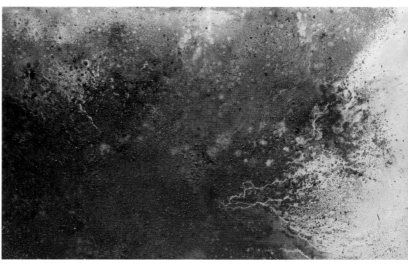

C

A. Interesting harmonization of colors done on paper with powdered pigments applied with a cotton rag.

B. Some contemporary artists apply the powdered pigment directly on the cloth; it remains attached due to the latex, oil, or gel that covers it.

C. Powdered pigment can be lightly powdered over a moist painting surface to achieve interesting color fusions with granulated effects.

Manufacturing OF PAINT

The quality of a paint is determined by the performance of each of the pigments that compose it: its opacity, covering quality, and stability under light. Many of the watercolor, oil, and acrylic colors on the market hide an excess of fillers that diminish the pigment's quality (especially calcium carbonate, the most common filler due to its low cost). For that reason, many professional artists manufacture their own paints from original pigments, to ensure that they have high quality paints.

Fine arts stores sell all kinds of pigments that allow artists to manufacture their own paints with the combinations best suited to their way of working.

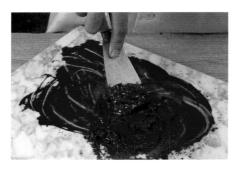

If you don't have a flat pestle to make paint, a flat metal spatula can be used.

COMBINING THE PIGMENT WITH THE BINDER

Paints are pigments bounded with different media. The medium added to the color determines the type of the resulting paint. To present the paint manufacturing process, we'll take oil as an example. First, we deposit a large amount of pigment on a smooth surface. We make a cavity in the center of it and pour the purified flaxseed oil inside. It is better to use the smallest possible amount of oil, as its capacity to bind pigment is much greater than it may seem at first glance. Next, we work the pestle over the oil and pigment by making circular movements until the paint takes on an even consistency.

1 A mound of pigment is deposited on a slab of marble, forming a volcano, and a bit of purified flaxseed oil is added in the middle.

2 With a flat pestle, we apply force, making circular movements, until the two components are united.

1

2

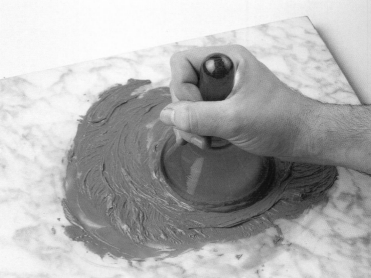

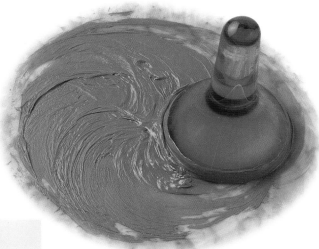

3

3 We continue mixing the pigment with the binder until the paint takes on an even consistency.

4 Once the color is done, we place it into tubes that were previously moistened with glycerin alcohol, and we then close the tubes with pliers.

4

ALUMINUM PAINT TUBES

When the paint has acquired the necessary consistency, it is picked up with a spatula or palette knife, which is used to fill a plastic godet in the case of watercolor, a glass jar for gouache, or an aluminum tube in the case of oil, acrylic, or even watercolor. Paint was first put in tubes (originally tin and zinc), like the ones we have today, in 1840, at which time the process was industrialized. Today, tubes are the most popular container for paint. When the format was invented, it gave artists great liberty because it allowed them to save time and to easily transport the tubes in a small suitcase for painting outside.

The paint tube has become the most popular container for storing paint, given its good paint conservation and portability.

PAINT QUALITY

Currently, many natural pigments have been replaced by synthetic pigments, although in some cases the original name has changed. In some cases, less expensive synthetic versions are available, called "hues."

PAINT REFERENCE

On paint tubes and jars, most manufacturers specify all of a product's information: what pigments the color was made with, its permanence (stability over the passage of time), resistance to light, opacity, etc. Reading an oil or acrylic paint tube, for example, we see a set of names, references, and symbols that are used to explain the pigment's reference, the name of the binder, and the characteristics of that specific color.

Tubes include a great deal of information about the pigment and characteristics of the manufactured paint.

Symbols of opacity: transparent, semitransparent, semi-opaque, and opaque.

The pigment reference used in the manufacturing of a watercolor paint tube is located on the back.

RESISTANCE, PERMANENCE, AND OPACITY

A paint's resistance to light is indicated with the + symbol. Thus, ++ equals between 25 and 100 years of color solidity under museum lighting, while +++ guarantees a minimum of 100 years. The information referring to opacity/transparency is important to the painter for the execution of certain techniques, for example, in applying glazes. Opacity is indicated by a square symbol: When a square appears in white, it means that the color is very transparent, while the black square represents maximum color opacity. In addition, there are two intermediate levels, semi-transparent and semi-opaque, which represent the square divided into two halves.

Watercolor paint pans have their color characteristics printed on the paper wrapping.

This watercolor paint manufacturer's color chart has hand-painted color spots so that each sample coincides with the real color.

The painted sample is a more trustworthy reference than if the color were directly printed on the paper.

COLOR CHARTS

Color charts are the sample books containing all of the colors that a brand manufactures. They constitute an essential guide for selecting the artist's desired tone. Although today the majority of manufacturers distribute printed color charts, the ones that produce high-quality colors provide hand-painted charts to avoid the tonal differences that appear in mechanical reproductions.

If you are going to paint with a wide array of paints, it is better to get most of them from the same manufacturer if possible, to avoid creating undesired reactions among the chemical components of different brands.

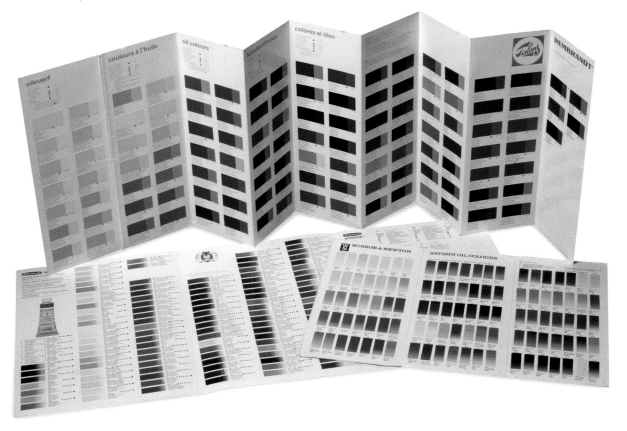

In watercoloring, the fluidity of the paint is as important as the direct mix between colors. It is applied by barely applying pressure on the brush, making skillful strokes with the hand.

Watercolor is the most subtle of paints. Its main attraction is the transparency of its colors, which makes it a fresh and very bright paint. Due to its nature and the ease with which it dissolves in water, watercolor is the perfect medium for capturing the subtlest light hues and tones. It is a very attractive medium because of its immediacy: It lends itself to looseness and spontaneity as few others do. Although it is of a fragile and humble nature because of the simple equipment that it requires, it allows the artist to create paintings of great beauty and presence.

In this section, we have also included gouache colors, which are very popular among many designers and illustrators and which share ingredients similar to those of watercolor, although they have more body and greater covering power.

WATERCOLOR AND TEMPERA EMULSIONS

Watercolor paints are manufactured by mixing powdered pigments with gum arabic and, in lesser proportions, glycerin, which acts as a plasticizer, taurine (an emollient), and even gum tragacanth to give it more consistency.

Types of watercolor:
PANS AND TUBES

In the studio, many watercolor artists use plates and other ceramic containers to mix colors.

Watercolor pans are ideal for working on medium and small formats, and are easy to carry.

Watercolor tubes are recommended for working on large formats.

PANS AND TUBES

Quality watercolors are made in tubes and pans (also known as "godets" in French). We recommend using tubes when painting in large format, as they allow the artist to work with abundant color, although the amount of paint wasted in each session is greater than with pans. The advantage of pans is that we always get the right color, but on the other hand, it is very difficult to get a generous amount of paint, and the brush suffers from repeatedly being rubbed against it. Pans are compact, and they're easy to carry and store, but they do not allow for working with large brushes or paintbrushes.

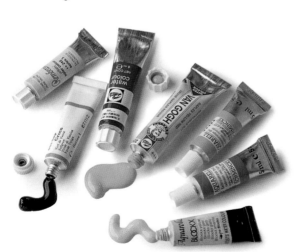

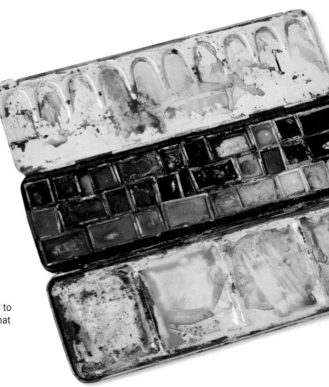

The boxes that contain the watercolor tablets tend to be used as palettes, as they offer a large surface that is suitable for mixing.

The watercolor artist must always have a test paper on which to check the color mixes and the wetness of the brush.

PALETTES

Watercolor pan or tube sets are often sold in metallic boxes that are also used as palettes. These boxes are made of white enameled iron and have a series of sections or concave cells inserted in them that allow the artist to mix the different colors separately. When you don't have a conventional palette or want a complement to it, you can use the white ceramic or porcelain plates. It is important that the surface on which the watercolors are mixed be smooth, impermeable, and a suitable platform for color assessment.

TESTING PAPER

In watercolor, the colors are frequently not well evaluated until they are applied to the paper.

Before beginning to apply the diluted paint on the watercolor paper, many professionals use a piece of paper of the same quality to test the result of the mixes. This is a good idea because very frequently the mixed colors are difficult to assess until they have been applied to the paper.

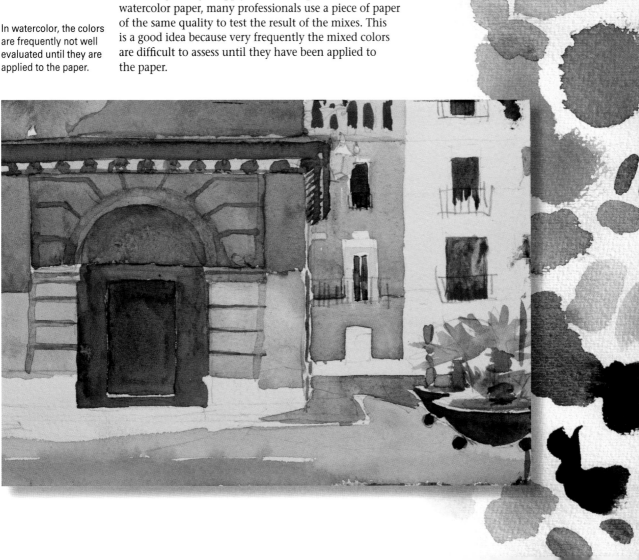

Brushes and APPLICATIONS

All artists must expect certain qualities from their brushes: good capacity for water absorbtion and retention, flexibility and ease in recovering their form after the brushstroke, and the ability to be used for dotting or stroking without having their bristles become disheveled. The effectiveness of a brush is determined by the quality of the materials used in its manufacturing.

Professional watercolor artists usually have a limited selection of brushes of different sizes and shapes. They must be very manageable and versatile, and offer a variety of different strokes.

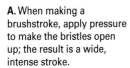

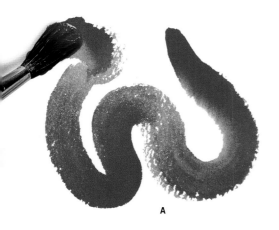

A

BASIC ASSORTMENT

Painting with watercolors does not require many brushes, since just one brush allows for many stain and stroke possibilities. Brushes made of sable and squirrel hair are very spongy and can load an abundant amount of water. Ox hair is the best for dotting and a good alternative to other brushes with more expensive hairs. The synthetic ones are the most affordable; however, they are more rigid and have less loading capacity. Finally, wash brushes—typically hog bristle—are suitable for applying very broad washes thanks to their high loading capacity.

A. When making a brushstroke, apply pressure to make the bristles open up; the result is a wide, intense stroke.

B. Applied on its side, a flat-tipped brush provides gashed brushstrokes that facilitate the creation of straight lines.

C. If a brush that is loaded with diluted paint is applied by increasing and reducing the pressure exerted on it, the thickness of the brushstroke is modified.

D. Flat brushes offer a stroke of stable thickness, provided that their tip is not rotated and is applied completely flat.

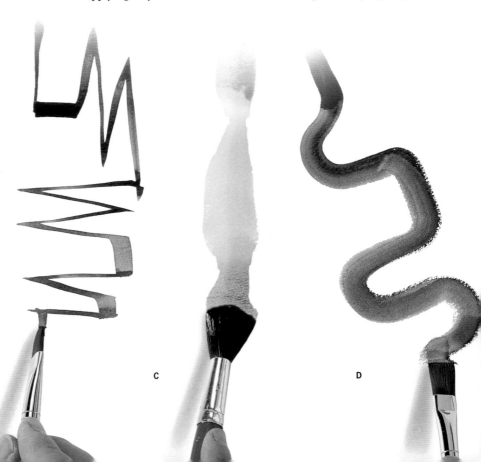

B

C

D

Wash brushes provide a wide brushstroke. They are used for quickly covering large surfaces.

The same brush offers the possibility of achieving different spots and applications. The variety depends, basically, upon the tilt and pressure exerted on the bristles on the paper.

The form of the bristles, the type of hair with which they are made, their angle, and their ability to hold paint determine the shape and intensity of the brushstroke.

APPLYING WASHES

Having gone over the basic materials, it is now time to practice the washes. The process is simple: The brush is loaded with one color and is applied over the paper, spreading the paint with water. The color accumulations that remain in the lower part of the moist stain can be eliminated by passing a dry or almost-dry brush over them.

CONTROL OVER BRUSHSTROKE

The importance of the brushstroke in watercolor is such that it is worth practicing in and of itself while checking how the pressure and movement of the hand immediately affect the appearance of the stain on the paper. By applying pressure to the brush's bristles, we can achieve thick, water-loaded strokes, while with less pressure the strokes are very fine and dense.

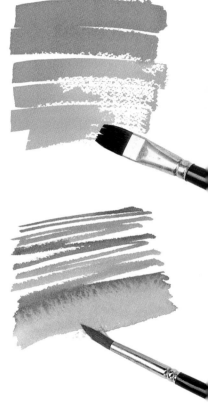

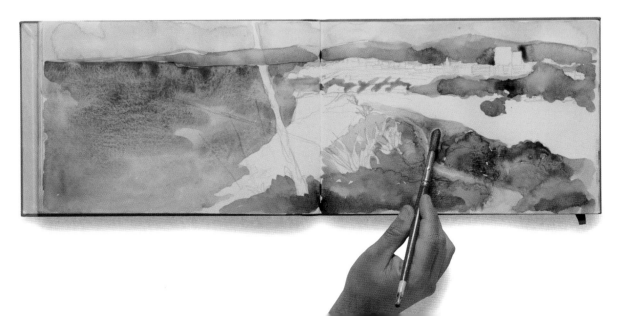

WATER CONTROL

Using watercolors is inseparable from the control of water when the paint is diluted. Water doesn't just dilute the colors—it is also the basic means of applying and tinting the paint. Watercolor technique can be studied in terms of the amount of water added to the process, from most to least.

WATERCOLORS WITH GRADIENTS

Gradients are soft transitions from one to various colors ranging from the lightest to the darkest tone. They are common in the creation of landscapes and tend to be used to create distant background elements and skies. Just be careful to apply the gradient with a single contribution of color, in a single session. If the process is done in numerous stages, the wash will appear to be choppy, with abrupt changes in tones.

A

A. To obtain gradients, it is sufficient to add water as the brush slides down the paper in order to reduce the intense shade of blue.

B. A gradient with two colors can be made by painting with the brush until both parts meet in the middle.

B

WATERCOLOR WITH DROPLETS

More than any other pictorial medium, watercolor depends on the diluent. The use of water and moisture, the drainage, and even the drops produce a result with unmistakable vitality. The droplets and the deliberate splatters invade the lower part of the work with a design of dynamic lines that marks the upstream of the composition.

The application of gradient stains of color between one or several colors is fundamental in the representation of the landscape.

The first applications of watercolor are very fluid and transparent. They settle the base of the colors and reduce the whiteness of the paper.

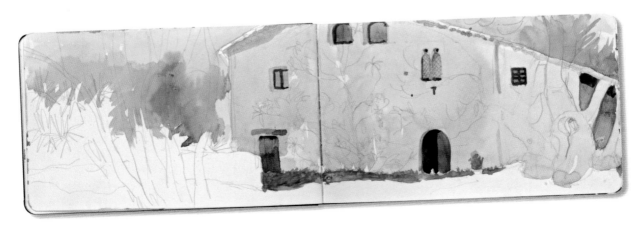

The control of water in watercolor allows for interpretations where the bled and dripped paint acquires an unusual graphic force.

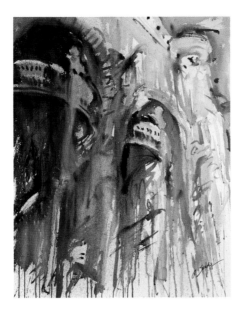

Clay-based earth colors and iron oxides enable them to leave traces where the grain of the pigmentary particles can be seen.

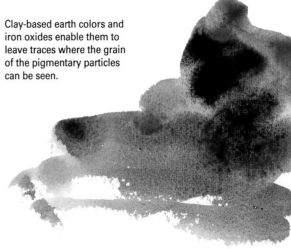

A distinctive feature of ultramarine is flocculation of the particles of pigment, which creates a sort of grittiness at the bottom of the stains.

GRANULATION AND FLOCCULATION

Some pigments may have a finish that's different from watercolor wash. In oil paintings, these differences disappear due to the stabilization of this medium, but with watercolor, the characteristics of each pigment are seen more clearly. One of the clearest effects is granulation: When the wash dries it creates a clear mottled effect. This happens with manganese blue and some earth colors. Another interesting effect is flocculation, i.e., the pigment particles tend to become joined, forming groups or lumps that produce a texture that's very characteristic of washes.

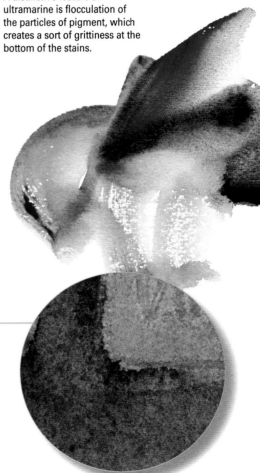

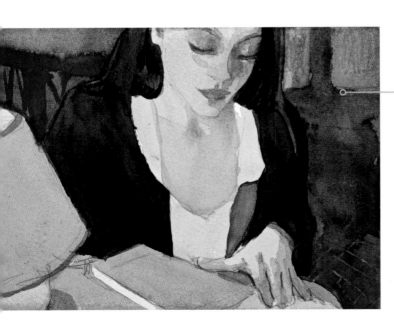

The watercolor granulation effect is clear in the background of this work, carried out with brownish-gray colors.

Simple monotones
AND DUOTONES

This watercolor technique consists of developing various shades of one or two colors. It is the heir of ink washes, but with the final finish of watercolor pigments. When the possibilities of this technique are understood, it is much easier to approach complex and colorful techniques.

A SINGLE COLOR

Prior to painting with all the colors, it is advisable to begin with the rudiments of the wash technique with watercolors of a single color. It is preferable to work with dark tones that allow for a very spacious, clean, and defined scale of values in each of their intensities. Monochrome work, therefore, is a good method of calligraphing light with the tip of the brush by gradually diluting paint as the work progresses. Payne's gray, dark ultramarine blue, and sepia brown are some of the colors preferred by watercolorists to perform this type of exercise.

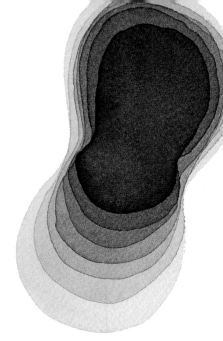

When working with monochrome watercolors, the effect of the overlapping of glazes makes it possible to progressively darken these areas.

Gradients of the same color are readily available once a few dark brushstrokes have been applied: It's sufficient to work on the stain again by applying the brush dampened with water only.

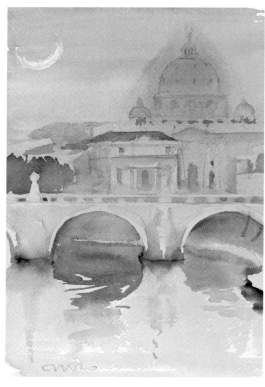

Before beginning to paint, it is advisable to develop a simple tone scale, remembering that the greater the dilution of paint, the lighter the gray will be.

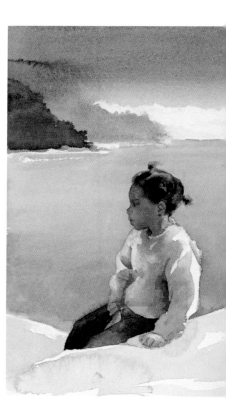

The saturation and smoothness of Payne's gray adds a high level of purity and graphic definition to the stains.

WATERCOLOR WITH TWO COLORS

Painting with only two colors is a good exercise to learn how to develop values and shades, by adding more or less water to the color and mixing both colors with thin glazes or the fusion of gradients. The best approach is to make an initial application to the model with a single color that is allowed to dry. Then the second color is overlapped. The overlapping of both colors on the medium creates an interesting temperature contrast and great tonal richness.

A B

A. Two colors can be mixed on a wet surface to allow the artist to see which is dominant; in this case, it's the ultramarine blue.

B. It's also possible to mix the colors by overlapping glazes.

1 The model is initially assessed with ultramarine watercolor. This technique is used by many watercolorists who paint outdoors, to fix the shadows.

2 The second color, a yellow ocher, is applied with translucent stains or glazes. The contribution of this color modifies the initial blue stains.

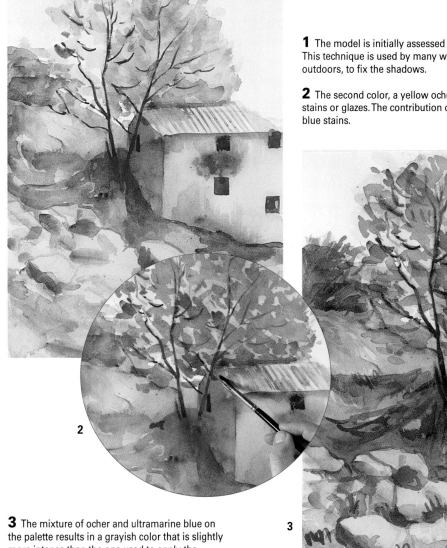

1

2

3 The mixture of ocher and ultramarine blue on the palette results in a grayish color that is slightly more intense than the one used to apply the texture of the nearest vegetation.

3

Painting with watercolor does not require any great tricks *or the development of complex blends or gradients with a large number of colors. This technique offers very good results when applied in the form of uniform stains, because the strength of the painting lies in the color itself and in the luminosity provided by the transparency of the paper.*

FLAT WASHES

If applying very large, flat washes, it is best to prepare abundant color in a cup in advance. This guarantees there will be plenty of color to make a homogeneous wash.

UNIFORM WASH

A flat wash can be achieved by using the same tone at all times, thereby creating a uniformly colored surface without chromatic alterations or stroke marks left by the brush. When these homogeneous washes are applied on dry paper, pigment particles tend to become evenly distributed, forming (when dry) a flat area of color with a well-defined stain contour.

PREPARATION IN CUPS

Uniform color washes are applied with a soft-bristle brush or a wash brush with high absorption capacity. If working on a medium or large format, it is advisable to prepare plenty of color in a cup to cover the area in one session, so as to not leave the wash half-done; this will prevent cutoffs that disrupt the homogeneity.

Adding more water to the paint will lighten the tone.

Watercolor does not require excessive mixtures. A few more or less uniform watercolors are enough to be effective.

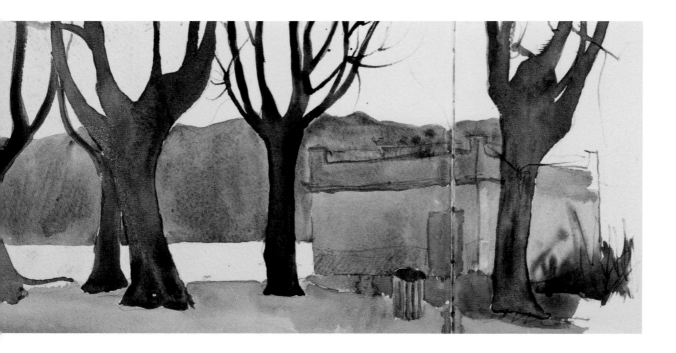

Each of the background elements of the landscape is created with a monochrome wash, thereby creating an interesting drop scene effect.

Accumulations of color contained in the spots after lifting the brush from the paper (A) can be removed by touching the lower part of the wash with the tip of the dry brush (B), as it will absorb them.

A

B

BLUE SHADING

It is common for many watercolorists to first paint the shadows of their subject with flat blue washes. This technique provides structure and depth; it also immobilizes the shadows, so you doesn't have to worry about changes in lighting that take place outdoors.

Many watercolorists begin painting with blue watercolor to set the shadows.

WORKING WITH GLAZES

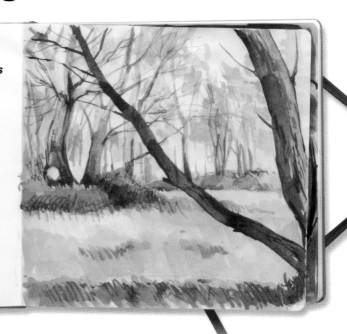

The vehicle or binder of watercolor paintings (gum arabic) is transparent; this is what gives the delightful brightness to colors when they overlap, forming glazes, i.e. a semitransparent coat of color over another already dry layer.

It is advisable to follow this order: First the lighter glazes are placed in the background, and then the more intense ones are progressively incorporated into the foreground.

OVERLAPPING MIXTURES

Glazings are ideal for producing soft tone transitions and deeper shades of color. Whenever two colors are overlapped, at the point of overlap, a third color is simultaneously generated that produces greater tonal intensity ; i.e., when the homogeneously applied color overlaps a dry one, the glazed area becomes darker. Some of the richest color effects come from the purest colors applied in thin, overlapped washes.

DRY GLAZES

Glazes have multiple applications, both to modify a color and to produce a lighting effect. They are always applied on fully dry paper, which allows the artist to control the paint stains. It's easy; one only needs to apply the transparent wash to the paper and shape the stain. The general transition from dark to light is achieved by overlapping the washes in the most shaded areas.

The system for working with glazes is very simple. A first stain is made with a yellowish wash.

Once the yellow applied to the base is fully dry, it is overlapped by a second blue transparent wash.

Carmine is also applied on top of the dry paint, and the three colors are mixed to obtain a glazing effect. The carmine's transparency allows the light that reflects on the paper to shine through.

TRANSPARENCY OF PAINTS

Not all paints have the same degree of transparency. Quinacridone pigments (orange, red, and purple) and phthalocyanine (green and blue) are extremely transparent and voluminous, whereas cadmium pigments (yellow and red), compounds (green and yellow), and iron oxides (red and ocher) are, to varying degrees, opaque. The artist must understand these differences and dilute the colors with more water to obtain more transparent glazes.

1

1 On top of a dry stain of color, a second one is added, which makes it possible to progressively darken the tones.

2 Overlapping the same color glazes densifies the stain, darkens the tone, and produces a deeper and more solid paint coat.

2

1

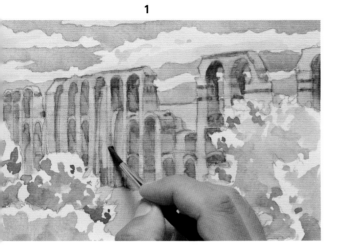

1 Begin a glazing exercise by applying a few blue washes, which give a greater impression of volume.

2 Little by little, the new transparent washes are overlapped with the existing colors.

2

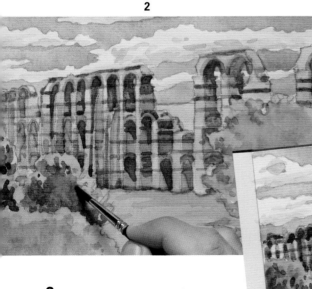

3 In the last phase, the greens from the foreground are given a tonal variety and the architecture's contrasts are pronounced.

3

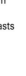

Washing TECHNIQUES

Washing or creating white spaces is an oft-used technique of the watercolorist. This means cleaning out an already painted color spot for the white paper to appear again. It is not only a form of correction, but also a resource for lightening or enhancing light.

OPENING WHITE SPACES ON A WET SURFACE

Opening whites on a wet color stain is very easy: Just press on the selected area with a sponge or a damp brush; these will absorb the color and the white space will open up. Rubbing the surface of the color with a dry brush will also absorb part of the paint and restore the color of the paper.

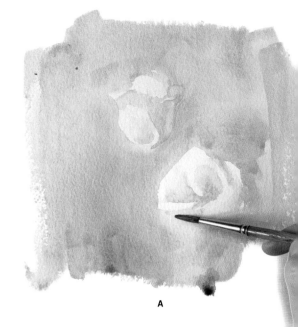

A

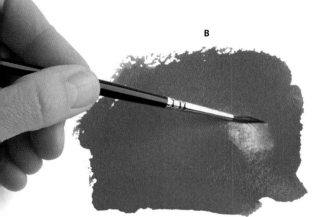

B

A. The tone of the flowers is created by retrieving the white of the paper; the flowers' shapes are formed by applying washes with a damp brush so their outline doesn't fade.

B. By wiping a dry stain with a wet brush, the artist can restore the color of the paper.

DRY WASHES

Reducing the color until real whites open up on a dry surface is not a difficult task. First, wet the brush and then moisten the area to be lightened; wait a few seconds, and then lightly rub the area with absorbent paper or stroke it with a wet brush several times.

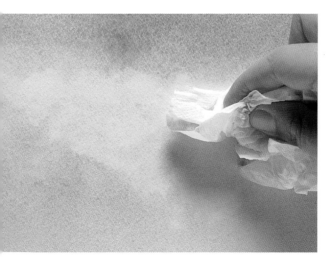

To perform a wash on a dry surface, simply wet the area beforehand with a brush and press with a paper towel or a sponge.

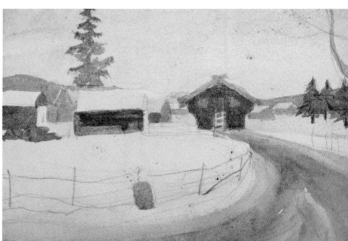

The dry watercolor is fully washed with a sponge, which diminishes the colors' strength and recreates the atmosphere of a winter day.

PIGMENT STAINING

The recovery of the paper's white color depends on each color's staining power. Some paints, including ultramarine blue, barely stain the paper and can be almost completely removed after a deep wash. Quinacridone reds, however, resist removal from paper even when scrubbed with a wet sponge.

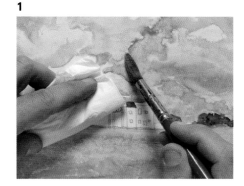

1 Washes with brushes are very common for making skies. The wash lowers the contrast between the blue and the masses of the clouds.

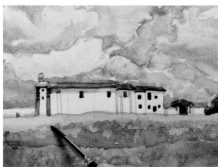

2 The washing effect breaks the uniformity of the color and creates light areas; thus, the colors look "worn."

3 Whitening prevents the sky from appearing too saturated with color, thereby reducing the significance of the main element of the landscape.

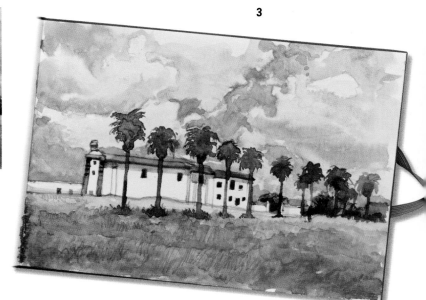

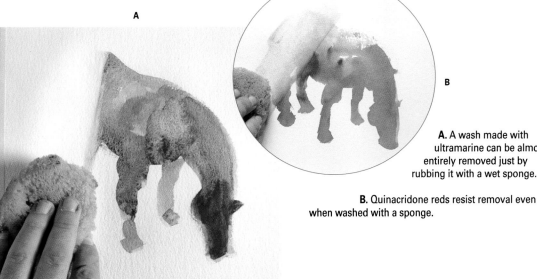

A. A wash made with ultramarine can be almost entirely removed just by rubbing it with a wet sponge.

B. Quinacridone reds resist removal even when washed with a sponge.

With a bit of experience and knowledge regarding the behavior of colors, watercolors can be mixed directly on the paper instead of on the palette. This is known as wet-on-wet *painting, because it is carried out with a first and single layer of interspersed colors.*

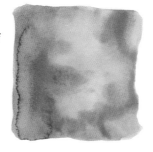

W<small>ET-ON-WET</small> WATERCOLOR

Mixing the colors with direct paint on a wet surface produces highly spontaneous colors.

Mixing the paint directly is very similar to working with gradients; the brush is stroked as the colors are added, without overlapping areas that have already been painted.

DIRECT WATERCOLOR MIXTURES

Working with direct mixtures on a wet surface means that the colors blend in an uncontrolled manner and become a watery veil that creates more or less continuous gradients. This unpredictability makes working with direct blends a much more watercolor-like prospect than painting on dry surfaces or with glazes.

1 The base color, a deep cadmium yellow, is applied first.

2 A second color is applied to the wet gouache—blue with a hint of carmine.

3 The colors are manipulated, allowing them to blend with each other, creating interesting browns and grays. It is advisable to do these tests to see how the colors react.

1	2	3

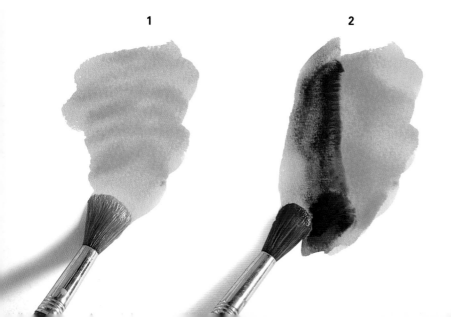
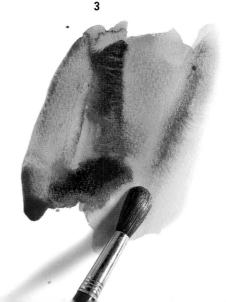

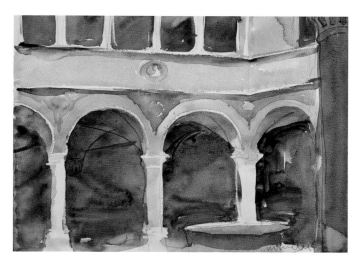

JUXTAPOSITION OF TWO STAINS

The first stain is applied with abundant water and a lot of paint to obtain a generous application of color. Along with this wet color, a second one is added, and the two merge, forming a mass of very dense and variable tones, which changes with each new stroke applied. As the new colors are added, the coat of wet paint spreads. An interesting aspect is that the colors randomly spread out, achieving an appealing pictorial effect.

1

An artist who is applying paint directly does well to work on one portion of the painting at a time. Regarding dark washes in the background, it is still possible to guess the colors involved in the mix.

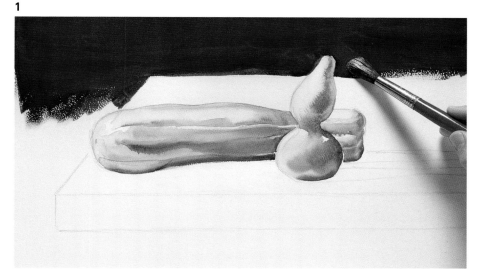

1 This exercise is painted wet-on-wet, and includes only three colors: dark ultramarine blue, crimson, and yellow.

2 The various textures and tones of the shadows have been achieved by mixing the colors directly on the support.

2

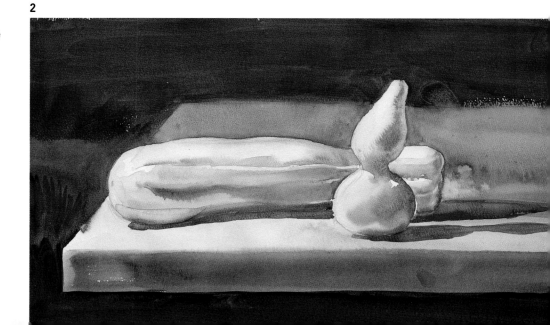

Optical Mixture and DIVISIONISM

The basic principle of the optical mixture consists of applying a mass of colors by means of small individual dots, which are mixed in the observer's retina. This pointillism is created from less to more, starting with the lighter shades and later adding the darker ones. The chromatic results that can be achieved with this technique always depend on the size of the dots and the distance between them.

SPRAY PAINTING

It consists of soaking a toothbrush with watercolor paint and pulling a finger across the bristles, causing hundreds of tiny droplets of paint to spray on the paper, to create an effect similar to that of pointillism. It is advisable to use paint that is somewhat thick, because if it is too liquid the droplets will be larger and the colors more muted.

The basic principle of the optical mixture is to apply a mass of colors by means of small individual dots, which are mixed in the spectator's retina.

1

2

In a pointillist-style art piece, the boundaries between two colors can be clear and emphatic or form a fade.

1 In pointillism, the colors of the model are not applied directly, but rather through the mixture of numerous dots of color.

2 Attention must be paid to the mixtures of colors in each area. Add yellow in the lighter ones and brown or violet in the shadows.

3 The accumulation of tiny colored dots produces an impressive appearance.
It looks like a painting composed of small, shimmering reflections of light that make the entire surface vibrate.

3

SPLATTER

To achieve an artistic splatter, load the brush with paint and water and make dynamic movements over the white paper. The intention is for the paint to splatter the surface of the paper, forming a multitude of drops of different sizes that mix when they come into contact with each other. It involves creating a network or plot of drops of different colors.

Sprayed watercolor created by rubbing paint-laden toothbrush bristles. Splatters create small units of color that interact with the washes and droplets, providing texture, depth, and an optical mixture of color.

HATCHING WITH THE WASH AND FAN BRUSH

Dry wash brushes and fan brushes are instruments that facilitate the optical mixing of colors. On a dry base of color, numerous dry brushstrokes are applied, showing the pronounced striations produced by these types of brushes, which create fusion and confusion of colors through a thick hatching of strokes.

Watercolorists use the fan brush to smudge and blend the colors, forming thin striations.

The fan brush allows for application of watercolor as striated brushstrokes that produce an interesting divisionist effect among the colors.

Many professional watercolorists are limited to working with watercolors, paintbrushes, and a bottle of water. However, there are a number of tricks and techniques that create a wide range of possibilities for finishing paintings, especially in relation to the recreation of texture effects on the paper, including the addition of gesso, modeling paste, or sprinkled salt.

A

Texture CATALOGUE

SCRATCHING

This system inevitably involves scratching the surface with the end of the handle of the brush or another sharp object. It can be used when the paint is still wet, or once it is dry, to create scratches or slight graphic effects on the surface of the color. It is also possible to wipe the dry surface of the paper with sandpaper or with the edge of a blade to create light effects. The grain of the paper plays an important role here, because sandpaper tends to erode the paint adhered to the most prominent ridges.

B

A. It is possible to add texture to a wash by rubbing the surface of the paper with fine grain sandpaper.

B. Once the wash is dry, artist scratches the color by scraping the surface with a knife.

There is an interesting variety of painting with watercolor that involves painting on top of a textured base containing modeling paste. The effect is astonishing.

SPRINKLING

To obtain a textured surface, simply sprinkle powdered pigment, ash, or even grains of salt on a still-damp coat of color. However, we must take two issues into account here: Moisture plays an important role, since the wetter the paint is, the greater the stains produced by each grain will be; on the other hand, a large amount of salt can imitate the granular texture of a rock or a particular type of vegetation.

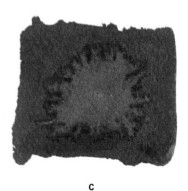

A

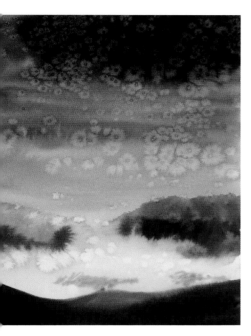

To obtain the texture of the sky, a few grains of coarse salt have been poured on the still damp wash.

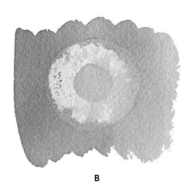

B

C

A. Salt sprinkled over a wet wash.

B. The paper can be previously painted with varnish, since once dry it repels paint.

C. Drops of clean water applied on a nearly dry wash.

Salt absorbs the water and concentrates part of the pigment around it, thereby forming its characteristic grainy texture.

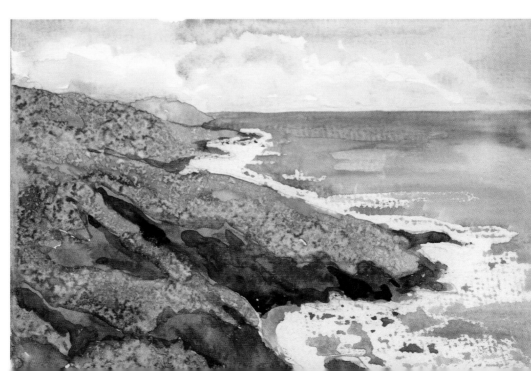

WET-ON-WET APPLICATIONS

Work that has been painted *on a wet support is called wet-on-wet watercolor. When the colors are applied on either an area of wet paint or wet paper, they expand on the surface and give the painted shapes a soft and hazy outline.*

When a touch of color is applied on a wet base, the color expands uncontrollably.

VARIEGATED MIXTURES

They are obtained when painting with the wet-on-wet technique. When adding color to a bed of wet paint, the pigment expands in all directions, producing a formless spot that expands uncontrollably and fades. The final effect is a tone that blends and is even confused with the background color.

The fusion and disintegration of the stain that provides this technique allows the artist to represent rainy scenes or backgrounds blurred by fog.

The first step is to experiment with different papers and very simple models.

The wet-on-wet technique allows the artist to create strokes with vague profiles.

TWO TRICKS TO TAKE INTO ACCOUNT

Although the wet-on-wet technique produces spontaneous effects, practice and experience are needed to determine how much moisture is required by the paper and how much paint should be applied to control its expansion and fluidity. The trick is to paint the paper with varying degrees of wetness and apply very intense colors. The color will appear very dark with the first application, but will lighten when it expands and dries.

The landscape peering from behind the house has been created entirely with wet-on-wet technique.

This technique is often used to blur the contours of the landscape with the distance.

It is painted with a soft wash on watercolor paper, to which a touch of green is added over different intervals. This allows one to ensure that as it dries, the stain expands less and less.

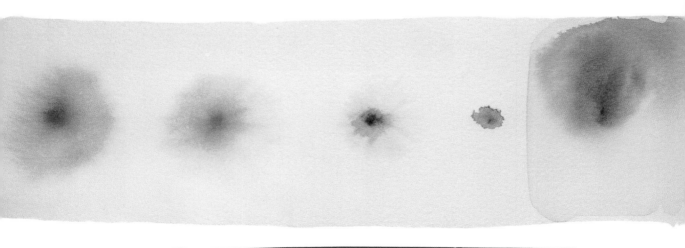

Dry brush
TECHNIQUES

The classical technique of watercolor painting that involves painting on dry paper with a brush loaded with paint slightly diluted with water is called dry brush watercolor. The strokes leave a characteristic rough trail according to the grain of the paper.

APPLICATION OF DRY BRUSHSTROKES

The brush is loaded with color but with little water in such a way that when the brush is applied, the paint adheres only to the protruding parts of the grain of the paper. When the brush is dragged along the rough surface, the paint adheres to the texture and gives the feeling of a sandy spot. You can paint with a dry brush on a white surface or on one that has been previously tinted with another wash. This way of working is a kind of "denial" of the natural nature of watercolor, since although the final appearance deviates from the magic of the liquid, it is very useful when a dramatic or textured effect is desired.

With this technique, it is essential to use pasty paint, with a small amount of water.

If the brush is soaked with lightly diluted paint, the brushstrokes will not blend with each other and will maintain a granular texture.

A. Dry brush applications must be made on an embossed paper, with a bit of grain, so that the color is deposited on the protrusions.

B. The striations and the brush lines are important if we intend to add an expressionist character to the work.

C. Dry brushstrokes do not have to be of a uniform color; the brush can be loaded with two colors at a time.

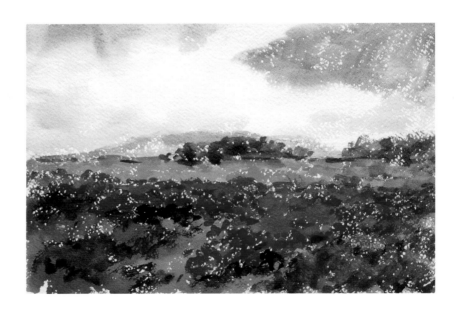

A

B

C

SPREADING THE BRUSH WITH THE FINGERS

Applying the dry brush that has been spread out in the shape of a fan by applying pressure with the fingers, the artist can use the bristles to produce a parallel stroke that can imitate the effects of grass or hair. It makes sense to try this beforehand on a separate piece of paper because it is very difficult to control the outcome. It is highly important to use the exact amount of paint; otherwise, the intended effect will not be achieved.

A

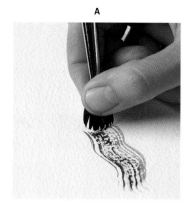

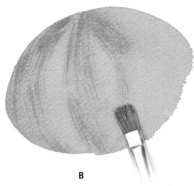

B

A. To obtain a dry striated stroke, it is sufficient to press the bristles with one's fingers.

B. It is possible to apply glazes over on a base of color.

1

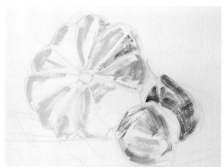

1 Dry watercolor brushstrokes do not leave a continuous wash, but rather produce texture and roughness effects.

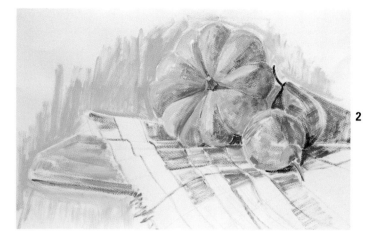

2

2 It is applied quickly and with confidence, since if it is done slowly the watercolor ends up drying on the brush.

3 The darkest colors, such as grays and browns, are left for the end, increasing the effect of the objects' volume.

3

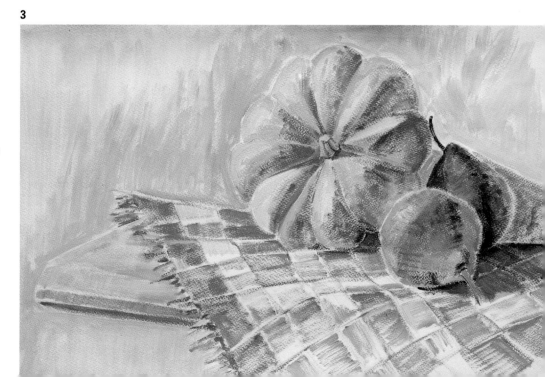

Resists AND MASKS

Much of the skill of a good watercolorist consists of pre-planning the work and knowing how to reserve the whites of the paper that are needed to represent highlights or reflections of light. Different resources are available that enable the artist to make resists that allow the white of the paper to remain intact; these let the artist paint quickly and without too much consideration when making strokes with the brush.

RESISTS WITH LIQUID GUM

Liquid gum or masking liquid is a substance that is applied on the paper as a cream and is easily removed once dry. It is often used when the area that must be preserved in the painting is very small, has a mottled texture, or contains fine lines, and in such cases, it is applied with a fine brush. Waterproofing isolates the areas of the paper that are treated from the painting's moisture. There are also other alternatives, e.g. adhesive tape, which is an excellent aid for areas with straight lines that have defined edges.

Masking fluid is a liquid glue that is applied before painting with watercolor to reserve white areas.

1

2

3

1 The umbrella's patterns are painted using a pale greenish masking fluid. A fine round brush is used.

2 Once painted with the watercolor, it is left to dry completely before the mask is removed by being rubbed with an eraser.

3 The masking liquid has retained the pattern of the umbrella in a lighter color.

The dark lines and white lines on the inside of the watercolor washes are interspersed.

RESISTS WITH OIL PASTELS

Because of its characteristic resistance to water, its impermeability based on the classical incompatibility between oil and water, wax is very practical for creating resists. White wax is often used, which is ideal for bringing out bright areas, or reproducing the mistiness of clouds or the effects of the foam in waves. The wax's resistance can even be taken advantage of by using color bars, which, combined with the washes of color, adds a more expressive effect to the watercolor.

Strokes made with oil or wax pastels integrate well in interpretations in which color plays a major role.

Wax resists can also be made with light colors that contrast vividly with the watercolor washes.

Resists have been created with white wax on the surface of the water, imitating the foam of the sea.

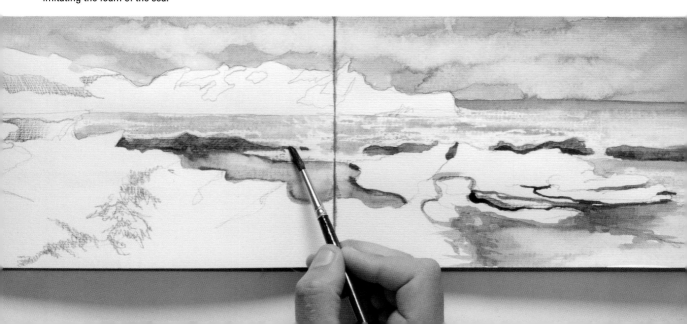

ADDING LINES
IN WATERCOLOR

Normally, watercolors are painted over a sketch done in pencil, with very soft strokes, so they are barely visible when the artist incorporates the colors. But sometimes, it is advisable to add marks or linear strokes of a different nature that are well-defined and provide a counterpoint to the stains of colors.

SGRAFFITO

This is the most rapid and immediate way of working. It is usually performed when the wash is wet. Sgraffito is obtained by scratching the surface of the paper with a very sharp metal object. That causes the paper in this area to absorb part of the color, so the sgraffito is more intense than the rest of the wash. This same action can also be done with a sharp water-soluble pencil.

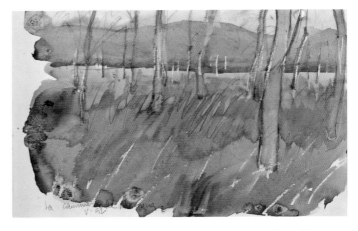

This watercolor uses sgraffito on a wet surface in the vegetation and water-soluble pencil strokes in the branches of the trees.

A. Sgraffito made with a metal tip when the wash is wet.

B. Strokes with a nib on a semiwet wash.

C. With a water-soluble pencil on wet watercolor.

Sgraffito can incorporate effects of texture in the foreground of a landscape.

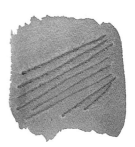

A

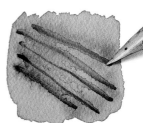

B

C

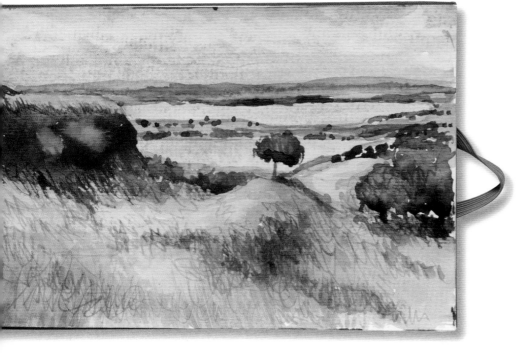

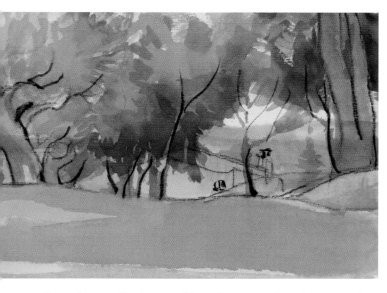

Some watercolorists prefer pressed charcoal because it offers a more compact and intense stroke.

Charcoal as a medium is not so different from watercolor as it may seem; it often is used to make intense strokes.

1

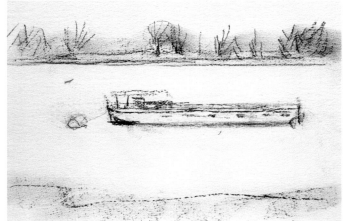

WATERCOLOR AND CHARCOAL

Unlike the graphite pencil, charcoal is not a usual medium in watercolor, but it is just as appropriate if used sparingly. It must be applied linearly, without excessive staining, shading, or scratching. Then, before using watercolor, it is important to shake the paper a little bit with a clean cloth, to prevent the carbon particles from dirtying the gouache more than is desired.

1 The drawing is done with coal, but it is rapidly erased with a cloth to prevent the emphasis of the lines from damaging the watercolor.

2 The watercolor strokes, although slightly grayed by the charcoal, are perfectly incorporated into the overall work.

2

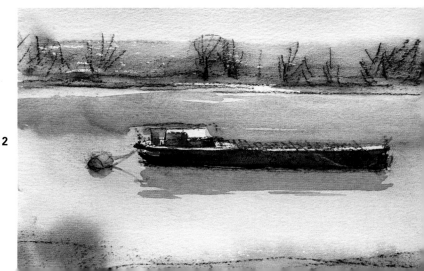

The main feature of the watercolor is its deliquescence, i.e. its watery, dissolving appearance. Controlling that deliquescence involves the formation of attractive water effects. In order to fully control these properties, it is essential to know about some of the watercolorist's advanced technical resources and be constantly open to improving your results.

Additional Media and Techniques

WETTING AGENTS AND RETARDANTS

To boost the wetness of the color, one can add ox gall to the paint or water in the container. If more drying time is desired, a home remedy can be used that consists of adding a teaspoon of sugar to the water, or a bit of gum arabic or a blending medium to the paint. The latter is a blending medium, the classic "watercolor medium," sold under this name, that is ideal for fulfilling both functions: drying retardant and wetting agent.

With ox gall, the color stays wet longer and the stains melt easily.

With gum arabic, the watercolor becomes brighter and acquires more body and a gelatinous appearance.

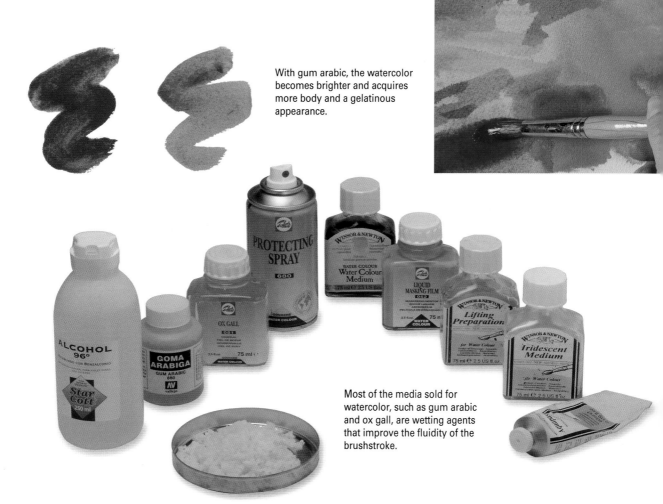

Most of the media sold for watercolor, such as gum arabic and ox gall, are wetting agents that improve the fluidity of the brushstroke.

This work combines watercolors made with typical ink drawing tools, such as reeds and metal pens.

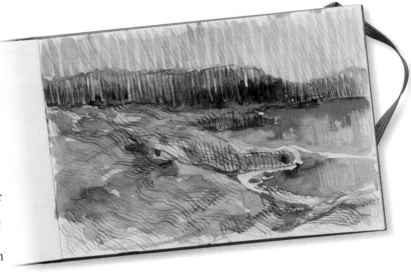

LINES AND FRAMES WITH OX GALL

Although washes and spots are the natural medium of watercolor, lines and patterns are also options. In these forms, watercolor strokes acquire a more linear character; they define and emphasize the contours of the shapes by combining the brushes with applicators typically used for drawing, such as pens or nibs. Mixing ox gall into your watercolor will make it easier to draw lines.

RINSES WITH TRAYS

It is possible to obtain a very atmospheric wash effect by passing the painted watercolor paper directly under running tap water, which will wear down and reduce the image by removing the pigment. Another option is to place the painting in a tray of water and gently caress its surface with a sponge or a brush to remove the color.

Atmospheric glaze created by dipping the brush and the paper in a bucket of water.

To draw lines with a pen and watercolor, it is necessary to mix the watercolor solution with a bit of ox gall.

It is washed in a tray by soaking the paper in water and stroking it gently with a sponge brush.

CREATIVE OPTIONS WITH WATERCOLOR

Many of the visual effects and textures we get with watercolor are the result of mixing the paint with other similar substances or with different ones that give it a special finish. Before applying materials we haven't used before, it is best to conduct some preliminary tests to see how the materials react.

WHIPPED GUM ARABIC AND ALCOHOL

Watercolor spots can offer rich textural nuances depending on the behavior of the pigment with water; however, external agents can also be added to obtain new textures, for example, gum arabic or bar soap (soap made with fatty acids), which can be vigorously beaten with color to create bubbles on the spot. Another way of breaking the wash is to splatter a wet watercolor with droplets of alcohol to create radiant light.

A

A. Watercolor mixed with gum arabic and whipped vigorously with the brush to create bubbles.

B. Effects produced by alcohol when drizzled over a wet watercolor to create radiant light.

C. This watercolor has been mixed with a textured and iridescent medium to give it texture and small areas of pearly luster.

D. Cobalt secant mixed with watercolor to create spots with open pores and rough edges.

B

C

LYRICISM WITH SPONGE BRUSHES

This creative technique is conducted using fine grain paper and a very limited palette of colors. Round and flat sponge brushes of different widths are used, which is unusual among watercolorists. The magic of this practice resides in the fact that the shapes are barely suggested and blend with the spaces in the background.

D

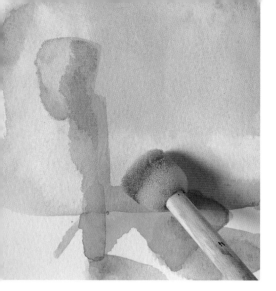

Round sponge brush used to recreate a lyrical representation on fine grain paper.

ABSTRACTION WITH A SPONGE BRUSH

A sponge wash-type brush is used to make abstract compositions with watercolor by creating transparent bands of color, lines, and curves that overlap and alternate. The washes of warm and soft colors are applied first in the background with a brush, and then striated strips are drawn on top with a wide sponge brush. The watercolor paper should be fine grain.

A

A. An atmospheric painting is created by overlaying successive washes with a sponge brush.

B. Abstract composition made with a sponge brush that is based on applying layers of color.

B

Flat sponge brush.

Gouache painting is a water-based procedure that shares many similarities with watercolor, from its composition to its application technique. In fact, until the end of the eighteenth century, there was no clear differentiation between the two types of painting.

GOUACHE PAINTING

OPAQUE WATERCOLOR

Gouache has the same composition as watercolor, and the two procedures are so similar that many artists consider gouache an opaque watercolor. Its milky, chalky, and matte appearance makes gouache a different medium from watercolor, in spite of the fact that the materials and supports that are used are the same in both cases. Gouache paintings have a high concentration of pigment mixed with an inert white that provides the color with greater consistency, creaminess, and opacity.

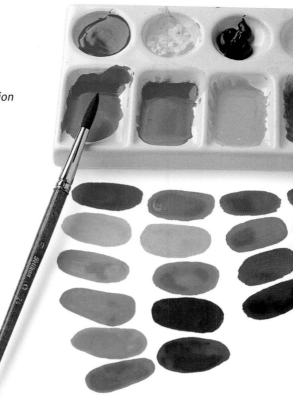

Gouache paint is applied similarly to watercolor; however, the color is more consistent and opaque.

Each gouache painting incorporates an inert white filler to make the color fully opaque.

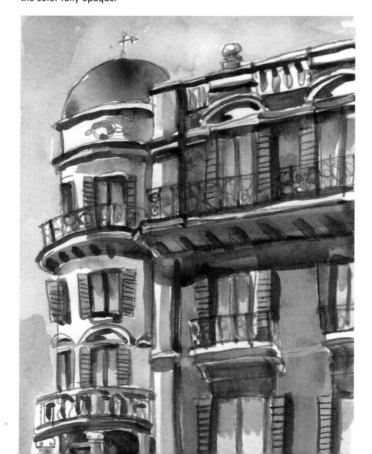

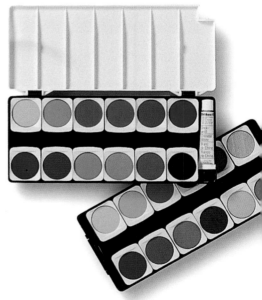

Cases of gouache colors in water-soluble cakes.

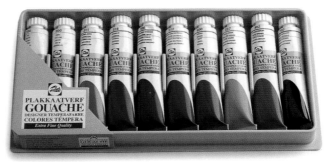

Professionals often prefer ranges of paint in tubes, which allow the color to retain more pigment.

Gouache containers show the paint in its creamy state and are sold in a wide variety of shades.

VARIETIES

Gouache colors are sold in three basic forms: tubes, bottles, and cakes. Dry colors in cakes are for school use, although they can also be a good alternative for artists, given their easy handling and transport. Most artists choose the tubes and bottles (according to the quantity required) because the paint has a creamy consistency that allows it to be applied immediately and directly. Colors with this presentation tend to be of professional quality.

The consistency of gouache paint allows the artist to construct very solid masses of vegetation while working other areas with more transparent applications.

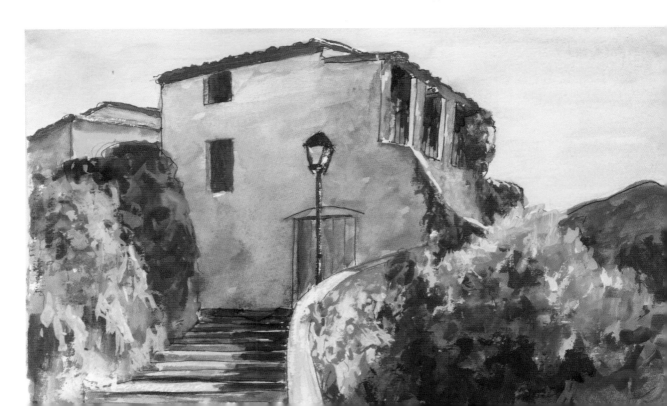

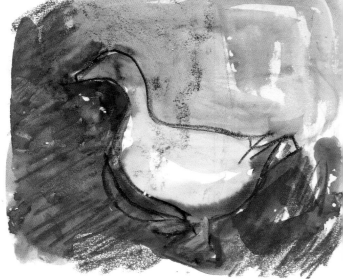

Gouache is an undervalued painting technique; nowadays, it is often relegated to school use or to exclusive fields such as fashion design. This is difficult to understand, considering the versatility this paint can offer artists.

Gouache painting can be combined with other media such as watercolor crayons or pencils.

SOLUBILITY OF GOUACHE PAINTING

A DELICATE PAINT

Like watercolor, gouache can be diluted with water to achieve the same lyrical and delicate effects. However, the greatest attraction of gouache is that these fluid and vaporous applications can be supplemented by others that are more solid and saturated and that, when dry, acquire a matte and velvety texture. There are those who prefer to use gouache in dense and thick layers to ensure that it fully covers the background color, though that is not recommended since when a thick layer of paint dries, cracks and crackle effects often appear.

You should check the different consistency of gouache paint depending on its dissolution in water.

The opacity of gouache depends on the degree of dissolution of the paint in water.

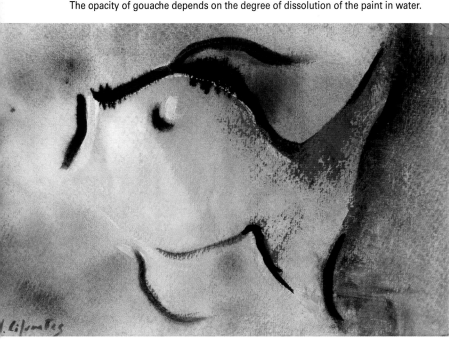

Illustrations and posters are the natural context for gouache painting.

Gouache tolerates overlapping colors, but excess paint might make it crack while it's drying.

LIGHTENING THE COLOR

There are two basic ways of thinning gouache paint: with water, which makes it look milky and translucent; and with white gouache, which will give it greater density and opacity, as well as a brighter and more pastel color. Lightening the paint with white, contrary to what happens with water, tends to unify the color and causes the final color coat to reveal a more uniform tone.

A. There are two basic ways to lighten the color: One is with water, although that method makes the coat of paint transparent.

B. The second is by adding a little bit of white paint, which makes the application more milky and opaque.

C. Lighter colors can be applied on top of darker colors provided that the color underneath is dry.

A

B

C

Opaque PAINT

Since gouache can be transparent or opaque depending on the degree of dilution, the translucency of the white support is not as critical as with watercolor, which means one can work on a variety of supports dyed with different colors.

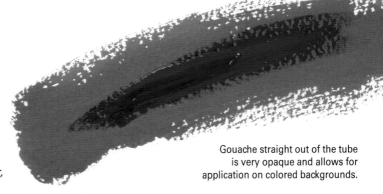

Gouache straight out of the tube is very opaque and allows for application on colored backgrounds.

BEST WITH DARKS ON LIGHTS

Gouache is an opaque paint, so it makes it possible to apply dark colors on top of light colors as well as the other way around. However, in practice, it is always best to apply dark color rinses on top of lighter ones since some colors (depending on their quality) can be semi-opaque and allow for a glimpse of the color underneath.

TINTED PAPER

Unlike watercolor, gouache can be indiscriminately applied on a white background, with a medium and even dark tone. An intermediate tonal background can be applied with dark and light tones at the same time, while the background also contributes to unifying the elements in the composition.

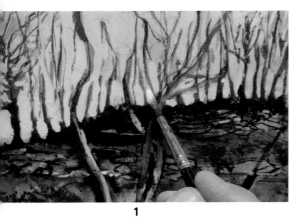

1

1 White gouache is a supplement widely used in watercolor painting to create highlights.

2 Representation of a burned forest made with a mixture of watercolor, Chinese ink, and gouache strokes.

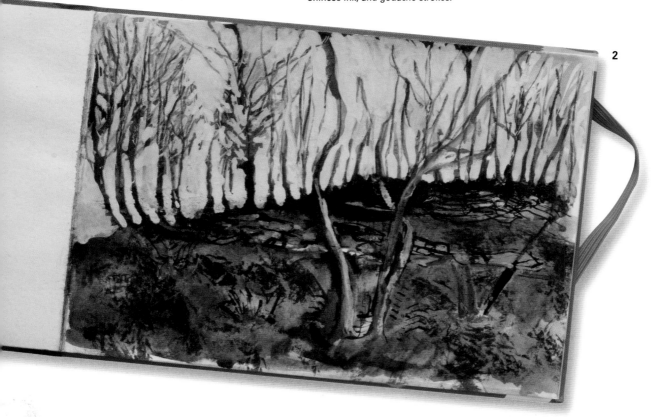

2

THICK PAPER

When painting with gouache, avoid using paper that is too thin or is extremely light. The coat of paint is much thicker than that of watercolor and tends to warp the paper when dry. For this reason, it is preferable to use high-quality paper or pasteboard, such as Canson or Ingres. One option is to work directly on pasteboard, wood, or even fabric primed for gouache or acrylic, which requires the *gesso* primer to be free of oils and other fatty substances.

It can be overlapped with dark color backgrounds fairly easily, to give the impression of light.

1

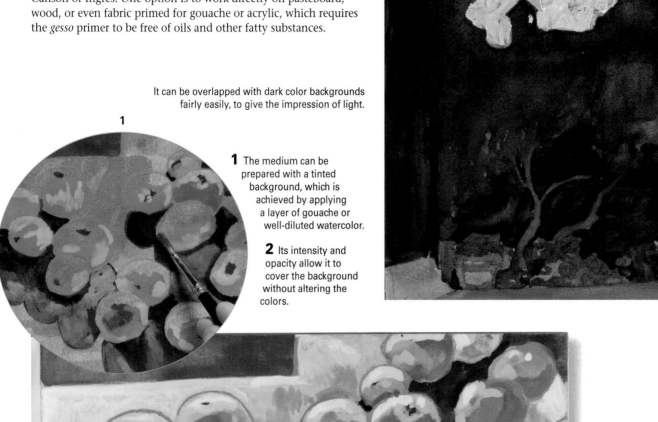

1 The medium can be prepared with a tinted background, which is achieved by applying a layer of gouache or well-diluted watercolor.

2 Its intensity and opacity allow it to cover the background without altering the colors.

2

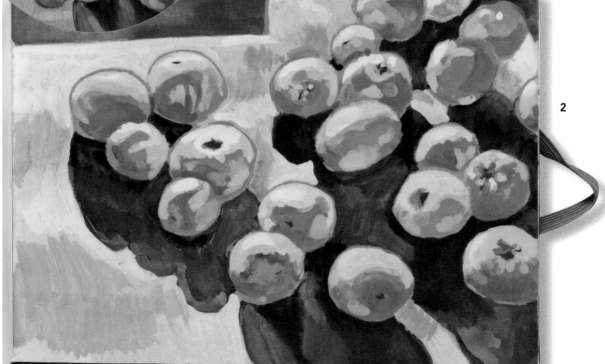

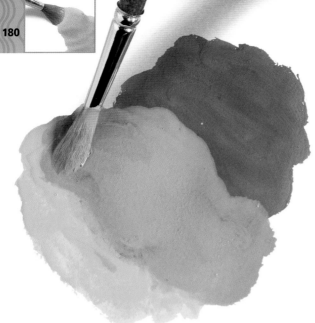

Gouache offers solid and intense color that allows for extensive and flat applications of the same tone with almost no variations. Its traditional use for poster art and design work has forced manufacturers to market a wide variety of shades of colors.

FLAT PAINTING
AND BLENDING

BLENDS AND TRANSPARENCIES

Today, many manufacturers offer a variety of different shades to adjust coloration and facilitate the use of direct colors by the artist, which saves artists from the arduous work of creating mixtures. Therefore, it is a medium that requires little mixing on the palette—the artist need mix only three colors, at the most. The aim is to achieve a high degree of homogeneity in the resulting color. Also gouache can be used to form transparencies, which gives it an intense and light-reflecting quality, which is very suitable for floral models.

Gouache paint can be applied very evenly, covering even a completely dry spot.

Complete representations are made with very few values of the same color.

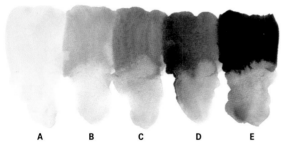

A B C D E

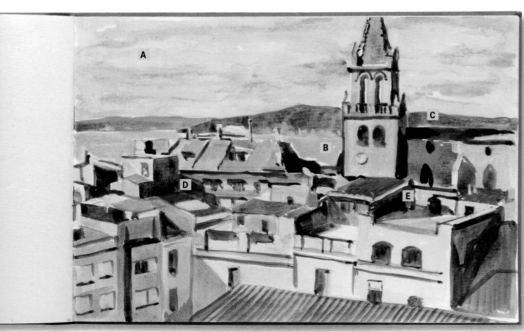

When painting with gouache, more or less diluted gouaches are combined with other intense and opaque applications.

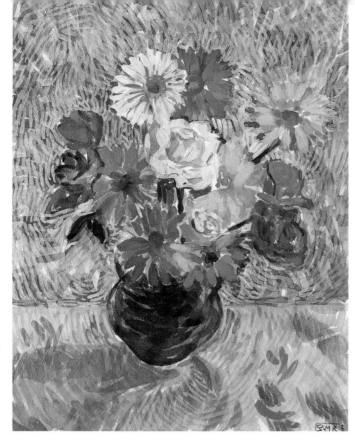

Overlapping strokes of different densities adds vibrance to the colors and creates a false effect of movement in the model.

BE CAREFUL WITH THE OVERLAYS

Gouache paint contains more pigment than binder, which means that, even if it is dry, the artist can dilute it by going back over it with a wet brush. Applying one wet color on top of another poses the danger that the underneath color will smear. To avoid this, let the previous coat of paint dry fully and add the new one with a soft brush, with the minimum amount of strokes possible.

Gouache allows for creating a rich and detailed work based on blending and fades between colors.

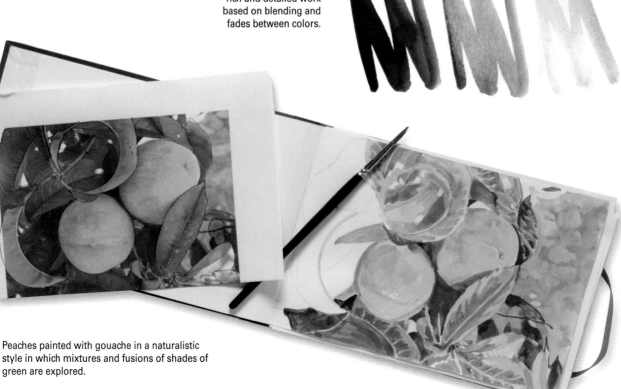

Peaches painted with gouache in a naturalistic style in which mixtures and fusions of shades of green are explored.

TEXTURE WITH GOUACHE

The density of gouache makes this paint suitable for creating textured effects. The texture depends on both the surface of the paper and how the color is applied (either with a brush or a palette knife), as well as on the marks and incisions on the wet coat of paint.

APPLICATIONS WITH BRUSHES AND PALETTE KNIVES

When you are working on paper with a well-defined surface engraving or even on watercolor paper, the grain of the support shows the stroke of the dry brush. Textures can also be created on fine grain papers or even pasteboard. Wash or sponge brushes are suitable for applying paint to form striations. Gouache colors are solid and vivid, which makes it possible to also apply them with a spalter, thus allowing for fusion between the top and bottom colors.

Gouache can also be applied with a palette knife by dragging the color; the results are interesting fusions and overlay effects.

The density of gouache paint makes it suitable for creating textured effects.

Gouache's density allows it to be sprayed with a brush, creating stippled texture.

The colors can be applied with a wash or a sponge brush to achieve a ribbed texture.

BRUSHES AND ROLLERS

Other painting utensils that are less common also provide interesting texture effects. Gouache paint is dense, and it can be applied with a toothbrush; when rubbed, it releases thousands of tiny drops of color that create a broad spray effect on the support. The sponge roller can be used to make backgrounds and bands of color. The result of the texture depends on the amount of paint absorbed by the sponge and the pressure that is exerted on it.

The roller can also be a very interesting tool for applying paint and creating sfumato effects.

Spots applied diluted in water and with different instruments to obtain a variety of textures.

Here, the handling of the brush with thicker paint allows for different graphic varieties in the vegetation.

Opaque oil paint allows the artist to work with color effects on a previously dyed background; it may be visible between the strokes.

Oil is one of the most popular pictorial media and was the medium preferred by the great masters of the past. Painting with oils is a dramatic, complex, and rewarding process that implies a slow pace, which allows the artist to work without haste and to retouch at will. The procedure is flexible and robust, and is adaptable to any requirement, from small-format works to large canvases.

The colors are vivid and are very stable under direct light and over the passage of time. The paint's oily consistency provides the colors with a richer tinge, and its pasty consistency and body mean it can maintains its texture on the support.

OIL PAINT

Introducing OIL COLORS

Although the composition of oil paint has not changed too much over the past six hundred years, the fine art industry has improved the performance of oil paint and has provided enthusiasts with an interesting variety of products and accessories that make their work easier.

COMPOSITION

Oil paint is composed of pigment in powder bound with a natural oil drying medium, usually linseed, although there are also other less usual options such as sunflower or poppy seed oil. The amount of oil required for each pigment is variable, but all the colors have the same thick, creamy consistency. Additives (paraffin, dryers, or plasticizers) are added to this initial mixture to accelerate the drying process and give the paint a thicker consistency. Solvents are used to lighten the creaminess and obtain greater fluidity; these include white spirit or turpentine essence, a very refined oil, popularly known by the name of turpentine.

Oils are unctuous colors, with a pasty consistency that allows them to be applied with a brush.

Oil is the king of mixing; with just a few colors, a wide range of tones can be created.

It can generally be purchased in tubes, which come in different qualities depending on their composition.

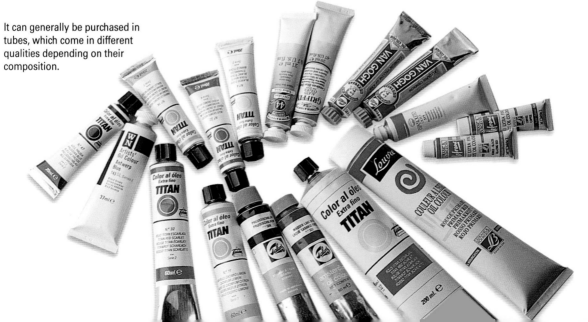

ASSORTMENT AND FORMATS

Oil colors come in aluminum or plastic screw-capped tubes, of four or five sizes and capacities, and of different levels of quality. It is common to choose an average-size container for all the colors, except for white—the artist needs a larger amount of this color. Oil is also sold in bottles or in one-kilo cans for those who work with large formats or who like making thick impastos. The assortment of colors is extensive and their characteristics (strength, transparency, and permanence) are specified in the color charts edited by the manufacturers.

Turpentine or turpentine substitute (less stong-smelling) is oil's universal solvent; it dilutes the paint and allows for a more fluid brushstroke.

Oil's slow drying process allows the artist to blend or retouch the contours of spots applied hours previously. In short, oil is the best medium for making corrections.

Its oily consistency provides solid, highly consistent and fluid brushstrokes that blend with each other.

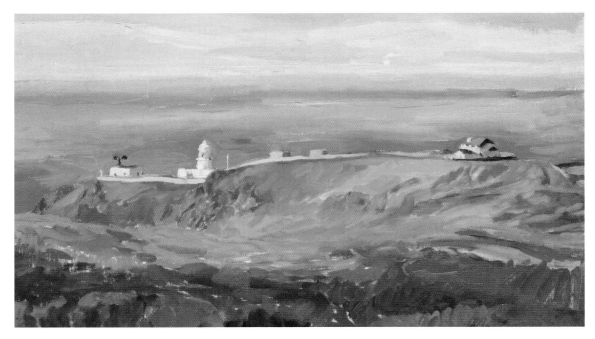

Oil allows the artist to paint subjects with heavy, oily, and easy-to-handle application with broad coverage.

PRE-PAINTING WITH DILUTED COLOR

The essential rule of working with oil paint states that the diluted color should be applied first, followed by the thicker one. This technique is known as "imprimatura." In the early stages of the painting, many painters choose to dilute the color in a balanced solution of turpentine or white spirit. These turpentine applications provide the first chromatic approach to the model.

VARIOUS FORMS OF PRE-PAINTING

The easiest way to begin is by staining the canvas with oil paint diluted in turpentine. It is a fast and immediate technique, but it tends to produce drops due to the thinning effect. Light areas can be opened up on top of the coat of turpentine paint by rubbing it with a cloth. A second option is to apply a dry spot with a brush loaded with slightly fluid paint, which produces a worn effect. Another possibility is to paint by areas of color, applying a coat of smooth and flat paint, simplifying each one of the chromatic areas.

Light areas can be opened on a layer of ocher diluted in turpentine by rubbing it with a cloth.

The first applications of color are somewhat diluted and imprecise; they are intended to mitigate the white of the support.

Stains are usually applied with oil paint diluted in turpentine to facilitate quick drying and to allow the artist to continue with quick overlays.

The first washes applied with oil diluted in turpentine, indicating the position of the shadows.

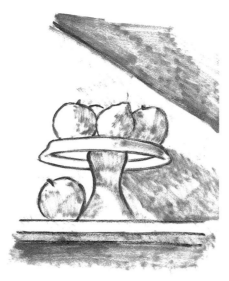

Oil sketch made by rubbing the paint with a paintbrush carrying a small amount of paint, creating harsh and worn brushstrokes.

A

B

C

DIFFERENT DILUTION METHODS

Oil paint can be diluted in three ways: with medium, oil, or solvent (turpentine or white spirit). If diluted with medium, the paint becomes more viscous and fluid, retaining its intensity and chromatic density. If oil is chosen, the color becomes more transparent and tends to turn yellow and greatly delays the drying process. When a solvent is used, the solution is more liquid and dries very quickly, although the finish is more matte.

A. Paint thinned with medium retains its shine and becomes very viscous.

B. With oil, the color becomes more transparent although it becomes yellow after drying.

C. When diluted with turpentine, the pigment appears more broken-down and has a matte finish.

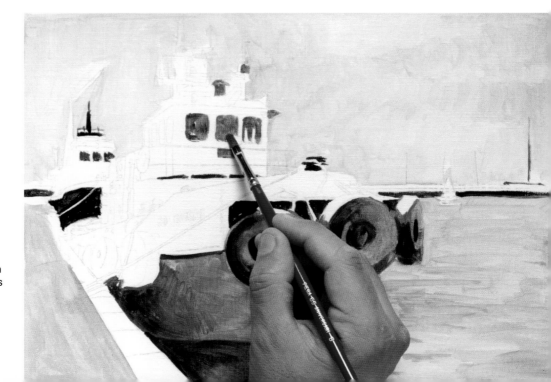

Try not to worry about the details; the most important consideration is to designate one color in each area that reduces the dominance of the white of the support.

PAINTING ON COLORED
BACKGROUNDS

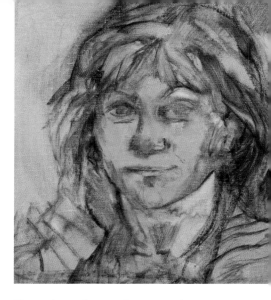

There is nothing that prevents one from working directly on the white background of the canvas; however, many artists prepare it prior to starting to paint and cover the support with pre-paint, which provides a richness to the overall work and intenstifies the the tonal value of colors.

DIFFERENT OPTIONS

The canvas's background color plays an important role in the painting's final appearance, so different options are often used to mitigate the white on the canvas. The most common technique is to create the background with paint diluted with turpentine. For landscapes, the background is often painted in gradients. The canvas can also be painted with a thick, flat, and uniform coat of oil paint. In the latter case, one must wait a few days until the coat of paint is dry before working on the painting again.

Many artists prefer to work on a neutral background such as brown, gray, or blue that has been created with turpentine-diluted paint. Prestaining or imprimatura is a technique that has been practiced since the Renaissance.

A. Perhaps the most common way to plan the background is to use turpentine-diluted paint.

B. When the subject is a landscape, the background can be stained with a fade between two colors.

C. The canvas can also be covered with a layer of dense and uniform paint, taking care to let it dry a few days prior to beginning to paint.

A vivid, high-contrast effect is achieved when working on a background covered with a saturated color such as cadmium orange.

A

B

C

1 A dark background allows the artist to begin to construct the composition by adding light areas. The light is what forms the shape.

2 The application of lighter colors is not flat, but rather blends with the darkness of the background, forming soft fades.

3 The most important highlights are left until last. The darkness of the background helps frame the profile of the illuminated areas.

DARK BASE COLOR

The canvas can be painted beforehand with a dark base, generally brown, to enhance the chiaroscuro effects. When the base color has dried, the lights are added and the gradients and blends are applied. The darkness may be enhanced by increasing the contrast of the deeper shadows with burnt umber mixed with a black ivory tip.

CONTRASTING IMPRIMATURA EFFECT

This involves working on an intense and saturated color background (such as a red, orange, turquoise, pink, violet, etc.) that contrasts strongly with the subject. Then, once painted, in between each spot, small bald spots or uncovered areas are deliberately left so that the color may be visible between strokes. The imprimatura effect occurs when the background's saturated color is still visible between the strokes, creating a curious contrast that enhances the strength of the colors.

Painting on a violet base allows the artist to create contrast with the range of prevailing greens in the foreground.

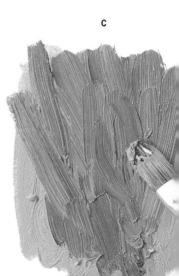

Oil is the king of mixtures; it allows the artist to blend colors in multiple ways to achieve opacity or impasto effects. An artist who has been painting for several years has a thorough understanding of the properties of all colors and knows how to select the most suitable ones to create a desired color.

PHYSICAL MIXTURE OF COLORS AND APPLICATIONS

TOTAL OR SOLID MIXTURE

To solidly mix two colors, take a large quantity of each and place them in the center of the palette, applying rotating movements with your palette knife or brush until a third homogeneous color emerges that has no streaks from any of the previous colors. The resulting mixture is now ready to be applied to the canvas. The palette knife is commonly used for mixing large quantities of paint, while the brush is left for incorporating small amounts of color.

This swatch presents a partial mixing of yellow and blue to create green.

To achieve a complete mix, stir with the brush until a uniform color is achieved.

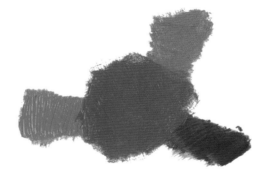

In general, two colors are used in mixtures (here, yellow ocher and compound green), and a third color (natural sienna) is used to tint.

A. Uniform mixture applied with a flat brush.

B. Barely diluted uniform mixture applied with a flat brush.

C. Striated mixture applied with a cat's tongue brush.

D. Uniform mixture made with a rubber tip brush.

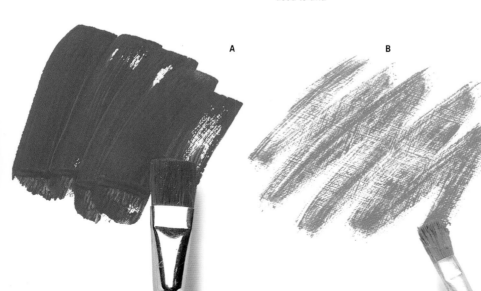

A

B

C

PARTIAL OR STRIATED MIXTURES

The creamy consistency of oil paint makes it good for creating striated mixtures. Two or three colors are mixed incompletely, either on the palette or directly on the canvas, so they are still visible in the form of fine streaks of paint. If a bristle brush is used, the chromatic streaks are added to the other ones produced by dragging the brush.

TWO COLORS AND A HINT OF ANOTHER

Avoid mixing three or four colors, since they tend to lower the chromatic intensity and turn a mixture gray. The ideal situation would be to mix only two colors and add a small amount of a third one (barely with the tip of the brush) to tinge it.

Partial or striated mixtures are more suitable when the paint is hardly diluted and is applied densely and thickly.

Still life with mostly flat color applications in which solid mixtures predominate.

D

OIL
IN LAYERS

Oil painting allows you to work in shorter or longer sessions that can be resumed the next day with the still fresh color on the canvas. It is a great advantage because it favors the enrichment and overlapping of successive layers of colors that enhance or complement the previous ones until the work is finished.

FIRST LAYERS

The usual process of painting with oils usually begins with a well-marked charcoal drawing, which can then be dissolved with turpentine. (One can also draw with a fine stiff brush in turpentine-diluted paint as well). The top layers of color are very fluid and liquid. At this stage most paintings do not have much chromatic quality because the colors can appear rather grayish. Diluted oil does not settle too well and it can break up. The second layer of covering color is used to correct the defects of the first. The color, now thicker, offers a more solid chromatic surface, which is valuable because of its richness of tone and its texture.

The opacity of oil allows one to comfortably paint in layers, even with light colors on a dark background.

The first phase consists of applying diluted paint. This method of working provides the artist with greater flexibity, especially with regard to portraits, which often need to be refined during the process.

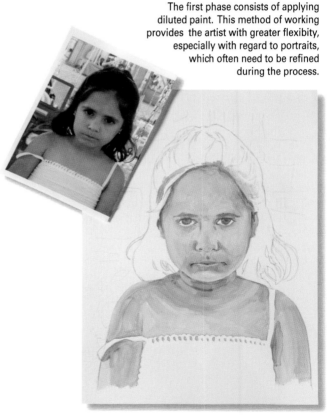

Drawing always precedes beginning any painting. The sketch is usually well defined, because the oil paint covers all the strokes.

THE FINAL TEXTURE

The finish of the pictorial layer depends on the accumulation of layers of color and on how the color was applied, resulting in dense lumps or delicate touches. The finish is important because it represents the physical body of the work; it is the last custodian of pictorial sensitivity.

STRESS MARKS

Touch-ups made once the work has been finished must be performed when the last layer of paint is completely dry; otherwise, so-called stress marks, or alterations in the brightness, will appear in such a way that the touch-up areas acquire a matte appearance and become clearly visible due to their dull appearance. Still, these small errors can be corrected using a special varnish for touch-ups.

Right, on a color base diluted with turpentine, thicker oil with more covering power is applied.

Below, final touches of color are added by incorporating overlapping strokes that overlay the base colors.

Above, simple blocks of color illustrate the oil painting technique of overlapping layers. The artist added the most intense and opaque colors on top of turpentine paint and tinted them with new chromatic additions prior to finishing the work.

DIRECT MIXTURES OF COLOR

Wet-on-wet *painting involves trying to boldly capture* a subject with large, intuitive, and direct strokes. It is usually best suited to a work that is completed in a single session, and where the colors can mix indiscriminately both on the palette and on the surface of the painting. This type of painting requires that the artist have a certain level of confidence.

When working with *wet-on-wet*, a preliminary drawing is not used; the work is created directly with indicative brushstrokes.

1

CAPTURING THE EXPRESSION

When painting with *wet-on-wet*, a color background is not prepared and a slight preliminary drawing may be made; it is enough to apply a few indicative brushstrokes with turpentine paint. From the very first moment, the model is developed with loose, fast, attractive, and lively strokes to capture the expression of the elements and the effects of light and movement.

1 With direct paint, the preliminary drawing can be done with very diluted paint and a brush.

2 On top of this base of turpentine paint, the spots of color are incorporated directly, without the artist's having to wait for the underlying layer to dry.

2

3 The colors are rapidly and freshly incorporated in such a way that they mix with each other. Observe how the brushstrokes affect the sky.

3

A LIMITED PALETTE

Wet-on-wet painting facilitates working with plenty of paint, with the brushes well-loaded with color, so that the first impression is not lost. The goal is to construct each area without having to clean, fix, or go back over the already painted areas. For this reason, a limited range of colors should be used to prevent the mixtures from becoming complicated and resulting in an overly grayish range of colors.

MIXING BY DRAGGING

Colors are mixed on the support by dragging. The color is first applied in a creamy manner, on top of which brushstrokes of another color are added later. The dragging of the new color drags a portion of the color underneath, thereby mixing them both.

Mixtures are produced on the canvas by dragging the layer of paint. Here, Prussian blue applied on top of a base of yellow turns it green.

Wet-on-wet work tends to be preferred by many artists when they are sketching or adding touches of color, because it allows for freshness and immediacy, and lets the artist mix colors directly on the support.

Most of the mixtures are produced on the painting's surface instead of on the palette.

This direct painting technique, coupled with the presence and persistence of the brushstroke, is essential to the final outcome of the work.

Oil paint, when applied on a dry surface, allows for the overlapping of various tones or very diluted colors, which are called glazes. This process can have multiple applications, both for changing the overall tone of a color and for creating a fade to produce a lighting effect. Below are some resources for using this technique.

Different drying agents can be used to accelerate the drying process when working with glazes.

WORKING WITH GLAZES

A. Overlaying with glazes facilitates an optical mixture of two colors.

B. If glazes are applied wet-on-wet, the bottom color will run slightly.

OVERLAPPED FINE LAYERS

Oil allows the artist to make wonderful glazes ranging from rich, matte-looking shades to thin, glossy layers. The secret of oil glazing lies in respecting the drying time in between coats; rather than mixing the colors on the palette, the artist applies thin layers of a transparent color on the canvas, so that each new layer modifies the color underneath. NOTE: Be sure to work in a ventilated space, as the fumes of varnishes and drying media can be strong.

C. The colors can be partially covered so that the overlapped color and the underlying one can interact.

D. It is preferable to start with light colors and finish with the darkest ones.

A

B

C

D

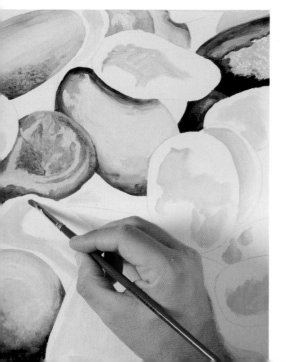

Working with transparencies made with oil paint and a drying glazing medium such as Liquin allows for great precision and an exhaustive control over the shades.

When light penetrates through a transparent film of color, it refracts on the white support, producing a rich and intense effect.

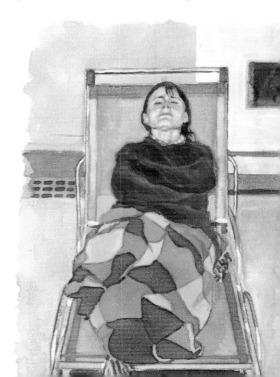

ACCELERATING THE DRYING PROCESS

The oil drying process is very slow, and working with glazes can be a problem because it may be necessary to wait for each layer of color to dry prior to applying a new one, which could result in long days of waiting. For this reason, the paint should be diluted with a special medium to accelerate the drying process. There are several alternatives, such as cobalt drier and other drying media like Liquin. Simply add a few drops of these substances to the mixtures on the palette. If you are making an excessive amount of diluted color, the paint can be prepared in a cup.

VARNISH GLAZES

The colors are thinned with a glazing varnish such as a drying varnish to increase their fluidity and transparency. Never use linseed oil or turpentine, because the former slows down the drying process and the latter turns the colors gray. Varnish, apart from adding a shiny and vitrified appearance to the glaze, enhances and intensifies the pigment.

1 The paint is diluted with Dutch varnish; turpentine is used only to clean the brushes.

2 With glazes, it is preferable to start with light colors and gradually overlap them with darker ones, but without losing the transparency effect.

3 The appeal of glazes lies in the freshness of the transparency of their colors.

1

2

3

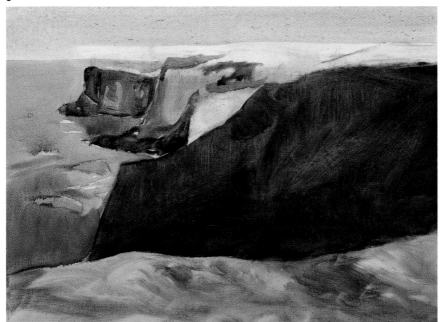

The paint can be mixed with varnish or drier inside a cup or container, especially if a large amount is required.

Blending, Smoothing, and EXTRACTION TECHNIQUES

Painting is not just applying paint on the canvas with a brush or a palette knife; it also entails mixing it, blending it, or even removing it to thin it or create transparencies. When extracting or mixing, more worn spots are created where the stroke of the brush on the layer of color disappears almost completely.

THE STROKES MIX

The final result of a painting largely depends on how the strokes are combined, the extent to which they are mixed, and the method by which they are mixed. If the mixture is very vaporous, the image becomes smoothed, blended, even blurry; if it is thick, it appears choppy and expressive; if no mixture is produced, the stains appear excessively flat and separated. It is interesting to experiment with different mixtures on the canvas to explore the possibilities.

A

B

A. This mixture was made by applying soft strokes of one color and then another on a contact zone.

B. Effect shown when loading the brush with undiluted oil; it provides a highly characteristic torn stroke.

C. The effect of brushstrokes made with undiluted oil on a canvas with a dark background.

C

The background of this painting has been created with different shades of gray and brown that appear completely faded and mixed, thus highlighting the foreground.

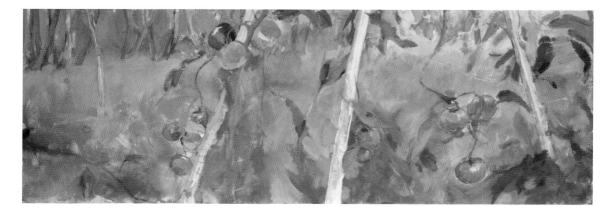

MIXING WITH GLAZES

This technique consists of working with light layers of paint, so that the strokes do not cover too much and allow the bottom layers of color to be seen. It creates a feeling of broken color and the typical mixture of color overlapping an underlying one. This way of working is a modern and contemporary style.

EXTRACTION

When the layer of oil paint is thin, a subtractive technique that consists of opening up light areas with a solvent can be applied. A few drops are poured on the surface, or it is rubbed by a cloth dampened with this substance. The color softens with the solvent, and the result is lightened spots and an opening of light areas that leave the white of the fabric or the bright color below exposed.

Mixture applied with badger-hair wash brush that provides a fresh and atmospheric effect.

Extraction made with a single palette knife stroke reveals only the color used to stain the support.

If the oil layer is very thin, it can also be erased with a sponge.

1 Prior to removing the color, it is advisable to moisten the area with a few drops of solvent.

2 Once the paint has softened, it is wiped with the cloth on top to remove the layer of color and open up the light areas.

1

2

CONSIDERING THE BRUSHSTROKE

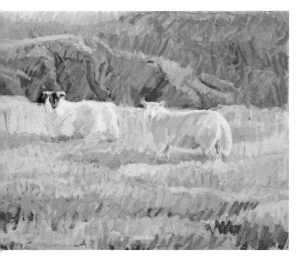

One of the main attractions of oil is the permanence of the brushstroke, which remains visible after its application.
The impression of movement and expression is associated with the direction and the force of the brushstroke, a feature that should be taken into account if we are to convey strong feelings in a painting. Here, we will briefly explain some of the most popular artistic styles or brushwork.

THE IMPRESSIONIST STYLE

Visual impressions of light and color may be created by applying the paint with intentional and short brushstrokes, in such a way that their juxtaposition produces a sketch of the subject. The color is applied thickly and clearly, and the strokes drag part of the underlying color. The brushstroke provides rhythm and animates the surface of the painting.

The effect created with brushwork can turn a simple and monotonous scene into a very dynamic chromatic effect.

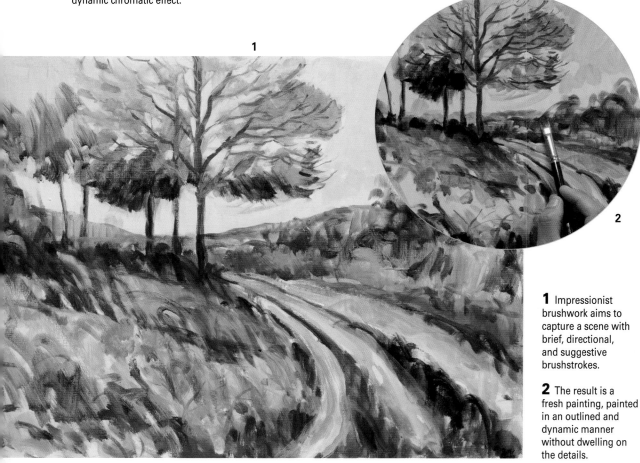

1

2

1 Impressionist brushwork aims to capture a scene with brief, directional, and suggestive brushstrokes.

2 The result is a fresh painting, painted in an outlined and dynamic manner without dwelling on the details.

CHROMATIC EXPRESSIONISM STYLE

The expressionist approach seeks the preeminence of purely chromatic contrasts, developed with areas of bright and saturated colors. Some areas treated with gray, brown, or dark colors are barely visible, and contrasts are achieved by overlapping a range of warm colors with cool colors. The paint is applied in a thick, opaque, and very saturated manner with the color slightly mixed.

POINTILLIST OIL

Pointillist paintings are based on painting with small spots of color or pixels of light. The strokes, when seen from a distance, almost disappear, representing the vibrations of light on the surface of the canvas, accumulating small photons of a saturated and vivid color.

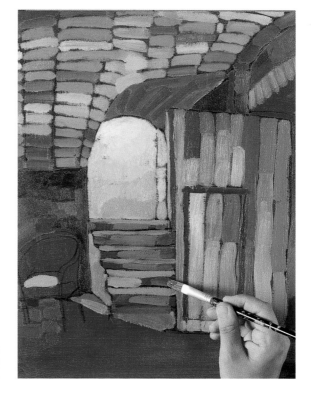

The expressionist interpretation promotes the use of pronounced contrasts among highly saturated colors.

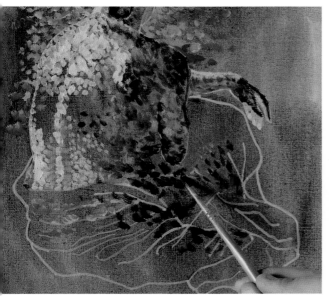

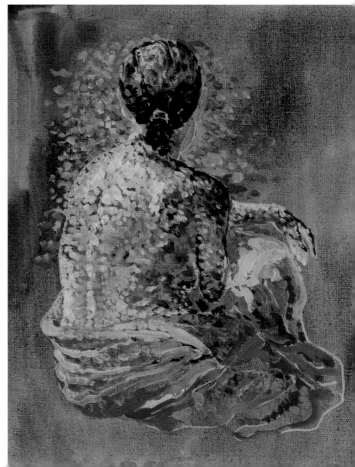

1 In pointillism, the paint is applied through small dots of light.

2 It is better to work on a tonal background to avoid having to worry about covering the white on the support.

Traditional modeling is based on the fusion of colors, which gives the objects more body and makes them look more solid. This effect is obtained by shading the model using fades with a clear intention of creating a chiaroscuro effect; thus, the artist may change from one color to another without causing abrupt cuts or discontinuities.

Modeling Techniques

A

MODELING WITH TONES

Tones are the primary element in the modeling of objects, and are responsible for depicting the relative lightness or darkness of the surface. If the model is created with a tonal range that goes progressively from the lightest values to the darkest, a fade is produced that enhances the modeling effect and the sensation of volume.

This sequence shows the direction of the strokes to create the modeling of the object.

To achieve a good modeling effect, the brushstrokes must follow the direction of each surface on the object.

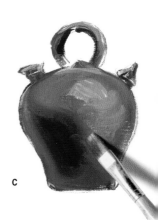

B

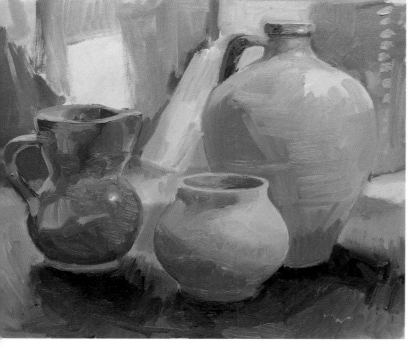

Finally, they are blended with a soft brush.

C

The best way to obtain a fading effect without leaving any brushstrokes is to work with thick, undiluted paint using a soft-bristle brush.

DEVELOPMENT OF THE FADE

Obtaining a fade with a smooth progression of color is essential to modeling shapes. Thick paint is used without thinner. When the paint runs creamily, the mixture is smooth and the outcome is an effortless transition from one color to another. This technique should be applied when modeling objects with curvy surfaces, or with cylindrical or spherical shapes.

REALISTIC PAINTING

Knowledge of detailed construction of tones, and of the lights and the changes in lighting that are produced on a curvy surface, allows for a very realistic interpretation; if in addition to the subject, attention is paid to the details, to highlights, and to the small texture effects, which tend to be applied with a fine brush, the finish may even be photographic.

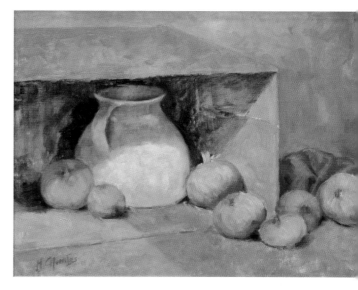

Use the brush carefully when modeling; the brushstrokes should follow the direction of the surface of the object, blending with one another.

1 Modeling can be taken to a degree of extreme realism, where attention is paid to the details, reflections, and textures.

1

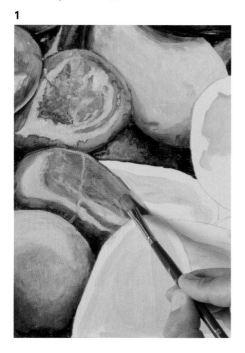

2

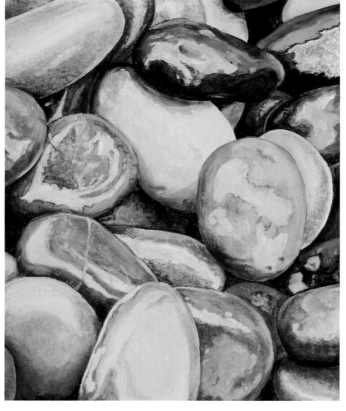

2 The secret of hyperrealism lies in taking the utmost care while modeling and in developing a fading effect very carefully and without leaving any brushstrokes.

Oil on a textured BACKGROUND

Textures are created with oil *when the artist incorporates either substances that modify the consistency of the surface of the support, or solid substances that adhere to or mix with the paint. It is possible to add, for example, stone pumice or marble dust (finely ground) directly to the paint, although it is most common to first prime the medium with gels or modeling paste.*

A

B

C

TEXTURED AND CRACKLED SURFACES

Most texturing mediums and modeling pastes used to paint with oils have an acrylic nature, so it is not advisable to directly mix them with the paint. It is preferable to first prepare the texture on the support and leave it to dry completely before painting over it.

An interesting way of preparing the background is to apply a thick layer of latex paint for interiors, because it cracks when dry. Next, the surface is sealed with a layer of varnish and painted over with oil.

Textures achieved with modeling paste colored with oil diluted in turpentine: directly squirted from the tube (A), thick oil impasto applied with the brush (B), light strokes applied with the brush (C).

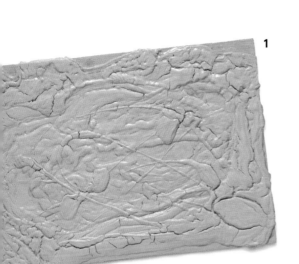

1

1 The support is covered with a thick layer of latex paint and the surface is dried and sealed with a layer of varnish.

2

2 The first spots are added with paint diluted with turpentine, working in the same manner as with any other support.

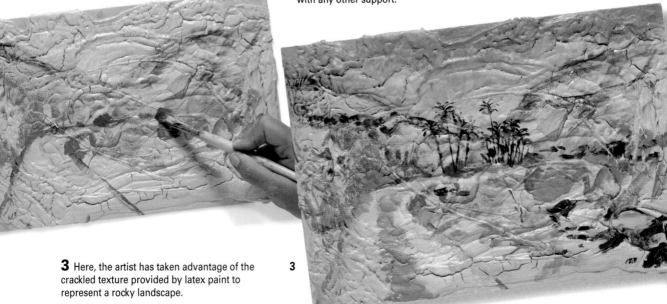

3

3 Here, the artist has taken advantage of the crackled texture provided by latex paint to represent a rocky landscape.

A

B

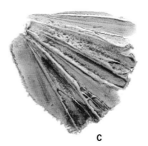

C

D

TEXTURED GELS AND MODELING PASTE

Various materials can be used to prepare the support: a layer of thick gesso, modeling paste, or textured gel. The first two options are consistent substances that allow the artist to apply marks with a brush or a palette knife; the textured gel, on the other hand, has the distinctive feature of having a high material content, which usually tends to be washed sands, marble powder, or pumice rock, which provide a rough and, at times, abrasive surface.

Texture effects achieved with thick gesso and colored with fluid oil paint: applied with the edge of the blade of a palette knife (A), impasto with the lower part of the blade of the knife (B), marks made in the form of a fan with the knife (C), and dragging of light gesso with a knife (D).

OIL DILUTED ON TEXTURE

When a color diluted in turpentine or varnish is applied on a textured surface, the application tends to settle between the cracks and hollows, forming wells that, when dry, enhance the surface relief. Working on a previously prepared surface with crumpled paper or a thick layer of textured *gesso* is very interesting for the artist, since the texture, although light, serves as a dynamic element in the painting.

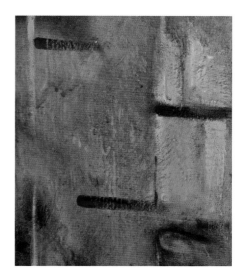

The background of this painting has been lightly textured with a mixture of *gesso* and latex, and then covered with a layer of varnish.

Modeling paste with fillers (marble powder or pumice rock) offers a grayish color that can be modified by covering the dry texture with a layer of *gesso*.

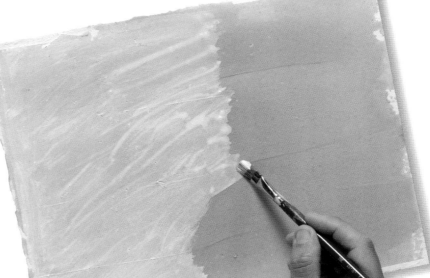

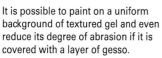

It is possible to paint on a uniform background of textured gel and even reduce its degree of abrasion if it is covered with a layer of gesso.

WORKING WITH GELS AND OIL MEDIUMS

Mediums and gels are creamy substances that are added to oils to obtain different consistencies, thickness, and bulkier finishes. There are many types, from those that alter the consistency of the paint to those that modify their drying time and provide a glossier or more satiny finish.

A

B

A. Although the medium is not entirely transparent, it barely alters the colors when mixed with oil paint.

B. The medium modifies the fluidity of the oil paint; it is translucent and very consistent.

C. A filler (pumice stone) can be added to the paint mixed with the medium or gel to obtain more opaque, solid colors and less shine.

C

The medium thickens the paint and makes the brushstrokes more visible and lasting.

VISCOSITY AND CONSISTENCY OF THE BRUSHSTROKE

When a large painting is made with oil or acrylic impastos, with thick brushstrokes and volume, an alternative is to add media and gels to the color to thicken it further. These substances alter the viscosity of the paint and can be applied with brushes or with palette knives. They add volume, relevance, and sustainability to the brushstroke. Obviously, when the paint is made thicker, the brushstrokes and the strokes of the knife are more marked than if the oil came directly from a tube. In addition, these additives offer an advantage: The greater the quantity of gel, the lower the paint cost, which is especially appreciated by those working with an expensive range of colors.

Some traditional oil paint mediums are Flemish medium, Flemish siccative (drier), and Venetian medium.

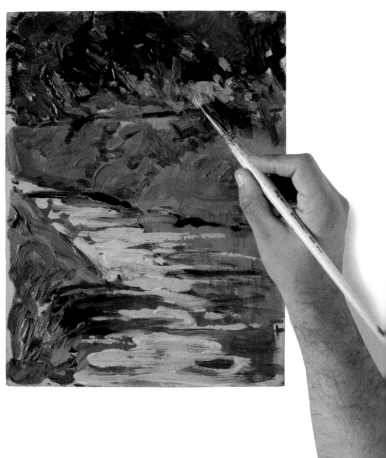

ACCELERATING THE DRYING OF IMPASTOS

Similarly to what happens when a drier such as cobalt drier or Liquin is added when working with glazes, gels and oil mediums accelerate the drying process of paint even when color is layered thickly. In this way, impastos that may take even longer than a month to dry under normal conditions can become dry to the touch in less than a week.

1

The mediums have an oily, gelatinous consistency and a color between caramel and ocher. They are translucent and mix easily with the oil paint. From top to bottom: Flemish medium, impasto, oleopasto, Venetian medium, and Flemish siccative.

2

1 Mediums are used to thicken the paint to enable it to be manipulated more easily on the fabric.

2 Many oil mediums are only versions of oil emulsions, so it is quite safe to mix them with paint.

WORKING WITH A PALETTE KNIFE
AND OLEOPASTO

The painter's knife is an essential tool when painting on reliefs. Many artists use it to spread the paint on the surface and drag it with the edge of the blade. The secret lies in working with determination and confidence, spreading the color using broad hand movements.

When working with a palette knife, it is best to place the impastos synthetically, using textures with creativity rather than being true to reality.

DIRECT IMPASTOS

The palette knife occupies its own highly distinguished place in the oil painting technique. Its metal blade allows for the paint to be applied thickly and directly. When working with it, the paint is mixed a little bit on the palette and is often directly applied on the canvas, with dense strokes, one on top of each other, aiming to distribute the color or outline the shape of the objects represented with movements of the knife.

When attention is paid to the hand movements and different types of knives are combined in the work, this instrument provides very interesting possibilities that do justice to the richness of the material applied with it.

1 The surface created with a palette knife is full of striated or partial mixtures of various colors.

2 Dragging, breaking, and accumulating paint produces a visually stunning impact.

1

2

IMPASTOS WITH OLEOPASTO

Oleopasto is an oil emulsion that increases the thickness and viscosity of the pictorial material in such a way that the stroke of the palette knife is strongly pronounced. This substance also offers the advantage of accelerating the pace at which the paint dries. The process is simple: The color is first prepared on the palette, and then a large quantity of oleopasto is added in the form of a translucent gel. The result of this blend is a viscous mass that is ready to be applied on the painting. If used correctly, it can reduce the amount of paint by 50 percent.

1

1 Mixing oleopasto with oil can increase its volume and pastiness, which facilitates the modeling of the surface relief of the painting.

2 The saturation of paint on the painting's surface allows the paint to be mixed with and drag the underlying colors.

3 Oleopasto facilitates working with the knife; it gives a greater consistency to the painting and accelerates the drying process.

Metal palette or painting knives of different sizes and shapes. The shape and size of the knife determines its use.

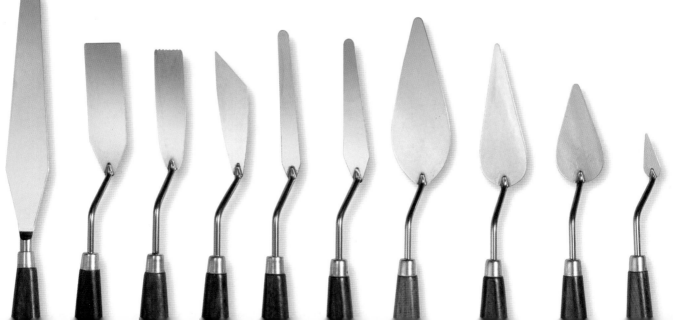

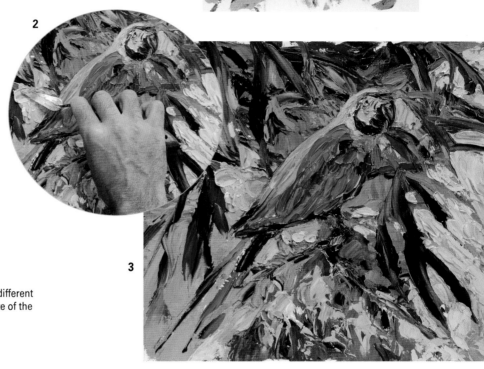

Oil pastels combine pure colors with grease, oil, and wax. Their linear structure allows the artist to create shapes with the stroke. They are usually applied dry on the support, but the stain can be diluted later by scrubbing it with a solvent-laden brush.

Techniques with OIL PASTELS

STROKES WITH SKETCHED BRUSHSTROKES

Oil pastels can be used prior to oil painting or can be incorporated afterwards. They are well suited for jobs that require a highly resilient stroke, and especially for sketches and other work done by hand. The drawings are simple and tend to be based on more or less continuous lines. Next, oil is applied undiluted and thickly; the artist rubs the brush on the canvas to reveal the texture. There are no color blends or continuous gradients; there is no modeling.

Strokes made with oil sticks are dissolved with turpentine.

1 Drawing with an ocher-colored oil pastel.

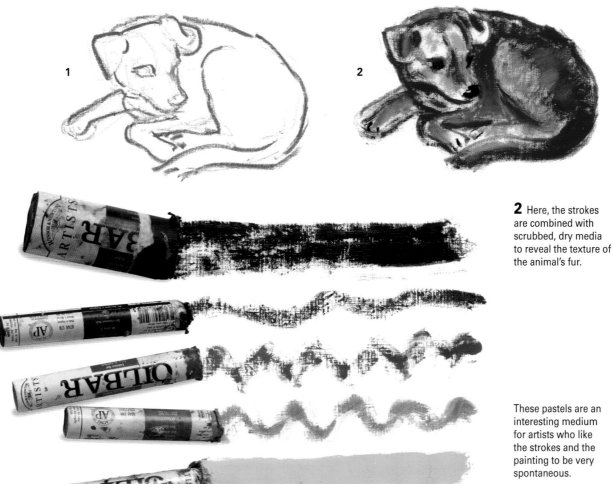

2 Here, the strokes are combined with scrubbed, dry media to reveal the texture of the animal's fur.

These pastels are an interesting medium for artists who like the strokes and the painting to be very spontaneous.

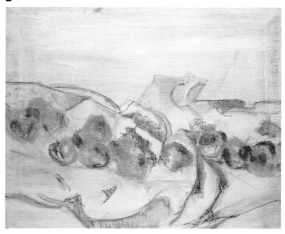

1 The firmness of the brushstroke provided by the oil pastel allows it to represent a still life with linear strokes, by structuring the basic shapes.

2 The strokes are blended by passing a brush moistened in turpentine over the top, or even by blurring them with the fingers.

DILUTED STROKES

The shapes are created with thick and pasty strokes from the mass or the linear structure, offering a very pronounced and well-structured design. Then, a brush moistened with turpentine is passed over it to decrease the intensity of the line, thereby achieving a milder and more transparent stroke. While the paint is fresh, some masses can be blended with the finger to emphasize their corporeality.

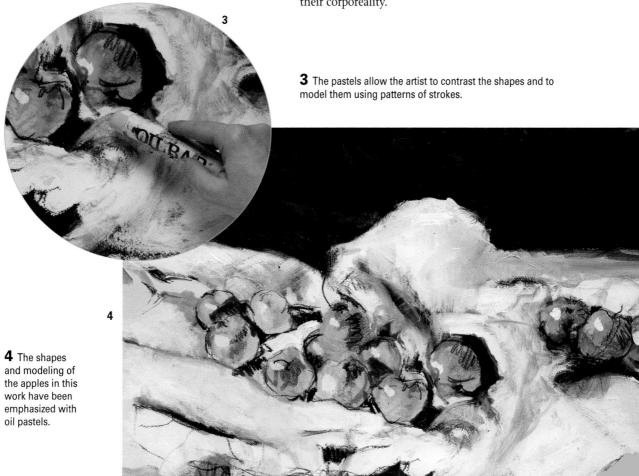

3 The pastels allow the artist to contrast the shapes and to model them using patterns of strokes.

4 The shapes and modeling of the apples in this work have been emphasized with oil pastels.

ENCAUSTIC PAINTING AND WAX

When wax is added to oil paint, its volume increases and its consistency is altered. Wax is often mixed with oil to achieve the effects of transparency or a dense, creamy texture. There are two basic ways of working with it: either hot or cold.

ENCAUSTIC PAINTING: HOT WAX

Wax for encaustic painting, which is used by many contemporary artists, is composed of refined beeswax or white paraffin; either is a suitable material. The mixture with oil is made not on the traditional wooden palette, but rather on a metal one that is kept hot by using a stove or with candles placed underneath. Wax that has been melted by heat mixes easily with oil and is applied immediately on the support. The brush must be worked quickly, since you have only a few seconds before the paint solidifies on the bristles.

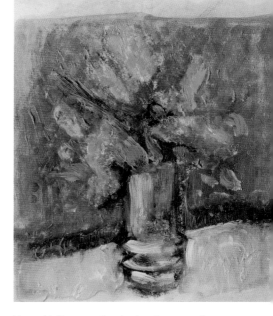

Vase with flowers painted using the encaustic technique. The hot-painting technique has been used with melted wax.

When oil colors are mixed with wax, a creamy and semitransparent brushstroke is obtained.

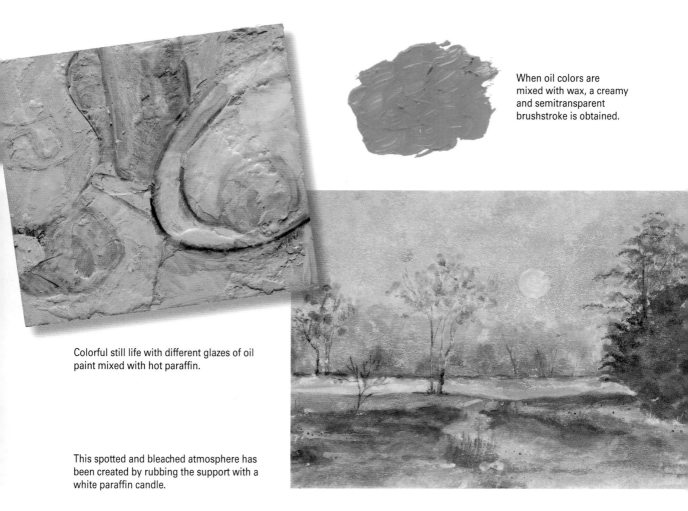

Colorful still life with different glazes of oil paint mixed with hot paraffin.

This spotted and bleached atmosphere has been created by rubbing the support with a white paraffin candle.

TEXTURES WITH WHITE WAX OR PARAFFIN

If the surface of the paper or primed board is rubbed successively with a white candle, the result is a very interesting texture—a layer of granular texture that incorporates irregularly shaped oil washes. A bristle brush can also be loaded with some liquefied candle wax, which is applied on the support while hot. Fine art stores sell paraffin granules that can be melted in a double boiler and mixed hot with oil.

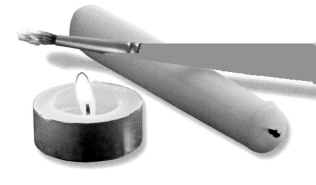

To obtain liquid wax, just take a bit of melted wax from the base of a flame with a brush.

Gel wax can be bought in fine arts stores and allows the artist to work with cold wax.

MIXES WITH COLD WAX

There is a gel wax that allows the artist to work without having a hot palette. Its consistency is reminiscent of pork fat, since it is very creamy and mixes easily on the palette with oil without being heated up. Like paints, it is dissolved in turpentine and the final result is very similar to that provided by hot wax, but without the inconveniences that the latter involves.

Gel wax is white, mixes well with oil, and tends to become more transparent once dry.

1

2

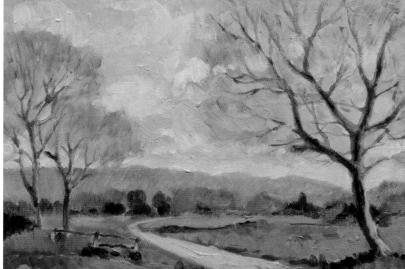

1 Wax gel gives an extremely creamy and oily appearance to the surface of the painting.

2 The final texture of oil works involving wax gel combines the impasto with the transparency and luminosity of the colors.

Sgraffito and RUBBER BRUSHES

Sgraffito is not necessarily a way of painting, but rather a way of manipulating the paint once it has been applied on the support. This technique consists of applying a coat of paint on the canvas and constructing images by removing the paint in some specific areas. Sgraffito can be done with different instruments; the most common ones are the handle of a brush, a metal palette knife, a sharp pencil, and rubber-tip brushes.

EFFECTS WITH RUBBER BRUSHES

Rubber or India rubber brushes make it possible to remove the paint from an area covered with a dense layer of color; they are useful for opening up white areas, adding linear marks, and even giving the effect of texture. The possibilities of these brushes are diverse because they allow different strokes according to their inclination and the shape of their tip. Rubber tends to remove color, enriching the work with interesting linear marks in the form of scribbles on a thick base of color.

Sgraffito made with a sharp pencil allows for recovery of contours and linear shapes.

1

1 The rubber brush provides robust sgraffito that helps to simulate the texture of the vegetation.

The main purpose of the rubber or the India rubber tipped brush is to remove part of the pictorial layer, thereby creating engraved textures.

2

2 The combination of dense paint and sgraffito made with a rubber brush in the same work gives the overall painting greater graphic variety.

A. Sgraffito technique with the sharp tip of the knife.

B. With the side of the blade.

C. With the rounded tip inclined.

D. With a rubber-tipped square brush.

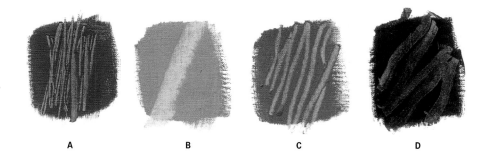

A B C D

CREATIVE SGRAFFITO

If the idea is to follow a very creative experimental line, one can switch between primers made with modeling paste and oil stains, to which sgraffito can then be applied with a scraper or a metal knife. The finest lines can be drawn with a pencil as long as the paint on the surface remains wet. This technique is not only suitable for adding graphic effects and lines that are combined with more homogeneous color areas, but is also used by many artists to recover contours and linear forms that have been lost in the brushwork.

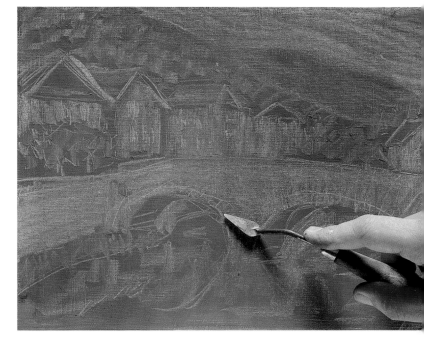

By combining the different sgraffito effects that a metal palette knife can make, one can even sketch a composition.

The sgraffito effect on a layer of modeling paste reveals part of the underlying oil layers.

Here, an orange background has been covered with a layer of drying varnish mixed with bitumen. To apply the final finish, the artist engraved a few small lines with the tip of a metal palette knife.

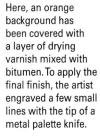

Monotype is a technique that consists of painting the image on a plate or other surface; it is then transferred onto paper by applying pressure. This method creates effects that are truly different from those of painting directly with oil paint on the support, since there is a transfer of color that is similar to transferred images and printmaking. But it is not a true print, as every monotype is unique and unrepeatable.

Monotypes
WITH OIL

APPLY THE PAINT

To create the monotype, it is advisable to have a sheet of polyurethane at hand. Color can be applied over it with diluted oil applied with a brush or a sponge roller. The paint film must be flat, and thick impastos should be avoided. Light areas can be opened up by removing part of the coat of paint with a cloth or by placing a reserve made with a cardboard template.

The oil monotype has a strong graphic force that is reminiscent of stamping techniques.

1 It is done on a plastic polyurethane sheet. In this case, oil is applied with a roller.

2 To erase or lighten, use a sponge slightly moistened with turpentine.

3 A template cut from cardboard is used, and some touches are made with oil directly from the tube.

4

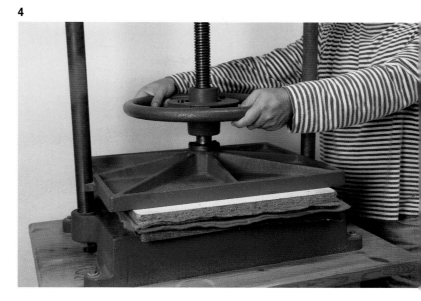

PRESSING AND TRANSFERRING

On a painted polyurethane plate, a sheet of paper—preferably fine grain—is applied on the fresh surface of the paint. The paper is pressed and flattened with the hand so that the layer of color underneath is absorbed. A press can also be used to exert greater pressure and ensure the transfer of the paint. In these cases, it is advisable to slightly moisten the back side of the paper with a sponge and place a piece of felt between the back of the artwork and the press to avoid damaging the work. The final monotype is a combination of techniques: spread spots of color, erasures, and templates, all made with oil, but whose style powerfully recalls the force with which the prints are transferred.

4 A piece of paper is placed on top of the plate and pressure is applied so that the paint is transferred.

5 The result is a combination of spread areas of color, erasures, templates, and direct drawing on paper.

Monotype is a testing ground for experimenting with shapes, sgraffito, and dragging with the knife. The result is always exciting.

5

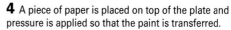

The polyurethane plate is cleaned with turpentine, and is now ready to be used to transfer the version of another monotype in which the composition and the colors vary.

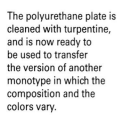

CREATIVE TECHNIQUES: FLUID OIL

This section is dedicated to enthusiasts of abstract oil painting, to those who have a restless spirit, and to daring artists who want to experiment and blend oil with other fluid techniques, and who are aware that they will obtain a less orthodox, but very striking and expressive outcome. Here, fluid oil is expressed freely, abstract images being the most appropriate for these works.

A

B

C

FLUID OIL WITH VARNISHES

Oil paint combined with varnishes increases fluidity, brightness, and transparency. This technique forces the artist to work with the flat support on a table, but provides a new field of possibilities in the world of mixing color. When applying fluid paint mixed with varnish, the artist can pour the paint over the fabric, allowing the fluid itself to create the mixtures. The result is an abstract work of great visual and chromatic impact, which effect can be completed by spreading pigment powder or ashes when the varnish is still in a mordant state.

A. Oil can be applied diluted in turpentine or even varnishes, providing uncontrolled fusions and interesting chromatic effects.

B. While the varnish layer is still wet, powder pigment or ashes can be spread out over the top of it to achieve various texture effects.

C. The fluidity provided by varnish oil makes it necessary to work a flat support on a table to avert running paint and dribbles.

D. This time, oil impastos are combined with a layer of walnut-colored varnish and synthetic ivory glaze.

E. This piece combines the oil painting with the collage and additions of black and silver paint.

F. A black synthetic coat of paint is added on top of the oil-based stains.

D

OIL AND SYNTHETIC PAINT

Another experimental technique is when the artist first creates the background of the painting by applying diluted oil paint stains, either with linseed oil or directly with turpentine. On the fresh paint, large stains, splatters, or drops of synthetic paint (which is used to paint metal or furniture) are added. Finally, both colors are mixed naturally. Synthetic painting is characterized by the spatters and high-quality linear runs that provide strength and dynamism to the composition.

E

F

CREATIVE TECHNIQUES: TEXTURES AND FILLERS

The preparation of a textured surface is an important element in abstract or semi-abstract treatments. The purpose of including textures in oil paint is to modify the final perception of the colors, as if the artist were trying to challenge the observer's common sense or confuse the viewer with new effects that are added to the purely chromatic ones.

CRUMPLED PAPER

The bottom of the support can be prepared using different glued scraps of silk paper, or even crumpled newspaper. This provides chromatic surfaces that are full of micro wrinkles or volumetric shapes with reliefs and highly pronounced creases. Some people prefer to include scraps of fabric, paper towels, or even toilet paper. Each material has different types of creases depending on its malleability and consistency.

1 Paper balls are made with wadded-up newspaper and are glued to the canvas with plenty of latex glue.

2 The fully dry paper texture is painted with thick oil in the usual manner.

3 Crumpled paper offers interesting low-relief effects on the support's surface.

Once the support has been soaked with extra-thick latex glue, different types of materials can be included—from scraps of crumpled paper to all kinds of fabric.

1

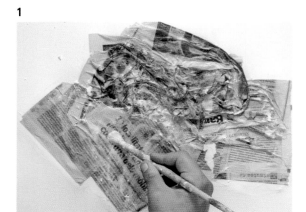

2

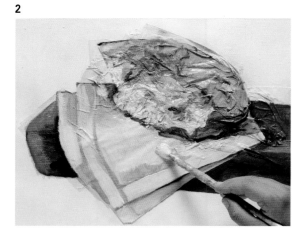

3

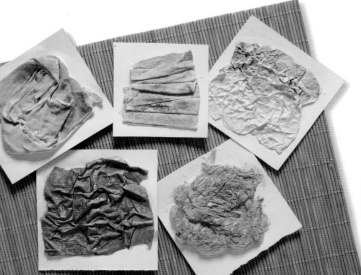

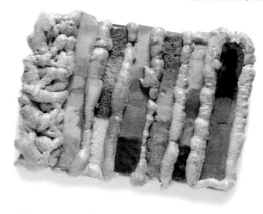

TEXTURED MATERIAL

Oil is mixed with sand and marble dust, and is deposited in large quantities on the support to create a very sharp, abrasive texture that allows for new dynamic and more expressive possibilities. The textured base in which oil, oleopasto, sand, and marble dust have been mixed is painted over with bristle brushes, as these brushes have the highest resistance when rubbed against very abrasive surfaces. The final result is solid and intense, and does not allow for the adding of details.

RELIEFS WITH FOAM RUBBER

Polyurethane foam is a porous plastic material formed by the aggregation of bubbles, popularly known as foam rubber, that is sold as a spray. If directly applied on the support it inflates until it becomes 4 inches (10 cm) thick. Once solid, it is a light and highly resistant material that can be covered with a thin or thick coat of oil paint. The final effect is impressive.

A few minutes after foam rubber is applied to the support, it becomes inflated until it reaches a volume between 3 and 4 inches (8 and 10 cm). Once dry, it is ready to be painted.

When too much paint is added to the oil, the work is feasible only with palette knives; the brush becomes useless.

Adding sand or marble dust to oil produces a marked texture that breaks the lines and prevents the addition of details.

After a first testing phase with foam rubber, the shapes can be worked even better with a highly pronounced relief effect.

Foam rubber is marketed in sprays at DIY stores.

The consistency and the quick-drying quality of acrylic paints have turned them into one of the most widely used media by contemporary artists embracing abstraction.

*A*crylic paints have wonderful qualities that in some cases enable the artist to match, or even surpass, works created with traditional painting techniques. Acrylics are offer the transparency of watercolor, the opacity of gouache, and the density of oil. Its resinous component provides acrylic paint with consistency, viscosity, and stability. In addition it has an advantage that is highly prized among today's artists: it is quick drying.

ACRYLIC PAINT

ACRYLICS: ADVANTAGES AND DRAWBACKS

Today, acrylic paint has become as widely accepted as oil paint and is very popular among both amateur and professional painters. It has gained a reputation for being an affordable, easy-to-use, quick-drying medium that has many similarities with oils.

COMPOSITION

Acrylic colors are agglutinated pigments contained in synthetic resin: a polyvinyl acrylate emulsion that dries when water evaporates, and captures the particles of pigment among its molecules, which are suspended, thus forming an elastic, transparent, and highly resistant film. The greatest advantage of acrylics is how quickly they dry, but this characteristic is also their greatest drawback since it prevents the artist from manipulating the paint on the support for any length of time.

A

Versatility is an attractive characteristic of acrylics. They allow the artist to apply washes or glazes (A), dense paint impastos (B), or fading effects with little dilution of color on the brush (C).

B

C

This paint can be applied to form dense impastos, combining colorful, vivacious, and highly concentrated masses.

Its straightforwardness means it can be used to conduct tests and experiments that would not be possible with other media.

ELASTICITY AND DURABILITY

Elasticity, greater transparency, and resistance are virtues that characterize acrylic paint and distinguish it from all other pictorial media. Once the paint is dry, the canvas can be rolled up and tightened again without fear that the pictorial surface will break. Unlike oil, acrylic paint does not turn yellow with the passing of the years, which enables it to be applied directly on different media, among them, fabric, wood, or even paper.

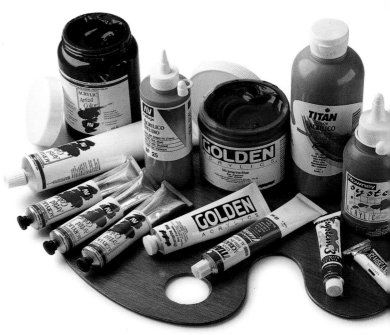

Different paint formats cater to the artist's needs.

CONTAINERS AND PACKAGING

Acrylic colors are sold in tubes, bottles, and jars. Acrylic tubes are often the same size as those used for oil paints. Bottles and jars can come in various kinds and capacities, from small containers with a dispenser to three-liter containers.

If it is carefully worked and if the surfaces are modeled, acrylic paint also performs well for the representational painter.

Acrylics are marketed in tubes, just like oil paints. This may be the cleanest and easiest format to transport.

A

Applying plain color, dry brushstrokes or diluted stains is a good strategy to begin the staining of the painting. In this approach, the shades and the details of the model are set aside and the artist can better concentrate on the chromatic essence of the different parts of the work.

Staining WITH ACRYLICS

WORKING WITH FLAT BRUSHES

Acrylic paint can be used with a flat brush and in a simplified way. Making a light mixture of different colors is a way of coming up with the first sketch. The flat or wash brush prevents the work from becoming too complicated and allows the artist to concentrate on an image rendered through truly simple mixtures.

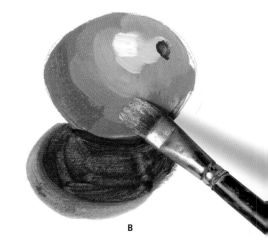

A. Acrylics applied with a flat or wash brush make striations with the bristles because of the paint's thinner consistency.

B. The first staining is usually made with fluid paint and flat brushes in an attempt to develop a first tonal approximation of the subject.

C. The flat brush helps to rapidly resolve an initial staining without having to pay attention to details.

B

C

Artists used to painting with oil find it easy to become accustomed to acrylic paint due to its immediacy and fast drying.

DRY BRUSH

This is a common technique involving loading the brush with a minimal quantity of paint, without diluting it in water, and stroking it along a textured surface so that it sticks to the grain. If you will be using this technique a lot, ensure you are well stocked with various bristle-like brushes, since they are the most appropriate for this kind of work.

1 The dry-brush technique is highly vaporous. The color tends to be applied by making a light rubbing movement with a strong-bristle brush.

2 The advantage is that the colors overlap, creating an effect quite similar to glazing.

APPLICATION ON CRUMPLED PAPER

Diluted paint stainings can be applied on a surface previously prepared with slightly crumpled silk paper soaked with latex glue. Microspheres can be distributed in a controlled manner on wet glue. After one hour, it is possible to start painting with diluted stains. The textured preparation gives it highly interesting jagged and rough contours. The staining is finished with linear drawings using a Conté crayon.

1 If working with diluted paint on a slightly textured base, the staining produces more inaccurate contours.

2 Staining consists of filling each area with different shades of color, with more or less even applications of flat color.

3 It can be finished by overlapping with a linear drawing made with a black Conté cryon.

WASH
TECHNIQUES

Acrylic paints can be used in a diluted manner, by overlapping several layers of transparent color. The advantage compared to watercolor is that, once the paint is dry, it is no longer soluble, which permits a greater overlap of the glazes without the color's getting mixed since the color coating is totally sealed.

ONCE THE ACRYLIC IS DILUTED

Once diluted with water, acrylic paint loses body and becomes lighter in color; however, if it is diluted in a medium, it becomes lighter in color but retains its density. By diluting the paints in plenty of water or in a medium, as is the case with traditional watercolors and oils, one can produce delicate washes and glazes through which the white surface of paper or canvas is reflected, which increases the luminosity of the colors.

A touch of color created with a mixture of acrylic paint, medium, and water. Fluid spots reminiscent of ink can be obtained with it.

Acrylics can be applied on any surface, except on a greasy or oily base paint or on a highly polished plastic surface. In such cases, the diluted paint is rejected.

Acrylic's fast drying time means the artist can overlap several glazes within a very short period.

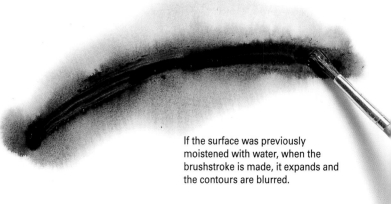

If the surface was previously moistened with water, when the brushstroke is made, it expands and the contours are blurred.

ACRYLIC ON WET SURFACES

Acrylics makes it possible to paint on wet surfaces. The procedure is simple: The surface to be used is first doused with water, and the colors are then applied. With each brushstroke, the pigment is randomly and uncontrollably expanded, producing truly vaporous and atmospheric effects.

FLUIDITY BOOSTER

The pigment of acrylics is not as homogeneously distributed as that of watercolor. To increase the consistency of the pigment within the vehicle, we may add a fluidity booster, or a little bit of matte or brilliant medium, to the paint.

To dilute the color evenly, we add a booster medium that increases consistency in the washes.

1

1 Diluted acrylic can be applied in a way that is very similar to watercolor, to such an extent that the two media are confused.

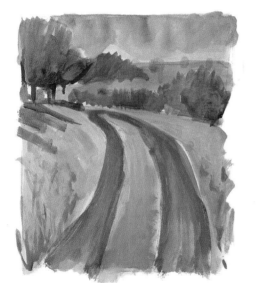

Touch of color made with several acrylic glazes treated with a fluidity booster.

2

2 The main difference between acrylics and watercolors is that with the former, each color glaze is fully sealed after it dries.

Sponges
AND ROLLERS

Acrylic allows for the possibility of experimenting with different sponges, which are wonderful tools for creating effects and special textures. They are useful for enhancing creative work and making your painting more expressive and less detailed.

Still life of two lemons in which an imaginative and expressive treatment has been applied that combines different strokes and contributions made with different kinds of sponges.

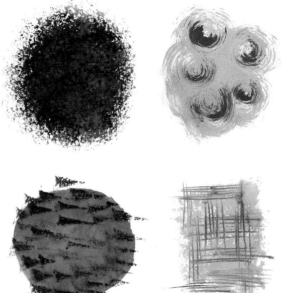

PAINTING WITH SPONGES

Different effects may be obtained based on the type of sponge used, which means it is worthwhile to have different types at hand and experiment with them a little bit prior to beginning an artwork. When working with a sponge, we mix the paint on a plastic or ceramic plate; therefore its consistency should be neither too thick nor too thin. The sponge is wet, wrung out by hand, and used on the support as if it were a paintbrush. It is not advisable to use it in small-scale works, as it is inadequate for these.

Sample of different effects obtained with the dragging technique, rotations, or simple pressures with the sponge full of paint.

Different sponges for working with acrylic: a foam brush, a synthetic sponge, a foam roller, various types of synthetic sponges, and a natural sponge.

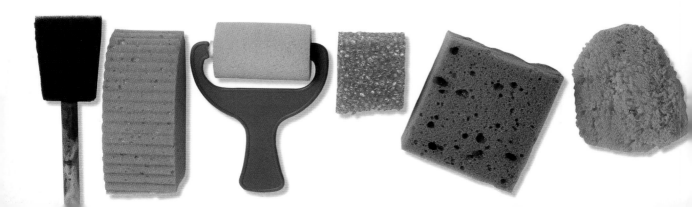

ROLLING

The sponge roller can also be a useful paint tool. Simply deposit paint on a plate and spread it on the support with a roller. This tool provides a wide, semicovering stroke without exact borders and with blurred edges. If the roller doesn't have much paint, the result is even, glazed, or translucid layers of color and shows no traces of brushstrokes.

The brush sponge offers wide and striated strokes. The final effect will depend on the load of acrylic paint and its degree of dilution.

FOAM ROLLER

The foam cylinder is inserted into a handle for easy handling. It can be used to create wide, diluted stains, which are characteristic of the use of this tool. The lesser the water content, the finer and more pronounced the striations, whereas excess dilution leads to a wide and homogenous stroke.

1 The roller-extended color makes it possible to achieve trimmed or blurred contours, depending on which of the two ends is used.

2 Color layers can be overlapped one on top of the other, but we must bear in mind that, once dry, they become more transparent.

1

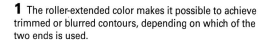

2

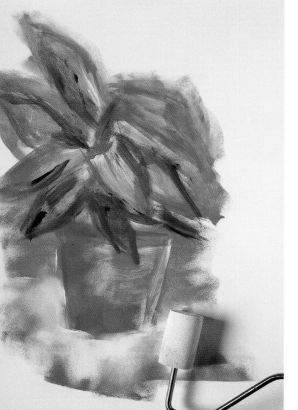

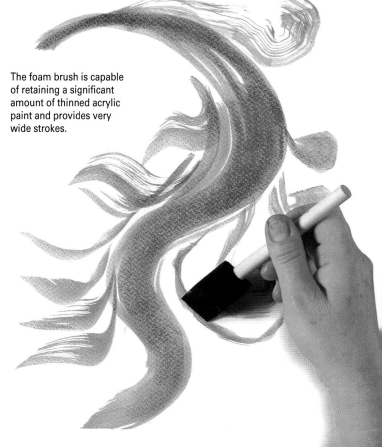

The foam brush is capable of retaining a significant amount of thinned acrylic paint and provides very wide strokes.

Undiluted acrylic paint has a thick consistency. Acrylics are used similarly to gouache or oil, although they don´t have the same covering power. The colors are overlapped, with the top colors covering the lower ones to modify or complement the tones.

Opaque Techniques WITH ACRYLICS

A DASH OF WHITE

Many artists add some white or acrylic gesso to make the paint look more opaque. However, white must be added carefully and in a small quantity, since it may alter the tone of some colors. It's important not to put too much gesso in the paint because the glossy quality of acrylic paint can give the final finish a plastic-like appearance.

1 Including a dash of white in the mixture adds greater opacity to the brushstrokes.

2 Dense, opaque paint is merged directly onto the support in a manner similar to the treatment of oil paint.

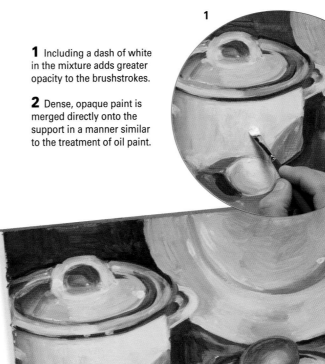

1

2

Some acrylic colors may seem opaque but become transparent when dry. To avoid this effect, cover the area with a white layer of titanium before applying the acrylic. Once dry, the titanium layer may be painted over.

When applied thickly, acrylic colors appear to be saturated and opaque, offering strong color contrast.

NOT ALL THE COLORS ARE OPAQUE

Some acrylic colors, such as cadmium red and yellow ocher, have an opaque nature. Others, because of the smaller amount of pigment they contain, do not; the most notable cases are quinacridone red and the shades of yellow. Painting with these colors on top of intense ones can be a problem. Pre-painting the area in question with a coat of white can ameliorate this difficulty. In this way the overlapped color will not lose its intensity and will look bright.

In this painting, image transfers from photocopies and covering applications of acrylic paint are applied.

OPAQUE WITH FLAT APPLICATIONS

Working on flat areas implies simplifying the model by establishing its main shade and color areas, and applying the paint coat by coat, juxtaposing covering and even color coatings. The model is built based on clearly differentiated shades of color without there being any blending among the colors or fades.

Flat acrylic color applications can imitate gouache-made illustrations.

Sphere recreated with flat color applications without blending or fades.

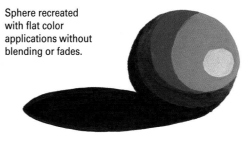

ACRYLIC WITH KNIVES

The density of acrylic paint, together with its perfect stability upon drying, allows for an ideal treatment of the blended stroke with the palette knife or spatula. The knife deposits the paint so it can be dragged, thereby producing a 3D effect with intertwined and intermingled colors offering unique and decisive movements.

Plastic knives and spatulas are more fragile than conventional ones, but their advantage is that they do not rust, which makes them useful for painting with acrylics.

PALETTE KNIVES FOR ACRYLIC PAINT

The blades of the palette knives are flexible and ideal for working on wide areas of color. The small, diamond-like metallic knives are the best for small formats, whereas the big, rounded-tip ones are for working on larger areas. Acrylics tend to be used with plastic knives or spatulas, but you must be careful not to overbend them (they don't always return to their original shape) and to clean them right away after each application before the dry paint ruins them.

Paint dragging, breaking, and accumulation applied with the palette knife produce a striking relief.

Working with the knife makes it possible to apply dense and opaque color coatings on a darker background.

A. Direct application of acrylic paint with a knife.

B. Acrylic paint mixed with *gesso*. Note that acrylic colors are not extremely saturated.

A

B

1

APPLICATION WITH A PALETTE KNIFE

The main difference between working with acrylics and with oils lies in the fact that acrylic is less dense; undergoing a small flattening process, loses 20 percent of its mass when dry. The secret of painting with acrylics using a knife is to alternate the tool's position when working, using flat base applications for the widest spots, the edge of the blade for contours, and the tip for small applications and textures.

GESSO WITH ACRYLIC

Gesso, when mixed with acrylic, gives the paint greater consistency and volume; it adds a matte finish, and the colors appear to be more luminous and bleached out. Given its pastiness, it can only be applied with a knife. When both dyes are mixed irregularly on the palette, the result is a striated paint. Even though the painting loses definition, the mixed spots of color make it more expressive.

2

1 Each color is mixed on the palette with some *gesso*, which gives it greater volume and thickness and is later applied to the support with a knife.

2 There is no mixing with the knives—only slight transitions from one color to another. This is due to the rapid drying of the acrylics and the *gesso*.

3

3 Acrylic and gesso impastos applied with the palette knife add great vitality and a pronounced relief. The greater volume of the pictorial coat makes it possible to include sgraffito.

Abstract acrylic paint on fabric made with large, rounded-tip palette knifes. The color is dragged to cover all areas in an irregular manner, forming undefined, imprecise contours.

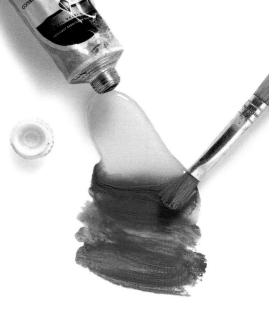

There is a wide selection of substances *known as mediums that can be mixed with paint to modify its fluidity or help create specific effects. If intending to explore all of the creative possibilities of acrylics, one must become familiar with the appropriate mediums and discover how they interact.*

Acrylic MEDIUMS

GLOSSY, MATTE, AND SATIN MEDIUMS

Ordinary acrylic paints, when dry, have a semi-matte finish. If water is not added, their shine is similar to that of an eggshell, which is the reason that some artists prefer to include a bright medium that, in addition to thinning the paint, enhances the color's luminosity and makes the finish more saturated once dry. The other option is to work with a matte medium, which involves using a wax or silica emulsion that, when dry, produces a shine-free, non-reflective surface. To achieve a glossy effect, it is sufficient to mix the glossy and matte medium in equal proportions.

Mediums give the paint greater consistency and prevent the excessive dispersion that can otherwise take place when paints are thinned in water.

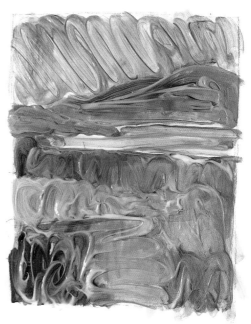

After the shiny medium is mixed with acrylic, the paint has greater viscosity and a glossy finish.

Once dry, the medium becomes more transparent and only the glaze of color remains, which can create interesting textures and thus enliven the painting's surface.

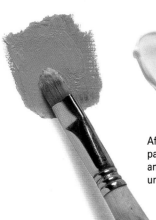

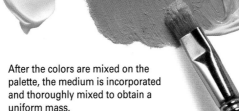

After the colors are mixed on the palette, the medium is incorporated and thoroughly mixed to obtain a uniform mass.

HOW TO WORK WITH MEDIUMS

Instead of thinning the paint with water, artists can use a medium as a thinner to prevent the paint from losing its properties or stability. The colors are first mixed on the palette and, once the desired color has been attained, a small quantity of medium is added with the brush. It must be thoroughly mixed to allow the color to become homogeneously distributed. Water is then added and the mixture is applied to the support.

DRYING RETARDER

It is the main solution to the main disadvantage of acrylics: their quick drying. The retarder extends the paint's drying time for many hours, which means it can be manipulated for a longer period, especially if one is using wet-on-wet or mixed smooth colors.

Retarder gel is transparent and can be bought in bottles or tubes. It is added to the paint to prolong the drying time.

1

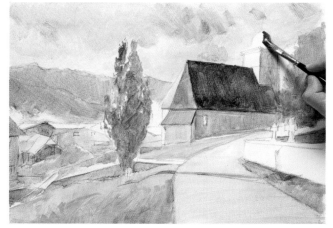

2

1 Work with glazes can be done on a matte surface to avoid having the colors become dull and to ensure quick drying.

2 The initial glazes dry in just a few minutes, which enables the overlapping of the new veiled layers with the previous ones.

3 The finish, though simple, produces great luminosity thanks to the medium's transparency and thickness, which allows some of the brush's strokes to be visible.

3

Opaque and TRANSPARENT IMPASTOS

One of the main advantages of acrylic paint is that *it can be combined with a large number of mediums, to excellent effect. There are many relief pastes, gels, and fillers on the market that are perfectly compatible with acrylics. Note that all the gels and the most of the pastes are white when wet, but become transparent upon drying.*

Special-texture paste for acrylic impastos. This thickening gel, when mixed with paint, increases its volume.

A B

Acrylic gel is a white milky substance (A) that becomes transparent when dry (B).

ACRYLIC PAINT VOLUME

Acrylic paint has less volume and consistency than oil, besides which mass is reduced by 30 percent after it dries. To make impastos, it is advisable to mix the colors with a thickening gel, because acrylic paint directly from the tube has a low consistency. It is through the addition of the gel that acrylic paint becomes more malleable while remaining enough to preserve the application made with the palette knife or a dense and striated brushstroke.

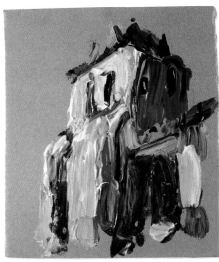

Impastos made with acrylics and mediums add greater stability; the colors remain vibrant and do not undergo perceptible alterations over time.

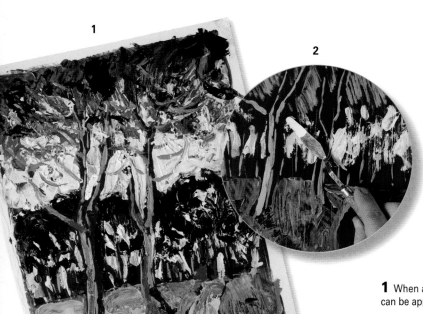

1 When acrylic impastos are dense and opaque, they can be applied on any surface or color background.

2 The thickness of paint, coupled with the mixture of the colors directly on the medium, provides a very expressive finish.

PHYSICAL PRESENCE OF IMPASTOS

Generally, impastos are dense and covering, and enable the creation of superficial reliefs and suggesting textures. The mass of paint has a significant physical presence that tends to protrude from the painting's surface. Therefore, the artist who wants to maintain the depth of the painting will need to reserve the impasto for the foreground or the main focus of the painting.

The mixture of a small quantity of acrylic with the medium or with abundant gel results in a transparent impasto.

A

B

Two possibilities for applying impastos with acrylic gel: In the first, pressure is applied slightly with an acetate and then removed to obtain the crackle appearance (A); in the second, the paint is kneaded with a brush (B).

1

2

1 The transparent impasto, if not dry, has a bleached appearance. It is advisable to let the painting dry before assessing the final result.

2 Once dry, the impasto becomes more transparent and the underlying colors can be seen.

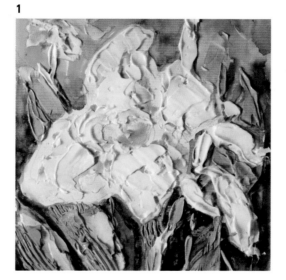

GLAZED IMPASTOS

A small quantity of acrylic paint mixed with plenty of thick gel allows the artist to create textured transparencies, that is, slightly color-dyed impastos that, when dry, turn translucent and offer a glimpse of the colors underneath. This means some models can be produced by overlapping thick and glazed veilings, to which the modeling effects and the palette knife's typical scratches are added.

Landscapes can be made using transparent impastos by overlapping thick and glazed veilings. The knife's typical modeling effects are then added.

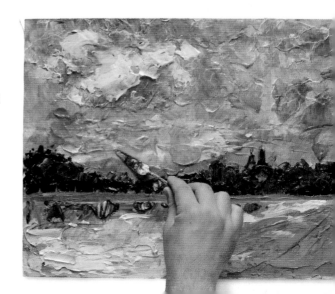

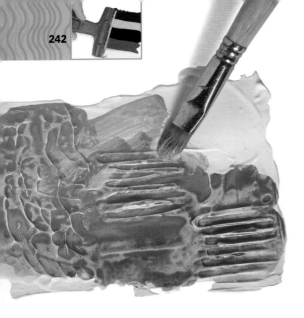

When applying glaze on a textured surface, the artist deposits the color in the grooves to enhance the surface's relief.

There are two basic ways of producing textures with diluted acrylic. One option is to work on a dry surface on which gesso impastos or modeling paste has been previously applied. Another is to try to crackle or break up the wash's uniformity using different mediums so that its application does not look uniform, but rather broken and cracked.

TEXTURES WITH DILUTED ACRYLICS

WASH ON TEXTURE

Prior to applying the color, the artist prepares the medium's surface using a modeling paste or gesso. It is applied using a palette knife, and the shape is modeled by adding texture with our preferred marks and sgraffito. The paste can provide texture, for example to represent the bark on a tree. It is painted with diluted acrylic on the dry texture. The watery color is deposited in the grooves, enhancing the surface's relief.

1

2

3

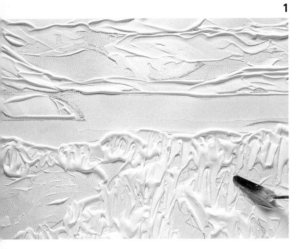

1 The artist forms the landscape using gesso and a palette knife, trying to trace the texture in each area.

2 The *gesso* is allowed to dry for a couple of hours and then covered with thinned acrylic paint.

3 The exercise is concluded by using two or three color glazings. It is important for washes to be very transparent so that the *gesso's* white color is noticeable.

A B

Two samples of cracking paste: The first is applied as it is taken out of the bottle (A), and the second is mixed with acrylic paint (B).

ACRYLIC WITH SOAP

One way of applying a truly textured acrylic wash is to dilute the paint with soap and mix it up. The color mixture is prepared on the palette; the paintbrush is then moistened and rubbed firmly on a bar of soap, after which it is used to stir the mixture. Finally, this mixture of paint and soap is spread with choppy brushstrokes to allow air bubbles to form, which, upon drying, will produce a very characteristic mottled appearance.

OIL AND ACRYLIC MIXTURE

Oil and acrylic paint are two incompatible media; however, that incompatibility can be used to create textures. When water is mixed with oil paint, bubbles and curious forms are produced, which can be taken advantage of artistically.

The refusal effect produced between oil and acrylic paint can be taken advantage of to obtain textured washes or partial blends among colors.

CRACKING PASTE

There is a cracking paste that can be directly applied as a base to be painted on, once it is dry or well mixed with the color, without losing its shape. If it is later decided to paint over it, the color to be applied must be highly diluted. The thicker the layer, the more extensive the crackle; thinner layers result in fewer cracks and breaks.

Landscape on a background to which latex, ash, and small granules of sand were applied previously.

To prepare a textured base, a plastic bag and an average grain modeling paste are applied and, once dry, painted over.

Dripped PAINT

Acrylic paint has some very marked plastic qualities that enable it to be used in a way that traditional paints cannot. One of them involves directly splashing it on the support using the acrylic bottle's dosing nozzle sold for this purpose.

Extruding or dripping paint directly from the tube produces bands of color with a pronounced relief.

Once the dripped paint is dry, the process can be completed by using a brush to apply paint.

The small plastic containers with dosing nozzles can be refilled with colors. Also available are a glazing nozzle and a ready-to-paint nozzle.

BOTTLES WITH A DOSING NOZZLE

Prior to using the bottles for the first time, the artist cuts the tip, being aware that the size of the cut will determine the thickness of the oil. It is sensible to start with a small cut and then make another one if a larger hole is needed. A wide range of colors should be available, as dripped paint does not allow for many mixtures to be made. Bottle colors can be used occasionally when making thick and impastoed lines.

Dripped paint can be used in some works to highlight linear effects in an emphatic manner.

It is not necessary for dripped paint to form linear sketches, as different original textures can be created using this technique.

EXTRUDED ON CHROMATIC BASE

There are two options when two colors are overlapped: waiting for the lower dripping to dry so the colors don't mix, or applying the colors while wet. This latter option may produce a murky mixture if not done carefully. Paint can also be extruded onto a dry color base to enhance the relief effect. Similarly, new acrylic glazings can be applied on dry dripped paint, thereby highlighting their relief effect.

The effect of embossed lines offered by oil paint can also be included in works using thinned paint.

1 The dripping process is simple. While squeezing the bottle, move from the top to the bottom, producing a smooth stroke.

2 If different colors are overlapped, there are two options: waiting for the previous applications to dry before overlapping the new ones, or mixing the dripped paint on the wet surface.

Fluorescent
COLORS

Acrylics, in addition to coming in a range of traditional colors, offer a variety of fluorescent, highly-saturated, and very bright colors. Fluorescent or luminescent colors seem to have their own light, which is why this type of coloration works well with current techniques and contemporary artistic styles.

These colors are an interesting tool for many contemporary artists.

Fluorescent paints are a range of acrylic colors, and are a nice chromatic complement to traditional colors.

COLORS THAT REFLECT LIGHT

Fluorescent and iridescent colors are a recently created range of acrylics. These are industrial-use colors that have been adapted for the artistic environment. Conventional pigments reflect some of the light and absorb the rest as heat. Fluorescent paints, on the other hand, absorb light and reflect it back again as a visible light in other spectrum bands. In this way, energy absorbed by these colors is transformed into light with a greater wavelength.

A porcelain plate transforms into an improvised palette on which fluorescent colors are combined with traditional acrylic ones.

Gestural abstraction and geometric abstraction use these new colors to amaze the observer.

GAUDY PAINT

Paintings made with fluorescent colors have a certain advantage over those made with traditional colors since they have a very gaudy chromatic palette, which attracts the observer's attention. When intentionally used in any type of painting, they become counterpoints and focal points. Therefore, they can be a very useful tool if the idea is for the observer to be drawn to specific areas of the painting.

MIXTURES WITH TRADITIONAL ACRYLICS

Nowadays, many artists choose to use fluorescent paints mixed with traditional acrylics to get a wider range of colors, or to mitigate the fluorescent effect when that is deemed helpful. This option results in works with very artificial colors that differ from more traditional paintings.

Not only do fluorescents attract the observer's attention, but they also keep it for a longer period.

1 Any model can be used by combining traditional acrylic paint and fluorescent colors; however, this treatment requires a looser and more modern interpretation.

2 The result is closer to abstraction than to realism, which allows the artist to create pronounced contrasts and deformations.

3 These paints transform a simple scene with ships into a colorful explosion: It all seems to be bathed in generous light and bright contrasts.

Dragging WITH ACRYLICS

The scraping or dragging technique consists of spreading paint on the painting's surface with a flat spatula, forming a thin layer. If we press hard with the spatula's blade as we drag it, the coat of paint will be applied in a way that produces an effect similar to glazing. This technique allows the artist to concentrate on creating paint based on solid and striated colors, and on forming color bands.

A. With the flat spatula, the acrylics paint is dragged, forming a thin layer of color.

B. As a result of loading unblended colors, color stripes are formed, whose thickness may be varied just by changing the spatula's inclination and direction.

C. To create this background, the colors are first aligned on the support and spread using a scraper, forming clearly differentiated bands.

Either gel or an acrylic medium can be added to give the acrylic greater transparency and a glazing effect that results from the applications made with the spatula.

Two dragging examples with a glazing effect made with yellow and yellow ocher.

DRAGGING MIXTURES

Dragging the scraper or the spatula blends the colors by overlapping them with each other, but maintains the purity of the color left between the strips. The best way of approaching this technique is to place dripped paint colors next to each other, either on the palette or directly on the support. You can do this by using the spatula as a shovel to load the paint and then applying the color to the painting with long strokes.

Color scraping with a spatula on wet paper creates transparent strokes, offering a very particular watery stroke.

WET SCRAPING

If wet scraping is conducted on paper, the color does not stick well. The dragging mark is visible, but the colors don't cover the support; they dye it slightly, and the coat of paint seems to be discontinuous and transparent. If one intends to paint by scraping on a wet surface, it is best to first use a moist paper to become familiar with the effects it may have.

BACKGROUNDS WITH SCRAPING

This particular way of applying color can also be useful for preparing acrylic backgrounds with multi-chromic effects. The paint is directly applied on the surface and the color is dragged using a wide spatula or even a plastic or metal ruler (depending on the size of the support).

1 The colors are partially mixed in the palette and are applied with a flat spatula by applying pressure consistently to drag the paint.

2 Dragging does not involve the creation of impastos since the application is somewhat flat; rather, the color is spread until a wide range of shades is achieved.

1

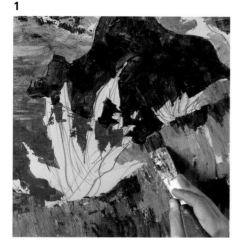

2

3

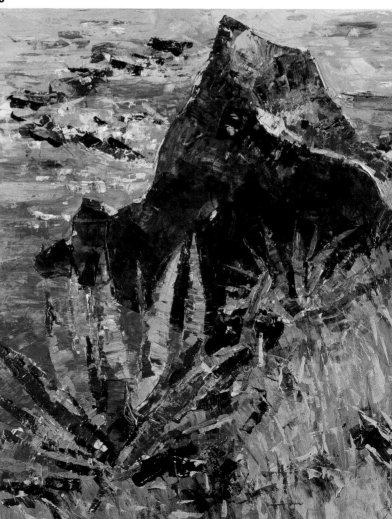

3 The painting finished with the flat spatula has a richness of textures and chromatisms that are hard to obtain using other, traditional means.

Fillers are solid, finely ground elements that are added to the paint either directly or via mixture with a medium. If you wish to add a filler to the acrylic paint, first moisten it with latex so that it will mix and set more effectively. There's also the option of using an already prepared textured modeling paste, a medium that incorporates a material filler and can be directly mixed with acrylic.

FILLERS WITH ACRYLICS

Some modeling pastes incorporate fillers. This landscape has been painted with a mixture of acrylics and a fine-texture paste.

IMPASTOS CONTAINING FILLERS

Granulated fillers can be applied only with a palette knife or spatula. It is absolutely not advisable to apply them with a brush. The impasto's final result depends on the thickness of the grain of the filler, and it may take quite a few hours to dry.

The best course is to let it dry slowly, without hurry. There are people who place the paint in direct sunlight or accelerate the drying process with a hair dryer; however, none of these measures is advisable since drying it too quickly may cause the surface to crack.

The thick-texture paste can be applied only with a knife or spatula. Note the difference in texture from the previous case.

1 Landscape made with a mixture of acrylic, regular gel, and a filler of marble dust. All applications have been applied with a spatula.

2 The sky has been constructed with impastos made with the lower part of the blade of a knife; the foreground of the landscape has been decorated with graffito, with lines that highlight the perspective effect.

1

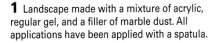

2

A

Four examples of acrylic fillers that produce wide-ranging and different effects: pulverized mica (A), black carborundum (B), thin sand (C), and microspheres (D).

PAINT WITH LATEX FILLER

It is often believed that latex and acrylic paint are the same thing, but it is not so. Latex is a much more adhering glue, but can also be used as a pictorial medium with certain features similar to those of acrylic. In this case, it becomes the perfect medium to receive agglutinated substances that replace the pigments in proportions that better suit our interests. The acrylic bases are prepared by texturizing the latex with tea, coffee, ash, or spices. Once dry on the medium, they become interesting bases on which to work.

Touches of color made with a latex filler mixed with ground coffee and sweet paprika.

Two conches made with acrylic paint and mediums on which thin sand has been sprinkled.

LIGHT-REFLECTING FILLERS

There are various modeling pastes on the market that contain all sorts of fillers. Some are glittery, such as mica, microspheres, and other minerals derived from volcanic rock. Mica is a thick grain filler that reflects light, adding a silvery shine to paints with which it is mixed. Microspheres are a recent contribution to the art industry. They are small crystal spheres that shine when laterally illuminated by light.

B

C

Painting done with carborundum fillers in the trees and pulverized mica in thin layers in the clouds.

D

Spraying AND STENCILING

Splashing or stenciling paint on the support is a very effective way of suggesting textures. These resources are used to liven up and add interest to a colored area that might otherwise look plain and monotonous. Artists that enjoy painting landscapes use this method of applying paint to represent the atmosphere through blends of color.

SPLASHING WITH A BRUSH

A toothbrush is dipped in acrylic paint that has been slightly thinned with water and, while it is held a horizontal position on a pictorial surface, the bristles are rubbed with the thumbnail; in this way, tiny drops of paint are spattered over the painting. Another way of spraying the paint involves soaking a thick brush in the paint and then striking that brush a bit against the handle of another brush.

For stenciling, small carton or pasteboard paper templates must be created that are fixed to the medium with adhesive tape.

1

1 For spraying, the brush is brought closer to the medium, which must remain in a horizontal position at all times, and the bristles are rubbed with the nail to remove the color.

2 The painting is created in stages. The templates protect the areas that cannot be sprayed with another color.

3 The model is represented with a heavier paint, without strokes, lines, or impastos made with the brush. The result is absolutely atmospheric.

2

3

STENCILING

Stenciling requires that the artist use a hard-bristle brush, preferably with short and uniform bristles. The bristles are soaked with nondiluted acrylic, and the tip is loaded enough to be sticky to the touch. The extra paint or lumps are discharged on a test paper. The painter may begin by making continuous strokes with the tip of the bristles. The result is a granulous brushstroke formed by tiny specks of color.

WORKING WITH TEMPLATES

Both techniques can be applied using firm pasteboard or paper templates, by cutting out certain areas, allowing the artist to apply the color only to uncovered areas. With the templates' cut-to-size pieces, the shape is preserved, since both the spraying and the stenciling prevent it from representing well-defined contours in the absence of limits.

The best brushes for stenciling are flat ones. Brushstrokes must be dry, and the paint must be denser than usual.

1

2

3

1 We recommend that you begin by stenciling the edges and then painting the inside of the window.

2 As the templates covering each area are removed, the stenciling is completed with a different color.

3 Once stenciling has been applied, the template is slowly removed to prevent smearing of the paint or blurring of the edges.

FLOODING AND WASHING WITH PAINT

This technique involves applying watery paint on a low-porosity medium, such as a piece of fabric or primed wood, but never on paper or pasteboard. The lack of absorption causes the paint to accumulate by forming puddles that, when dry, become irregular rounded spots that add interest to the interpretation of the model.

THE EFFECTS OF WATER

The versatility of acrylic invites the artist to experiment with it fearlessly by applying it highly diluted on a medium that must be completely flat on a table or on the floor. When spread, acrylic flows and forms puddles that can be left to dry either partially or fully on the medium, producing attractive and stunning effects. Since flooding is not used with a preestablished shape, this technique tends to be associated with abstraction.

Mixture made with different applications flooded with paint that, when dry, forms glazes.

1 The classical applicator, the brush, can be substituted for a less orthodox applicator, such as a spoon.

2 Here, acrylic has been mixed with different mediums and acrylic varnish to increase the paint's density.

Flooding involves applying coats of highly diluted paint with abundant water on top of one another. It is a slow process, as each application must be dry before the next one is applied.

To open holes in the paint, the artist can interrupt the drying process of a wash or a stroke by placing a wet brush on top of the surface. Once the process is completed, the paint will have some "bald areas" inside the stain.

PARTIAL DRYING

The puddle of diluted paint can be allowed to dry only partially—that is, the full drying process of the wash is interrupted in order to obtain interesting graphical effects. With acrylic paint, the edges of the applications are the first ones to dry, and the process moves forward to the center of the wash until it is completed. Thus, the flooding is allowed to dry and afterwards cleaned with a sponge soaked in water and placed directly under a jet of water. The washing generates a hollow and empty stroke on the inside, but preserves the outer edge.

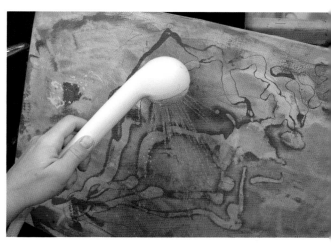

When the fabric being worked on is large, water from the shower can be applied directly to remove some of the still wet coat of paint.

This work has been washed with the pressure of tap water to break up the density of the brushstrokes.

Still life with acrylics that was washed in various ways before the paint was fully dry.

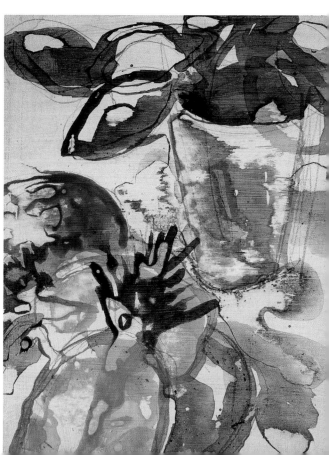

Drawing created with chalk, acrylic paint and varnish. Several cuts have been made with a cutter to allow shadows to be projected onto the paper.

The support is the structure on which media is fixed. Choosing the right support is crucial, as the surface's characteristics determine the work's process and the appearance of the final work of art; therefore, it is advisable to be well aware of the types of supports and their qualities so you can choose the most appropriate one for each artwork. This section also contains information on a selection of aqueous and oil additives that modify the fluidity of the paint, and offers a more complete overview of the mediums and fluidity modifiers covered in previous chapters.

SUPPORTS
TEXTURES, VARNISHES, AND ADDITIVES

It is advisable to be familiar with the basic characteristics of a good paper in order to incorporate the necessary selection criteria.

Making strokes and shadings with drawing instruments applied by rubbing, such as charcoal, chalk, and graphite, reveals the paper's texture more than any other technique. Therefore, it is important to choose interesting textures that are pleasant to the touch and that are also appropriate with regard to the intended artistic finish.

Collage created using different papers for each element of the still life. Charcoal is the medium used.

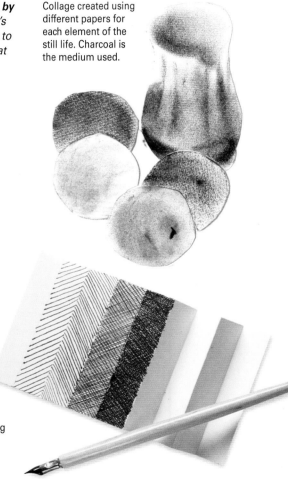

PAPER: COARSENESS AND DENSITY

FINE TEXTURE PAPERS

They can be rapidly covered; the support is easily stained, and charcoal sticks, chalk, and pastels slide easily, but it is difficult to apply various coats of paint because the grain is covered right away. When this happens, the surface becomes saturated and the pigment particles no longer adhere, as the paper does not retain them, which makes it difficult to work with too many coatings. Therefore, these papers are suitable only for sketches or works that require little elaboration and that can be resolved with truly simple shadings.

Working with inks and drawing pens requires the use of fine grain or even glossy papers.

The result obtained with pencil strokes on different papers varies depending on the paper's texture: sketch paper (A), average grain paper (B), average grain Canson paper (C), and Ingres paper (D).

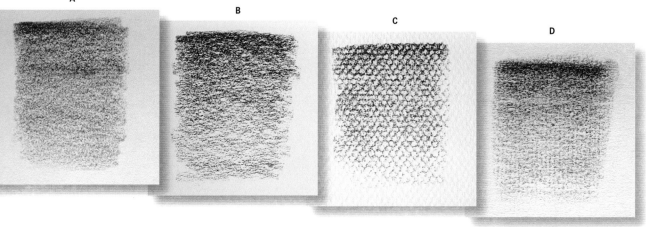

A

B

C

D

THICK-TEXTURE PAPERS

The coarser a paper's texture, the greater the quality of the pigment retained, which allows for greater saturation of color. But, on the other hand, highly textured paper makes it difficult to move the stick, and it prevents the artist from creating defined edges in the drawing. Finer papers make the work easier and favor a cleaner and more defined finish. With coarse texture papers, it is more difficult for the color to fully hide all of the small cavities of the paper—for which reason it is easier to apply successive coats, resulting in richer artistic results.

PAPER DENSITY

The weight or density of paper is measured in grams by square meter, and ranges from thinner types of Japanese or vegetable paper with a density of 12gsm (grams per square meter) to 250 and 300gsm for paper for painting with watercolors, up to 640 gsm for pasteboard prepared for gouache or watercolor, which guarantees the firmness of the work.

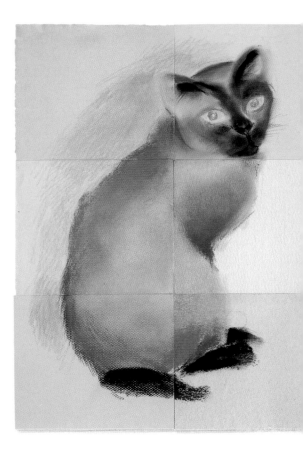

Drawing of a cat made on a collage with six different types of paper, making it possible to check the differences between the pigment's saturation and grip in each area.

Three samples of watercolor paper with different grains and the effect of charcoal spots on them.

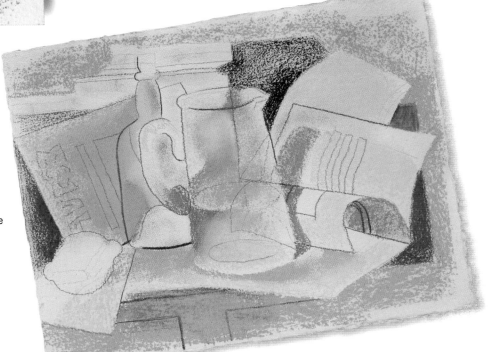

The paper's thick texture produces a peculiar atmosphere of great warmth in this work created with dry pastels.

PAPER QUALITY

Drawing paper is manufactured in glossy finishes of fine and laid grain. The first method is appropriate for working with graphite, pens, and color pencils, whereas the latter two methods are ideal for working with charcoal, chalks, and pastels. Thick, oily paper is reserved for works with pastel or watercolors. Each drawing medium requires a different type of paper, which must be properly understood and tested.

LAID GRAIN PAPERS

These are average grain papers that have a characteristic mechanical texture (laid). It has a design of vertical and horizontal lines created by a wire mesh on the mold applied to the paste; it is the traditional paper used in works with charcoal, agglutinated cardboard, and sanguine. Its special texture offers the right amount of grip to retain carbon or chalk particles and to obtain fine and blended gray tones.

Glossy or coated papers have an imperceptible grain and have been hot-pressed to accentuate their smoothness.

A. Laid paper has a light, streaked texture and easily retains color particles.

B. Canson paper is highly regarded for its granulated texture and is the favorite for working with chalks and pastels.

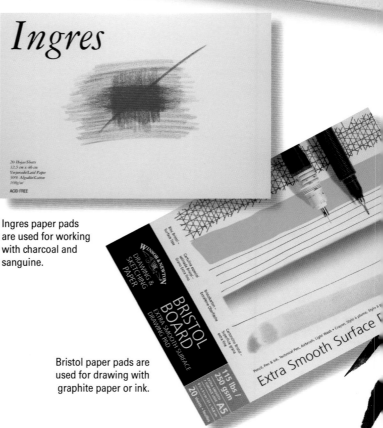

Ingres paper pads are used for working with charcoal and sanguine.

Bristol paper pads are used for drawing with graphite paper or ink.

FINE GRAIN PAPERS

This category includes all sketch papers, which almost always come in sketchpads and are highly used for esquisses. These are low-weight supports (between 60 and 150g), which are appropriate for working with graphite pencils, pencils, and charcoal, and can also provide great results for those working with India ink drawings (as long as the paper is not too light). with India Ink drawings (as long as the paper is not too light).

BRISTOL-TYPE PAPERS

These are glossy papers with an imperceptible grain; they are hot-pressed to emphasize the smooth surface. As graphite supports, they provide a wide range of grays and yield very good results for mixed and blended colors. They are also the most appropriate paper for dip pen or nib drawing since the tip of such utensils slides easily across the smooth surface. However, they are not suitable for working with charcoal.

JAPANESE PAPER

This is a light paper that is manufactured with special fibers, making it highly absorbent. It is the paper traditionally used for Japanese gouache, the success of which in the West has made this method accessible in fine arts stores. It is usually used as a base with aniline, ink, and even watercolor works.

Kraft paper and wrapping paper (laid), in addition to being very cheap, are feasible media for drawing with graphite pencils.

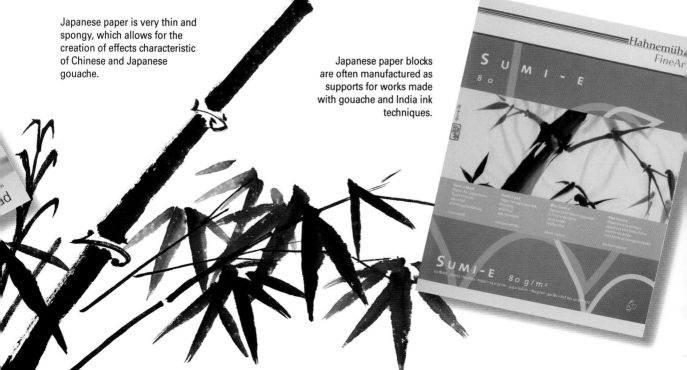

Japanese paper is very thin and spongy, which allows for the creation of effects characteristic of Chinese and Japanese gouache.

Japanese paper blocks are often manufactured as supports for works made with gouache and India ink techniques.

Colored PAPERS

When one draws on colored paper, the tonal background integrates naturally with the work, so unpainted areas can be left alone in the knowledge that the base color will look like just another color. Also, from the very beginning, the paper itself highlights both the light and the dark applications through contrast.

THE MOST SUITABLE COLOR

As a general rule, when intending to draw with dark, intense, and well-defined strokes, it is important to choose a paper with a light tone. An intermediate tone is appropriate for works in which all possible shades are included, from the lightest to the darkest. The most widely used paper tones are earthy ones (siennas and light ochers), as well as grays of different levels of intensity. Because of their soft or slightly warm or cold tones, they tend to work well with charcoal, chalks, and pastels. Graphite pencil provides an extremely weak line; therefore, it is not the most appropriate medium for drawing on colored paper.

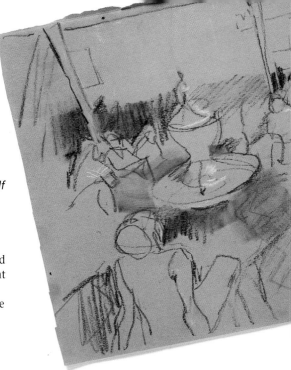

Colored papers, as long as they are not too dark, offer a feasible option for drawing with charcoal.

Papers with an intermediate tone can be highly suitable for use in works in which white is especially prominent.

Handmade papers offer endless varieties of textures, tones, and sizes, multiplying the options from which the artist may choose.

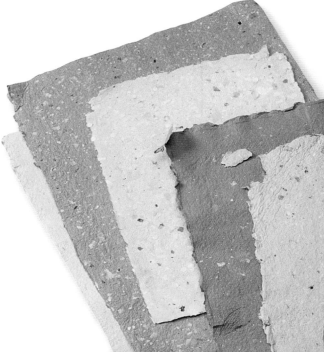

ARTISAN PAPERS

The artisanal finish on these papers, with its coarse and irregular textures, is one of its main features. Its greatest advantage lies in the high quality of the materials used to manufacture it and in the absence of industrial chemical components. It comes in a wide range of colors and impressive textures. It is important to experiment with this kind of paper, as it tends to have great absorbing power and does not behave like conventional papers.

Handmade papers are porous and each type reacts differently to washes, which is why it is necessary to test them prior to beginning the final drawing.

Black paper is used only in specific cases, for example for drawings made with white chalk or, in this case, opaque white ink.

Ingres paper comes in pads of multiple colors to choose from.

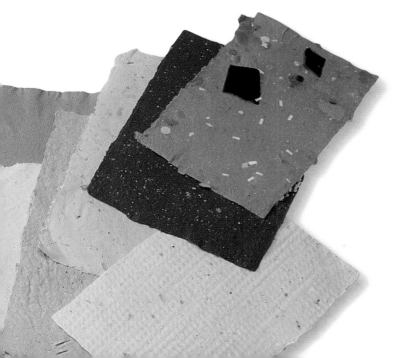

PAPIER COULEURS ASSORTIES

INGRES/PASTEL

COLOURED PAPERS

8 COULEURS ASSORTIES
SANS ACIDE
25 FEUILLES

8 COLOURS ASSORTED
ACID FREE
25 SHEETS

8 FARBIG SO
SAUREFR
25 BLAT

8 ASSORTI KLEUREN
ZUURVRIJ
25 VEL

8 COLORES SURTIDOS
SIN ACIDO
25 HOJAS

8 COLORI
SENZA
25 FE

36 x 48 cm
130 g/m²

Clairefontaine

Papers for watercolor PAINTING

Watercolor paper is made up of plant-based cellulosic fibers obtained from wood or different plants, such as cotton, flax, or hemp. It is generally manufactured in three textures or finishes: fine, medium, thick, or coarse grain paper. For those painting with watercolors, the quality of the paper plays a decisive role, as on a professional level, there are numerous varieties leading to truly different results.

FINE GRAIN PAPER

The fine quality of paper is achieved by pressing it with rollers or hot presses to flatten it. It demands from the artist great control of the borders of brushstrokes, color blends, faded areas, and wet contours, since it dries faster and hardly allows for touch-ups. It is not a paper that's easy to work with, but it does boost the colors' luminosity.

COARSE PAPER

Medium grain paper has a type of grain that partially eliminates the need to work quickly and in a controlled manner. Coarse grain paper has a texture that builds up and retains water by delaying the color's drying process. This variety of paper detracts from the color's sheen, but largely enables long-session painting.

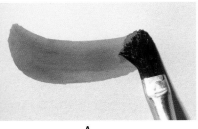

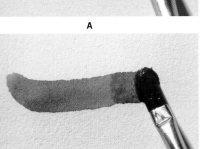

A. On glossy watercolor paper, the stains are clearly defined and homogeneous.

B. Fine grain paper is appropriate for delicate and precise works that don't need too much water.

C. The sheets of coarse grain paper reveal the texture with each stroke.

Water or dry marks on paper guarantee the origin and quality of the paper.

A

B

C

Low-density watercolor paper pads are very practical for sketching and applying of fresh color.

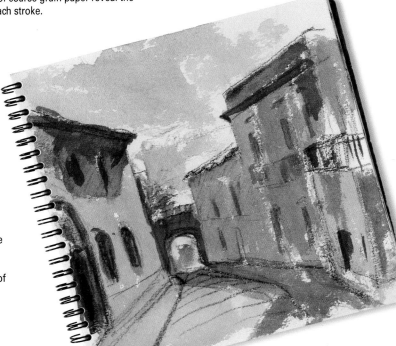

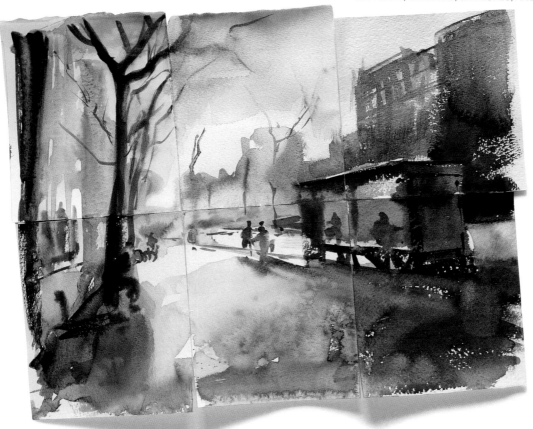

NOTEBOOKS AND PADS

Top-quality paper can be bought as loose sheets or in pads of sheets glued together along the edge in such a way that the bundle of paper forms a single body. This gluing has the same function as the previously mentioned sheets of adhesive paper. When the paint is fully dry, the sheet is released from the rest with a penknife or a letter opener.

RECOMMENDED PAPER DENSITY

A good watercolor paper must have a density of 300 grams per square meter. A higher-density paper can absorb more water without becoming deformed and allows for all kinds of applications of pressure without it being visibly noticeable on the surface.

Work painted on six different kinds of watercolor paper. Notice the clear definition of the shapes and color, which is due to the different textures and absorption of the various types of paper.

Some pads of paper are glued along the spine, while others are bound with a spiral. The former are a higher-quality paper.

Watercolor papers, which are more highly glued, absorb water at a pace that is suitable for the work.

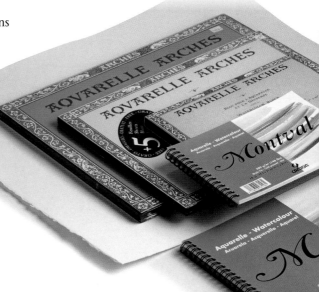

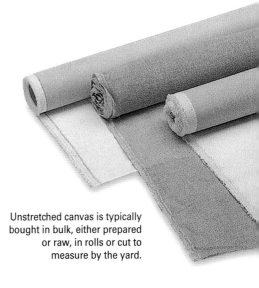

Canvas is the traditional and most commonly used support for oil and acrylic paint. The materials used to manufacture the canvas fabrics are flax yarn, linen, hemp, or cotton, and, nowadays, polyester. The best-quality fabrics are those made of linen, due to their fineness and excellent performance in humid environments.

Unstretched canvas is typically bought in bulk, either prepared or raw, in rolls or cut to measure by the yard.

PAINT SUPPORTS:
CANVAS

Flax fabrics are woven with soft and resistant fibers that are not very sensitive to changes in humidity.

Cotton fibers are shorter and more resistant than linen ones. The mixture of cotton and flax can be one of the most reasonable options for artists.

Hemp or sackcloth fabric is composed of thick and rough fibers; its texture is attractive for use with thick pictorial contributions.

A

B

FLAX, COTTON, AND HEMP

Flax fabrics are woven with very soft and resistant fibers and are not as elastic as cotton, but they are less sensitive to changes in humidity and are therefore more stable. Cotton fabrics are shorter and less resistant, and absorb a lot of humidity, which causes them to frequently tense up and loosen. The fibers of hemp or sackcloth are very thick and much rougher than those of cotton. Their thick texture is attractive to artists who like making thick impastos.

C

D

These four pieces are small samples of supports for painting with oil or acrylics: thick sackcloth canvas with a standard preparation (A), cotton canvas with a standard preparation (B), pure cotton with an acrylic preparation (C), and polyester canvas with a background of smoothing paste (D).

POLYESTER CANVAS

In recent decades, synthetic fibers such as polypropylene, nylon, and polyester have been used to manufacture canvas. Unlike natural fibers, polyester fibers are much more rigid and resistant, and they absorb little humidity, so they maintain a stable and optimum tension.

TEXTURE OF PRIMED CANVAS

Once the canvas has been primed, that is, covered with a preparation for painting, it develops different surface textures that the painter should be familiar with. The high-quality linen canvas has a very fine texture and a desirable thickness. Cotton canvas has a decidedly marked texture and is appropriate for dry paint applications. The coarseness of a prepared sackcloth support is so pronounced that the brushstroke seems to break, or to come apart. Canvas made with a combination of cotton, polyester, and viscose is a cheaper alternative to linen and offers a fine and less pronounced texture.

A

B

Canvas made of 100 percent high-density linen (28 threads per square cm) (A), 100 percent high-density linen (24 threads per square cm) (B), average-quality cotton (C), a mix of cotton, polyester, and viscose (D), and prepared sackcloth (E).

C

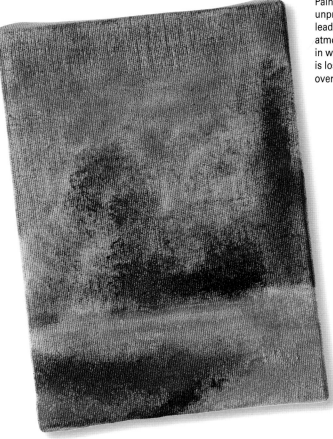

Painting on unprepared canvas leads to vague and atmospheric results in which the detail is lost amid the overall work.

D

E

Wood, pasteboard, copper, leather, aluminum boards, and even fiberglass sheets are some of the materials commonly used by artists when creating their works. Any surface can accept both acrylic or oil paint if it is appropriately prepared. Next, we present other mediums as alternatives to paper and canvas.

Canvassed cardboard panels with different formats for oil painting.

Cardboard, wood, and other SURFACES

CARDBOARD

Cardboard is commonly used by many artists to make sketches and add touches of color. It has a problem with excessive absorption which, with the passing of time, creates serious dents or grooves on the pictorial layer, which may be fixed by applying liquid sealing primer or gesso. Any pasteboard that isn't too spongy or soft can be used as a support.

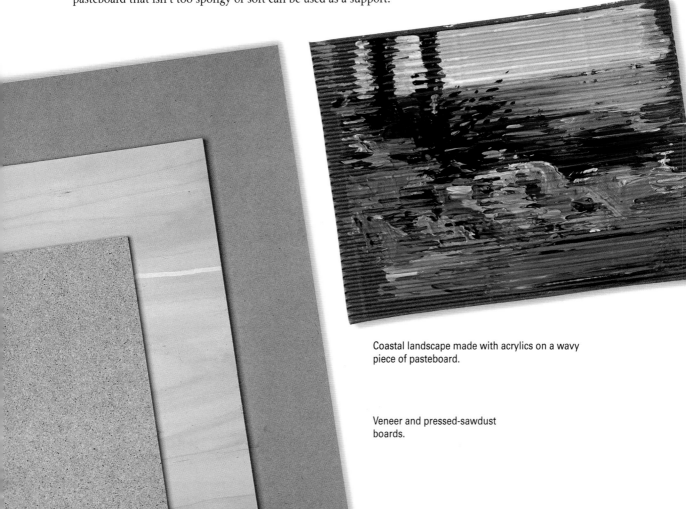

Coastal landscape made with acrylics on a wavy piece of pasteboard.

Veneer and pressed-sawdust boards.

CANVAS PANELS

Art supply stores sell different-sized panels of canvassed board that are specially prepared for oil painting. These are rigid pasteboard sheets with a fabric firmly adhered to the surface. They are useful for sketching and small-scale works.

WOODS

Wood prepared with gesso can be completely smooth. Works made using this medium have a special transparency and gloss, though wood does not allow for large impastos and it can crack or bend with the passage of time. Even though artists used to use fine woods, modern artists are able to use solid plywood boards, pressed wood chips, chipboard, or even combined boards, a kind of rigid but very stable support made with pulp-reduced timber mixed with synthetic resins. Additionally, all wood boards can be reinforced with a frame to prevent them from warping.

By adding pigments to the base glue or to the gesso, one can obtain color primings with which cover the cardboard and wood boards.

An old pressed pasteboard that has been used for numerous art projects can also become an interesting alternative support.

There are papers for oil and acrylic whose grain imitates the texture of prepared fabric. Their laminated preparation makes it easier for the artist to make strokes with the paintbrush.

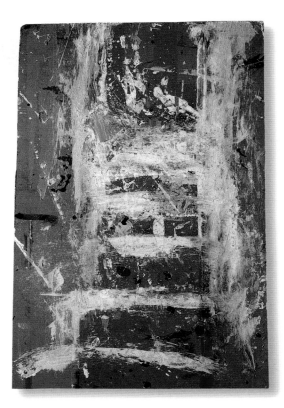

ALTERNATIVE SUPPORTS

Drawing or painting need not be reduced *to working with traditional media such as prepared fabrics, watercolor paper, or board, since there are other supports that provide a different approach to the work. In recent years, notepads, sketchbooks, and even acetates have become fashionable for applying esquisses or color touches in small-scale works.*

Study of a group of geese made with graphite pencil on vegetable paper.

NOTEBOOKS

Notebooks, sketchbooks, or artist's books are used with the aim of experimenting, testing, and verifying the effectiveness and the impact of an initial idea. This type of support is not designed for finished works; they are only for tests and do not necessarily always need to make a good impression. The best idea is to have several of them and use whichever is most appropriate.

Notebooks, sketchbooks, and artist's books are alternatives to fabrics and high-quality papers. They are a test bench for experimenting with techniques, compositions, ideas, and colors.

Some contemporary artists use acetate as a support for synthetic, acrylic, or oil paintings. It can also be used to develop monotypes.

ACETATE AND VEGETABLE PAPER

There are other methods for developing ideas that do not conform to traditional techniques; one of these is working on acetate paper with black synthetic paint. This material allows one to test how a graphic would look with a simple overlap, without having to stain any fabric. Another alternative is vegetable or onion paper, whose transparency and translucency makes it an interesting support for tracing or creating glazings or light transparencies.

PAINTING ON GREIGE FABRIC

Unprimed, spongy, and absorbent fabrics and cloths of different colors can be an interesting support on which to paint. They can be fixed to a medium using an acrylic glue, latex, or white glue. The artist must take into account that each fabric soaks up the paint differently.

Each type of fabric absorbs and soaks up paint differently, so it is always a good idea to conduct tests prior to using a fabric as a support.

1

2

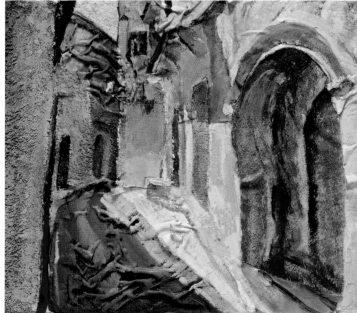

1 Support covered with different griege fabrics glued with latex. It is possible to moisten them with watery latex to reduce their porosity.

2 The result: a sunny street corner created with applications of acrylic paint on greige fabric.

There are certain substances that can be spread on a raw support, such as board, cloth, or wood, that are useful for preparing these materials to be painted. Imprimatura or sizing creates a base with the proper absorption, adhesiveness, and texture conditions that will allow the paint to settle under the best possible conditions.

Rabbit-skin glue can be purchased in pellets.

PRIMING
FOR CLOTHS

RABBIT GLUE PRIMER

It is the most traditional and common of all primers. It can be bought in pellets, which have to be soaked for a few hours prior to being cooked in a double boiler. Once the glue is creamy, it is mixed with a little bit of white chalk or calcium powder to give it a white and matte finish. Then it is ready to be spread on the fabric with a brush.

1 It is soaked in water for 24 hours.

2 The granules swell and increase in volume until they fill the entire container.

3 It is cooked in a double boiler until it forms a creamy liquid.

4 It is poured over a white filler and mixed with a palette knife.

5 The mixture is kneaded until a uniform paste that is ideal for priming surfaces emerges.

Sealing liquid applied with a
spatula to a wood board.

SEALANT LIQUIDS

If the surface to be worked on is very porous, a
sealant liquid can be used to reduce absorption.
It is generally applied with a paintbrush, a roller,
or even a spray, as a coating prior to applying
gesso. Some resins, such as epoxy, polyamine,
and polyester, are highly stable and have a great
adhesive power, which enables them to be used as
surface finishes.

GESSO PRIMING

It is currently the most commonly used mixture,
and is made up of acrylic resin and titanium
dioxide. It is adequate for virtually any pictorial
technique, but better results can be obtained
with acrylic paint. It is a white paste that can be
thinned in water and applied in thin or thick
layers, as needed. It dries out quickly and, when
dry, forms an impermeable, insoluble, and highly
elastic film.

Gesso is the most universal and
commonly used preparation; it's
user friendly and dries quickly.

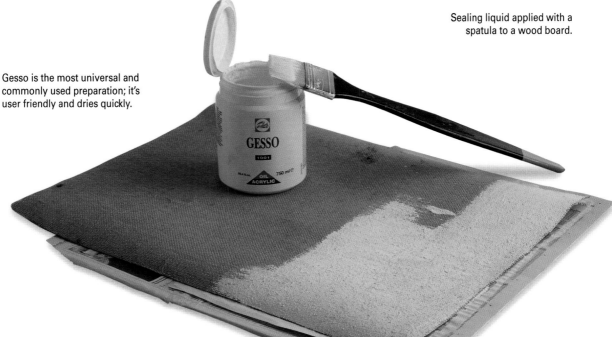

WATER ADDITIVES

In addition to the media marketed for acrylics (see the previous chapter), there are other additive aqueous substances that enhance or tone down the properties of watercolor, gouache, and even acrylics. These include ox gall, arabic gum, and drying retarders and accelerators.

GUM ARABIC

It is a vegetable resin that comes in amber lumps that are very hard but are easily dissolved in water. Once diluted, gum arabic becomes a golden brown, dense, sticky liquid that dries easily, producing a glossy and transparent film. All of these characteristics make it an ideal color binder for watercolor and gouache. There is a natural substitute for gum arabic, which is egg yolk. The paint dries and can be thinned by being rubbed with water.

DRYING ACCELERATORS AND MOISTENING AGENTS

To accelerate the drying process of watercolors and gouaches, a small quantity of 96 percent alcohol can be added to the water used for painting. The drying process will be longer or shorter based on the quantity of alcohol added. In regard to watercolor, in addition to ox gall, it is also possible to add a small quantity of glycerine to the water to keep the paint wet longer.

Gum arabic forms resin lumps in its natural state. These granules can be dissolved in water to obtain an additive for watercolor and gouache.

Gum arabic for watercolor and gouache is sold pre-prepared in fine arts stores.

When added in moderate quantities to watercolor or gouache, gum arabic enhances the paint's transparency.

CASEIN

Various types of glue can be used, including gelatin and sizing, which can be mixed with gouache; but the most popular and one of the most effective is casein. The advantage of this glue is that, when mixed with pigment or incorporated into gouache, it dries fully in a matter of hours and is fully insoluble even if the surface is rubbed with a brush soaked in water. Casein is a component of tempera paint.

WATERCOLOR VARNISH

Almost all manufacturers of art supplies make a special varnish for watercolor. Some artists use it all the time to protect and brighten the colors by applying it in light coatings and only in certain areas.

96 percent alcohol is added to water to accelerate the drying process, whereas gum arabic and ox gall are used to retard it. Protective spray is a sort of final varnish for watercolors.

Egg yolk is used as a binder and works like gum arabic.

A. Mixing egg whites into watercolor makes the paint more viscous and transparent.

B. Adding sugar to watercolor paint makes the paint thicker and adds gloss when drying.

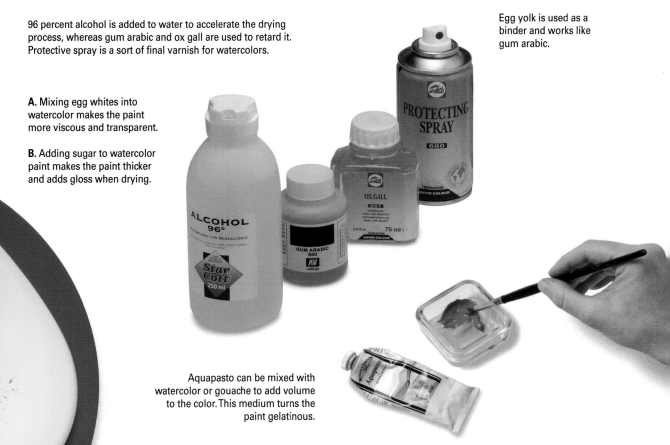

Aquapasto can be mixed with watercolor or gouache to add volume to the color. This medium turns the paint gelatinous.

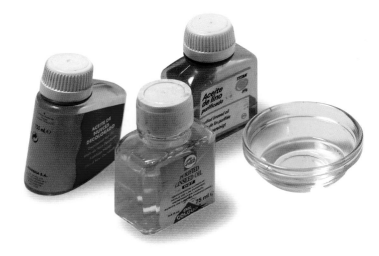

Since ancient times, artists have combined various substances in efforts to improve their paintings' finishes. Different varieties of oils and oil drying accelerators are available, and artists can decide for themselves whether these substances are beneficial for them, or are simply modifications of what they're already using.

O<small>IL</small> ADDITIVES

Oils are used not only to manufacture oil paint but also to dilute it; in other words, they act as a pictorial medium.

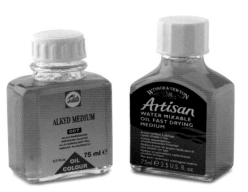

Mixed or alkyd resins can be indiscriminately mixed with water or oil; therefore, they can be used as agglutinants for aqueous or oil techniques.

VARIETY OF OILS

Oils can be added to oil paint to dilute it or to maintain the vividness of the color. Flax oil is the most widely used oil since it dries well, although it tends to turn yellow. Universal and poppy seed oil offer more neutral tones but dry at a slower pace than linseed oil. Walnut oil is ideal for glazings since it yellows only slightly and dries rapidly; it tends to be mixed in equal proportions with essence of turpentine to reduce its density.

Flax oil acts as a thinner and maintains the intensity of oil paint.

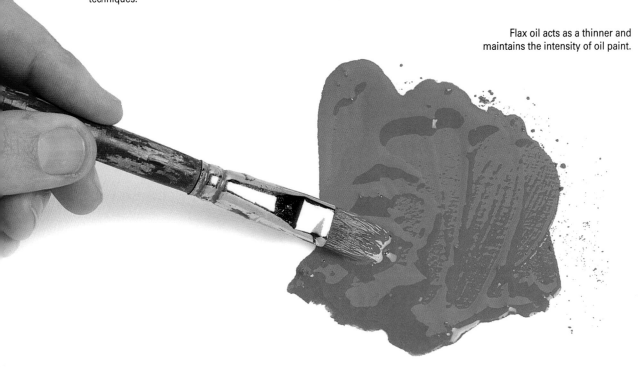

MIXED OR ALKYD RESINS

Mixed resins can be mixed with water or oil and can be used as binders for both aqueous and oil techniques. These are one of the market's latest developments. Alkyd resins are diluted only with oil-based solvents, but they dry out faster than oil paint. The artist can bind the pigments with these resins and produce paintings that are very similar to works done with oils.

DRIERS OR SICCATIVES

These are chemical substances that, when the paint is mixed with oil, accelerate the drying process. They must be used wisely since they tend to modify the pigment's color, especially light tones. The most common type of siccative is cobalt, which should be applied in very small amounts, perhaps one or two drops of siccative in each mixture, and only with slow-drying colors such as titanium white, or cadmium red or yellow. A universal siccative and Coutrai siccatives are also recommended.

Most oil additives used in oil painting are made from oil, which is diluted more or less using essence of turpentine.

Available driers or siccatives: from left to right, universal siccative, cobalt siccative, dark Coutrai siccative, and white Coutrai siccative.

Cobalt driers accelerate the drying of oil paint; it is sufficient to add a couple of drops to each mixture blended on the palette.

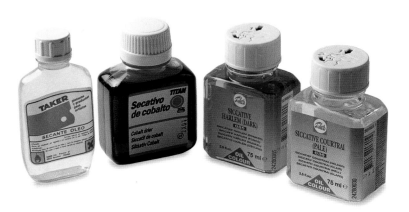

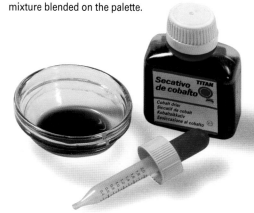

Mixing oil paint with varnishes or driers makes it possible to apply thin color coatings that dry in a few hours.

MEDIUMS AND SOLVENTS
FOR OIL

Oil painters tend to use different substances that, when mixed with paint, modify their transparency, gloss, and liquidity, thereby customizing the paint for their purposes. In addition to selecting the liquidity modifiers obtained from oils, varnishes, or mediums, it is also important to make a good choice as to which solvent to use when cleaning the brushes.

Drier medium for oil. In addition to adding volume to the paint, it accelerates the drying process.

MEDIUMS

Commercial brands offer preparations that combine oils, essences, resins, and other substances to create different liquid mediums. The most commonly used are copal medium, which is made of copal resin; venetian medium, which helps dry and blend the paint and turn it matte; Liquin or a painting medium, which is used for glazes; and oleopasto, which has a denser appearance and is used to create impastos.

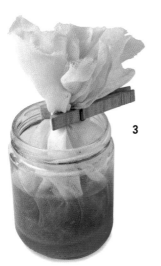

1

1 Ingredients used to manufacture a wax medium: turpentine, rosin, and virgin beeswax.

2

3

2 The rosin is first ground by crushing the lumps, which should be wrapped in a piece of cloth, with a hammer.

3 The rosin is wrapped in a mesh or nylon sieve, and then submerged in turpentine to dissolve.

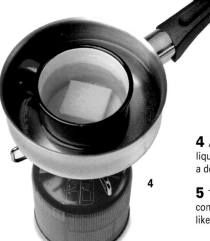

4 A piece of wax is added to the liquid produced, and it is all cooked in a double boiler.

5 The result is a medium with a consistency similar that of to honey, like ointment.

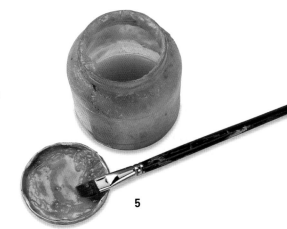

WAX MEDIUM

It is a medium made from rosin and wax that adds a translucid quality to oil colors. It is easy to manufacture: The rosin is ground and wrapped in a mesh or in a nylon sieve, and then submerged in turpentine to be dissolved. A piece of wax is added to the liquid and it is all cooked in a double boiler. The resulting substance is stored in a jar and used as a medium. Other artists manufacture the medium by mixing essence of turpentine with flax oil. They use this medium as a thinner while working on the painting.

SOLVENTS

One of two substances is used to dissolve oil paints: turpentine or White Spirit (also called turpentine substitute). Rosin or its derivatives (turpentine, etc.) is a clear distillation essence that gives off an intense odor and happens to be toxic. There are other more user-friendly solvents, such as orange skin, and odor-free solvents that are equally effective, although more expensive. White Spirit is a transparent, odor-free, less toxic and irritating solvent than turpentine. However, when mixed with colors, it reduces their shine, for which reason it is more commonly used for cleaning brushes than for painting.

The characteristics of the "liquin" impasto are very similar to those of oleopasto, although it offers a thicker consistency.

Mineral essence and vegetable solvents: purified essence of turpentine, conventional essence of turpentine, and White Spirit (turpentine substitute).

The solvent used can be recycled if successively poured in different containers, as the impurities are deposited in the bottom.

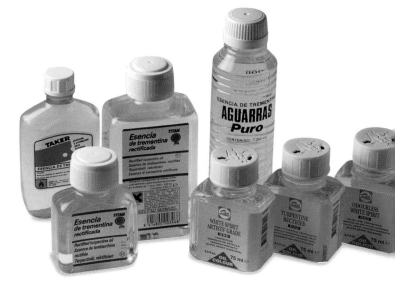

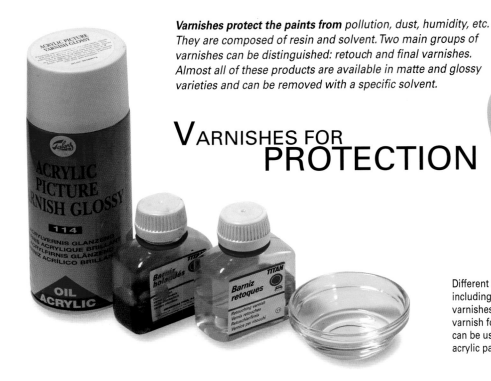

Varnishes protect the paints from pollution, dust, humidity, etc. *They are composed of resin and solvent. Two main groups of varnishes can be distinguished: retouch and final varnishes. Almost all of these products are available in matte and glossy varieties and can be removed with a specific solvent.*

VARNISHES FOR PROTECTION

Different types of varnish, including Dutch and retouch varnishes, as well as a spray varnish for final finishes that can be used with oil and acrylic paint.

There are many brands of final, retouch, and even crackling and aging varnishes.

FINAL VARNISH

It creates a protective film that isolates the pictorial layer from the atmosphere. Varnishes used with oils must be removable so the artist can varnish the work again after several years. Varnishes should never be used until all of the paint has fully dried (between four and ten months); otherwise the varnish will become mixed with the paint and become permanent.

A varnish is more or less transparent depending on its tone. Gloss varnishes are the most transparent.

Varnishes create an insoluble and flexible transparent film that protects finished works.

RETOUCH AND VITRIFYING VARNISH

It is used exclusively for oil painting. It is a highly thinned varnish and helps to determine the matte portions of a painting by absorbing of the oil in the lower layers of paint. It is very useful for unifying the pictorial layer when retouching the paint, as it takes time to dry completely. Other varnishes used to vitrify thinned paint or to work in layers are Dutch varnish, which is very dark but dries rapidly, and damar varnish (thinned in essence of turpentine), which is very transparent but dries slowly. This varnish can also be used as a medium for oil paint.

A
B

A. Aging varnish dries fast, and its typical brown color gives the pictorial coat an aged appearance.

B. Even though it may seem as if varnish is insoluble, there are especially designed solvents in restoration studios that eliminate coats of yellowish or aging varnish.

Varnish can be used to seal the support or to fix fine papers, rendering a very interesting cracked relief.

ENHANCING TEXTURES

Textures can be used to enhance the tactile quality of a painting's surface. They tend to be integrated in a work of art to achieve a more graphical richness, and they are very important in abstract and semi-abstract treatments, since it is by means of fillers and the addition of materials to the paint that they may be pronounced in their own right. This section contains a variety of effects that can be implemented to modify the appearance of the painting's texture.

FILLERS FOR ADDING TEXTURE

Apart from the different fillers that can be obtained at a fine arts store, elements can be found in nature or even around the house, such as crayons, sawdust, cereals, and ash (among many others). All of these materials are mixed with white glue, latex, or oil or acrylic paint, forming a dough that is generally applied with a spatula. Once they are dry, a thin coat of washed paint can be applied to them, which enhances the relief effect.

TEXTURES WITH ORGANIC MATERIALS

The paint makes it possible to incorporate more ephemeral organic materials obtained from nature, such as straw, stones, seeds, branches, and so forth. Be sure to only use dry elements and to avoid green or undrained shoots. Given their texture, these items can be used for expressionist interpretations that are far different from figurative representations.

Sgraffito made on fine grain modeling paste. A light wash with thinned paint was applied later.

Wax gel texture mixed with thin sand.

Light modeling paste mixed with fillers of coffee grounds.

Varnish mixed with glass microspheres.

Organic material (straw and shredded dry grass) mixed with kneading mass.

Acrylic base mixed with small mica films gives a special texture and shine.

Two-color oil applications on an average grain modeling paste texture.

Pink gesso mixed with glass microspheres.

Impasto made with thick *gesso* dough and acrylic color glazing.

Acrylic gel mixed with grains of rice covered with brown acrylic paint.

The black lava has an average and dark-colored, grainy texture.

Acrylic gel mixed with edible noodles painted green and orange.

GLOSSARY

A

Acrylic. Synthetic resin used as an emulsion to prepare paint with the same name.

Acrylic paint. It has a synthetic resin as an agglutinator, generally polyvinyl acetate, thinned with water.

Alkyd resin. Synthetic resin made with oil and used in paintings and mediums.

B

Background. Surface on which color is applied, referring to the tone or base color of said surface, not the material itself.

Binder. Liquid that is mixed with pigment dust to make paint.

Blending. Technique that involves softening the contours and shapes to produce an overall blurred appearance.

Blending stump: Rolled paper bar that forms a cylinder and is used for fading or to apply the pigment of a graphite pencil, charcoal, chalk, or pastel to a drawing.

C

Casein. Binder made up of milk protein mixed with pigment to produce paint.

Charcoal. Drawing medium that is obtained through the combustion of twigs or small logs in the absence of air.

Collage. Artistic technique that consists of adhering different materials, for example paper or cardboard, to the paint, to add color or texture.

Composition. Organization of the different elements composing a drawing scene to achieve an impression of balance and harmony.

Consistency. Subjective term that describes the paint's thickness and body.

Cross-hatching. Two overlapped hatchings whose lines cross each other, forming a homogeneous and intense tone.

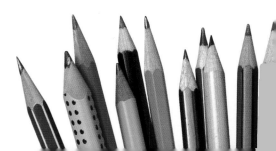

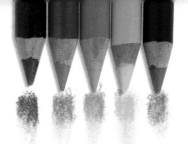

D

Damar. Conifer resin that, if properly treated, can be used as a medium for oil paints and varnishes.

Dragging. Technique that involves exerting firm pressure on a flat spatula or palette knife and dragging it across the canvas so that the color, when applied, forms a very fine coat of paint.

Drier. Quick-drying varnish that can be added to oil paint to accelerate the drying process. (Also called a "siccative.")

Dry brush. This technique consists of working with the paintbrush soaked in dense, thick, undiluted paint so that it will adhere only to the grain of the support, leaving some parts of the background visible.

E

Egg white. Animal-based viscous substance derived from acacia; used as a natural binder.

Encaustic painting. Technique characterized by the use of hot wax as a natural pigment or oil paint binder.

Esquisse. Rough preliminary sketch.

F

Fading. Progressive, almost imperceptible transition of a color to lighter or darker tones without an abrupt change of tone.

Filler. Substance that, when added to paint, alters its graininess, surface relief, and volume. There are different types of fillers made from marble dust, sand, wood chips, etc.

Fixative. A spray, generally used to stabilize drawings made with dry techniques (such as charcoal or chalk); it prevents portions of pigment from detaching.

Flat spatula. A slightly flexible square or rectangular blade used for dragging, creating striated paint effects, and applying paint to large areas.

G

Gesso. Made up of acrylic resin and titanium dioxide, it is used to prime fabric or to create impastos or volume on the support's surface.

Glazing. Thin layer of color that covers an underlying surface, allowing for a mixture between two or more colors.

Gloss. Name given to a drawing's light areas that are either left white or enhanced by means of color.

Gouache. Paint bound with gum arabic, though with a greater concentration of pigments that increase opaqueness and covering power.

Gum. Secretion of resin from some trees that can be dissolved in water.

Gum arabic. Plant-based binder used to make watercolor paint.

Grain. The texture of a canvas or a watercolor paper (also known as "tooth").

Graphite. Crystalized charcoal which, when ground, mixed with clay, and bound with glue, used to make pencils, sticks, and graphite pencils for drawing.

Grid. Method used in drawing to transfer an image into a different-sized format.

H

Hatching. Series of parallel lines, drawn from different angles of inclination, that are applied to define shadow areas.

Highlight. Specific application of a color to enhance certain pronounced contrast areas; can be either a point of light or an intense gray area.

I

Impasto. Technique that consists of applying paint in thick layers to create a textured surface. It is generally done using palette knives.

Imprimatura. Semi-thick liquid substance applied to the surface of a support to act as a pre-painting primer, and which can show through thicker subsequent layers of paint for effect.

K

Kneaded eraser. Soft, pliable eraser that can form different shapes when pressure is applied with the hand. Its sticky quality makes it ideal for working with charcoal.

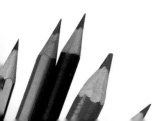

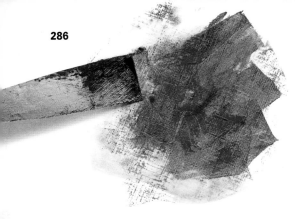

L

Lacquer. Ocher-toned resin obtained from insect secretions that is used to manufacture varnishes.

Laid paper. High-quality paper produced by placing the paste on a tray with an interweaving of interlocked lines, lines that then appear engraved on the surface.

Latex. Glue with a high adherence power used to adhere papers to the support; may even be mixed with a filler to achieve relief or volume effects.

M

Mask. Substance or material used to hide certain parts of the support's surface to prevent the paint from staining the paper underneath.

Medium. Liquid used to modify paint's consistency when the pigments are suspended within it.

Mixed technique. Process by which different media, such as acrylic and oil, are mixed in the same work.

Mixing. Involves fading or smoothing the edges of one or various colors by mixing them until a light shading is formed.

Modeling. Use of tonal progression or fading to create a three-dimensionality illusion.

Modeling gel or paste. Thick, fined-grained acrylic substance used to add volume to a painting or a painting's surface.

Monochromatism. Representation of a model with barely any color (may be black, brown, blue...) and white for lightening.

Monotype. Simple system for making impressions consisting of soaking an impermeable surface with paint and covering it with a sheet of paper. Next, pressure is exerted with the hand and the sheet is then lifted. The paint stains are then transferred to the support.

O

Oil. Paint obtained by mixing powdered pigment and drying oil.

Opacity. The capacity of a pigment to fully cover an underlying color.

Optical mixture. Chromatic unit perception produced in the retina through observation at a given distance, by the juxtaposition of several colors that are applied by means of small "touches" or brushstrokes.

P

Palette. Flat rectangular surface manufactured from wood or plastic, or a pad with waxed paper, on which the artist mixes the paints prior to applying them to the support.

Palette knife. A highly flexible rhomboidal or triangular blade used to mix colors on the palette and apply colors in different ways to the support, depending on the blade being used.

Pastel. Pure, hardly agglutinated, and highly fragile pigment in the shape of a stick.

Pigment. Powdered coloring substance that is mixed with a binding agent, such as oil or gum arabic, to produce paint.

Pointillism. Pictorial method that consists of applying small dots of paint very close to one another on the canvas, which, when seen from a given distance, compose well-defined elements.

Pre-painting. Regularly thinned preliminary paint on which colors are applied, done by applying a diluted color to dye the white canvas. See "imprimatura."

S

Saturation. Chromatic intensity of a color, in such a way that a highly saturated color will appear to be very pure.

Scraping. Effect resulting from exerting pressure on a surface painted with a palette knife or with a flat-edged spatula to make the surface to look translucent on the support.

Sfumato. Pictorial technique based on applying colors with soft-bristle brushes to form faded or slightly mixed contours among them.

Sgraffito. Method that consists of scraping or scratching a coat of paint to reveal the underlying color.

Sizing. Glue solution that can be used to prime a support, that is, to prepare it so that it becomes adequate for being painted on.

Sketch. Drawing that is produced in a quick and immediate manner.

Sketch. Test or trial drawing aimed at planning a composition that may lead to a final work. It can be synthetic and without too many details.

Solvent. Liquid used to thin paint. Turpentine or turpentine substitute is used as a solvent for oily and oleaginous mediums, and water is used for waterbased paintings such as watercolor, gouache, and acrylic.

Spraying. Rubbing the paintbrush's bristles with the fingernail to provoke raindrops on the support. The result is an interesting textured effect.

Staining. Drawing process that consists of creating the painting with overlapped stains of color, without paying attention to the details or textures, in order to produce an initial outline of the drawing.

Stretchers. Wooden frame on which a painting is fixed and to which the canvas is adhered. When it is fairly large, joists are added to prevent deformation of the painting's structure.

Striated painting. Application made with a palette knife in which the color is mixed not on the palette but on the medium, forming striations or bands of color.

Support. Physical surface on which the drawing or the painting will be applied.

T

Tempera. Painting produced out of the mixture of glue (animal), chalk, and a water-based pigment. It was very popular in the fourteenth and fifteenth centuries, when it was used to apply retouches on wall paintings or to paint altarpieces.

Tone. Refers to the relative darkness or lightness of a color. See "value."

Transparency. State of a coat of paint that allows light to filter through it.

V

Value. Synonym of "tone," it indicates the relative degree of clarity or darkness of a color, on a scale ranging from white to black.

Varnish. Thin and transparent layer used to apply retouches or to solidify paint. It is also applied to the work once finished, to protect it from pollution and humidity.

Volatility. Ease with which a solution or paint evaporates.

Volume. Three-dimensional effect achieved by shadowing on a drawing or a two-dimensional painting.

W

Wash. Highly diluted coat of paint. Also applied on watercolor when repetitively rubbed with a wet paintbrush to remove part of the color from the area.

Wash. Ink or watercolor application thinned in water that provides a thin coat of paint, which is generally translucent.

Watercolor. General term applied to hydrosoluble paints containing gum arabic as a binder.

Wet-on-wet. A technique that consists of applying fresh colors on top of each other, quickly and without going back over what has already been painted, by making the mixtures directly on the fabric and finishing the painting in a single session. Can also refer to a method consisting of applying paint on wet or humid paper or on a still fresh coat of paint.

White Lead. Pulverized chalk used to make *gesso*.

STERLING
New York

An Imprint of Sterling Publishing Co., Inc.
1166 Avenue of the Americas
New York, NY 10036

© 2016 by Parramón Paidotribo
English translation © 2016 by Sterling Publishing Co., Inc.

ISBN 978-1-4549-2147-9

Distributed in Canada by Sterling Publishing Co., Inc.
c/o Canadian Manda Group, 664 Annette Street
Toronto, Ontario, Canada M6S 2C8
Distributed in the United Kingdom by GMC Distribution Services
Castle Place, 166 High Street, Lewes, East Sussex, England BN7 1XU

For information about custom editions, special sales, and premium and corporate purchases,
please contact Sterling Special Sales at 800-805-5489 or specialsales@sterlingpublishing.com.

Manufactured in Spain

2 4 6 8 10 9 7 5 3 1

www.sterlingpublishing.com

Design by Parramón Paidotribo